Tippett Studies

Michael Tippett (1905–1998) was one of the major figures of British music in the twentieth century. This collection of studies is the first completely new, internationally available book on the composer to appear for over a decade and includes the thinking of established scholars and new commentators. Detailed analyses of individual works are counterpointed against critical investigations of contextual issues, such as the composer's relationship to the past, his 'Englishness', his fascination with ancient Greece and his pursuit of the visionary. The book covers all of Tippett's style periods and many of the key genres within his *œuvre*. What transpires is a rich portrait of an artist whose work reflects the century's triumphs and tragedies with particular intensity and who is upheld by younger generations of composers as a source of inspiration and example.

DAVID CLARKE is Senior Lecturer in music at the University of Newcastle. He is author of a forthcoming monograph on Michael Tippett.

Tippett Studies

EDITED BY DAVID CLARKE

PUBLISHED BY THE PRESS SYNDICATE OF THE UNIVERSITY OF CAMBRIDGE
The Pitt Building, Trumpington Street, Cambridge CB2 1RP, United Kingdom

CAMBRIDGE UNIVERSITY PRESS
The Edinburgh Building, Cambridge CB2 2RU, United Kingdom
40 West 20th Street, New York, NY 10011–4211, USA
10 Stamford Road, Oakleigh, Melbourne 3166, Australia

First published 1999

Printed in the United Kingdom at the University Press, Cambridge

Typeset in Adobe Minion 10.25/14pt, using QuarkXpress™ [SE]

A catalogue record for this book is available from the British Library

Library of Congress cataloguing in publication data

Tippett studies / edited by David Clarke.
 p. cm.
 Includes bibliographical references and index.
 ISBN 0 521 59205 4 (hardback)
 1. Tippett, Michael, 1905–98 – Criticism and interpretation.
 I. Clarke, David (David Ian)
 ML410.T467T58 1998
 780'.92–dc21 97-41862 CIP

ISBN 0 521 59205 4 hardback

To Ian Kemp

Contents

Preface

In the late 1990s little justification is needed for a book on Michael Tippett – a composer who in his own lifetime attained a canonical position in British music and prominence internationally. However, it is perhaps surprising that despite the levels of institutional recognition accorded him, Tippett (1905–98) has not been the subject of more widespread scholarly attention. For example, while the period between approximately his seventy-fifth and eightieth birthday years saw the publication of what still remain key texts on the composer – including most notably Ian Kemp's substantial monograph, Arnold Whittall's extensive technical investigation of Tippett's (as well as Britten's) *œuvre* and Meirion Bowen's introductory volume[1] – no new comparable book-length studies materialised as the composer approached and entered his nineties.[2] Against this background, then, *Tippett Studies* will, I hope, be seen as a timely venture. The essays below, the work both of established commentators and of new contributors to discourse on Tippett, can be claimed collectively to represent a significant expansion of research on the composer. Many of the studies were originally presented as papers at the Newcastle University International Tippett Conference in 1995, and the volume as a whole continues the philosophy of that event: to offer new perspectives on Tippett, while re-assessing and building on existing scholarship.

In a heterogeneous compilation such as this it would of course be gratuitous to make claims for a neat overall structure. That said, across essays

1 Ian Kemp, *Tippett: The Composer and his Music* (London, Eulenburg Books, 1984); Arnold Whittall, *The Music of Tippett and Britten: Studies in Themes and Techniques* (Cambridge: Cambridge University Press, 1982); Meirion Bowen, *Michael Tippett* (London: Robson Books, 1982).

2 Notwithstanding two less widely available books published in the intervening period: Margaret Scheppach's *Dramatic Parallels in Michael Tippett's Operas: Analytical Essays on the Musico-Dramatic Techniques* (Lewiston, New York: Edwin Mellen Press, 1990), and my *Language, Form, and Structure in the Music of Michael Tippett*, 2 vols. (New York and London: Garland Publishing, 1989). Additionally, Kemp's, Whittall's and Bowen's studies have been re-published in further editions (either reprinted or revised).

which encompass a range of genres and style periods a number of recurring themes may be detected. Their appearance may to some extent have been a matter of synchronicity, but together they invite a network of narratives such that the volume as a whole can with some justification be considered to be greater than the sum of its parts.

One such narrative has to do with attempts to tease out connections, or homologies, between biographical knowledge and musical inquiry. In the first two chapters, Anthony Pople and I seek to identify specific features of the character of the tonal language of Tippett's earlier style in relation to possible formative influences at the time of his apprenticeship: respectively the tutelage of R. O. Morris in the case of the *Fantasia Concertante*, and discourses around folk music in the case of the Concerto for Double String Orchestra. The concern of these studies to engage with details of musical language is also characteristic of many of the ensuing essays – a concern pursued sometimes in relation to questions of context, sometimes from a more purely immanent standpoint. This is surely a welcome development, given that in the past only a few have made sustained attempts in this direction. The recalcitrance of the music itself to analysis is no doubt a potential deterrent (one sometimes wonders whether Tippett through his quasi-intuitive creative temperament did not inoculate himself against music analysis), but, as a number of the contributors here demonstrate, that recalcitrance is best dealt with not by attempting to subvert it, but by embracing it. For example, Arnold Whittall's subtle analysis of possible parallels between technical musical strategies and dramatic content in *King Priam* demonstrates the importance of remaining alert to the tension between the specificity of musical particulars and the reductiveness inherent in the conceptual categories of analytical inquiry. As Whittall reminds us, analytical tactics should function as a trigger to thought, not as their own self-reproducing ends. And perhaps the fact that Tippett's music does not permit analysis to stop at reinforcing its own terms of operation is another index of its value.

That said, the analysis of this music still calls for rigour and precision if it is to advance beyond mere descriptive platitudes: formalised methodologies still have their role. While some readers will be more sympathetic than others to certain of the approaches taken here, I have no doubt that the demands of close reading entailed by the studies in question will bring their

own rewards. One recurring issue within the analytical seam of this book is the hybrid nature of Tippett's language, which even at its atonal extremes retains vestiges of its earlier tonal character, and even at its most tonal contains organisational features that prefigure its later, post-tonal attributes. This prompts commensurable pragmatism from contributors, though what is significant (and perhaps unexpected) is the extent to which Allen Forte's set-theoretical methodology has been productively applied. Those less familiar with the principles of Forte's theory of pitch-class sets might want to consult his primary text, *The Structure of Atonal Music*.[3] By and large, however, contributors have sought to incorporate explanation of their various applications; and to ease the way further, I have incorporated a glossary of some of the main theoretical terms from this methodology as an appendix to the present volume.

Another leitmotiv that surfaces in the following pages is Tippett's relationship to the musical past. This will perhaps increasingly provide the key to a fuller understanding of his music, and might well be seen in the light of the insistence of his one-time mentor T. S. Eliot on the importance of tradition in the forging of the new. Indeed, Tippett's shifts of style – his changing modernisms, one might say – could be construed in terms of the shifting nature of his relationship to different pasts. Such an assertion would seem to be corroborated by contributions below. Kenneth Gloag, for example, suggests that the neoclassical practice enshrined in a key work concerned with stylistic change, Tippett's Second Symphony, can be interpreted as a double play of defamiliarisation: a critical distancing from a Stravinskian neoclassicism which is itself defined by a processes of defamiliarisation from its own invoked pasts. In a not dissimilar vein, Christopher Mark independently suggests that the sequential treatment and patterns of transposition common to much of Tippett's music could be considered as metaphorical: as 'standing for' their counterparts received from the historical practices of Western tonal music. This implicitly throws different light on the 'recalcitrance question' of Tippett's language, for such musical gestures should be read, on this view, not in terms of their organic linkages to the work as a whole, but for their connotation of earlier stylistic patterns. And Alastair Borthwick arrives at a similar conclusion in his

3 (New Haven and London: Yale University Press, 1973.)

analysis of tonal voice-leading figures in Tippett's decidedly extended-tonal Third Piano Sonata. These melodic entities signify primarily through reference to their 'historical archetypes', rather than themselves aggregating organically into sustained middleground structures as their traditional counterparts would have done.

A different gloss on Tippett's relationship to the past is provided in chapters by Stephen Collisson and Peter Wright. Collisson investigates the relationship between the Triple Concerto and the past represented by Tippett's own *œuvre*, while Wright explores the composer's return in his Fifth String Quartet to his beloved Beethoven, who was such a powerful influence in his earlier stylistic period. What both these commentaries suggest is that the *rapprochement* between Tippett's late works and his earlier period is not just a matter of style-reference, but also has to do with a re-adoption of a more organicist aesthetic. This stance need not necessarily be seen to conflict with the positions of Borthwick and Mark, since the works in question issue, broadly speaking, from a different, later moment in Tippett's *œuvre*; but in any case, the purpose of this account is not to render invisible potentially profitable differences of perspective.

Connections can also be made between Collisson's account of the transcendental in the Triple Concerto and Rowena Pollard and David Clarke's discussion of a related issue in *King Priam*. The latter essay likewise has a past connection, only this time the more ancient past of classical Greece, with which Tippett has an expressed (implicitly humanist) affinity. In addition to tracing the textual mediations whereby the composer reinvents the aesthetic of Greek tragedy, our intention is also to consider how this can be achieved through a modernist musical language. Like Collisson, we find that the transcendental – one of Tippett's abiding concerns – is conveyed not (or not just) as an immanent aspect of a particular kind of musical language, but through the strategic context in which those linguistic features are situated; interestingly Peter Wright makes a similar point with regard to the 'visionary moment' of heterophony that bursts into the development section of the first movement of the Fifth String Quartet.

My comments at the outset of this Preface alluded to the intertextual background against which *Tippett Studies* is set. In its widest sense that background is discourse about Tippett's music at large: a discourse which constitutes the reception history which, I would say, is assumed in one way

or another in all writings on the composer, even if such a history has still to
be formally written. The final two chapters of this book relate to that history
in a more explicit way. Wilfrid Mellers's deeply felt personal memoir might
in the best of senses already be considered a historical document, for a
number of reasons. Most obvious is the case made by Mellers himself, that
his account is told from the standpoint of a near-contemporary and one-
time close associate of the composer himself. Secondly, Mellers represents a
point of contact between the present book and the earlier anthology
Michael Tippett: A Symposium on his 60th Birthday[4] – a volume to which
Mellers contributed, which Ian Kemp edited, and which, as the first full-
length book on the composer, surely marked an important stage in the
reception of Tippett as an artist of stature. Thirdly, Mellers's stance in his
memoir is typical of many within the reception history of Tippett's music:
one which asserts that the early works are the stronger ones; that the music
written after *King Priam* is not quite of the same calibre. Although Mellers
also admits qualification to his basic premise, others have been more explic-
itly polemical, not least the late Derrick Puffett on the occasion of the com-
poser's ninetieth birthday.[5] In the final chapter of this volume, Peter Wright
picks up the gauntlet, arguing that the Fifth String Quartet refutes any claim
that Tippett's creative powers might have dwindled in his later years. In
dedicating his essay to his former teacher's memory, Wright makes the
point that Puffett's views (and those of others like him) need to be taken
seriously, but at the same time contends that the force of any counter-argu-
ment comes through close, thoughtful reference to the music itself. And in
effect Wright's is not a lone voice in this volume, given that a number of
chapters consider Tippett's later works in the kind of detail and with the
kind of incisiveness that has not always accompanied negative critiques
made elsewhere. If in its own way *Tippett Studies* adds to the level of
informed debate about Tippett's music, and begins to effect a shift in per-
ceptions of it, then the contributors' purpose will have been served.

As ever, a project such as this could not have been undertaken
unaided. My thanks go to Penny Souster and Arnold Whittall for their
support, especially in the planning stages; to Schott & Co. Ltd for kind per-

4 (London: Faber & Faber, 1965.)
5 'Tippett and the retreat from mythology', *The Musical Times* 136, no. 1823
 (January 1995), 6–14.

mission to quote from Tippett's and Stravinsky's works; to Meirion Bowen for various points of consultation; to Grove's Dictionaries of Music, *Music Analysis*, the Society for Music Analysis, The Royal Musical Association, the Vice-Chancellor's Office, Arts Faculty and Music Department of Newcastle University, all of whom gave financial support to Newcastle University International Tippett Conference 1995, papers from which form the basis of much of this book; to Susan Lloyd, Frances Hopkins and Leo Nelson for unburdening me of some of the more onerous aspects of producing the typescript; to Gavin Warrender and Tim Poolan for assistance with various of the music examples; and to David Robinson for his forbearance at my rather too lengthy absences while editing this book.

And one final but important acknowledgement: there is no question that this venture would have not been possible without the achievement of previous scholarship. In particular, students of Tippett's music continue to owe a major debt to Ian Kemp. The significance of his *Symposium* celebrating Tippett's sixtieth birthday has already been mentioned; but his own life-and-works study, *Tippett: The Composer and his Music*, continues to be a mine of information and wisdom on its subject, and if the number of references to this work in what follows is anything to go by, its status will remain definitive for a long time to come. In dedicating our book to him, we contributors celebrate his seminal role in the enterprise of Tippett studies.

Sadly, Sir Michael Tippett died shortly before *Tippett Studies* was due to go to press. However unwished, his passing establishes a kind of closure – in effect a historical vantage point – which was absent when these essays were written (notwithstanding the fact that the composer's *œuvre* had by then already been declared complete). This is to suggest that the experience of reading what follows will inevitably be a subtly different one from that originally envisaged, given the significant change of biographical context. That the book was not consciously intended as a retrospective (one can only speculate how the contents might have differed if it had been) will not undo the fact that it might nevertheless now be read as such. But since the serious-minded engagement of the authors in any case always constituted its own implicit testimony to Tippett's music, it is indeed fitting here by way of memorial to underline the tribute paid by these studies to a remarkable artistic creator.

DAVID CLARKE

References to Tippett's scores and essays

With few exceptions Tippett's scores tend to employ rehearsal figures rather than bar numbers. Score references in this volume are accordingly made using the term 'Fig.', with suffixes where necessary to designate points a given number of bars before or after any such figure. Thus, for example, 'Fig. 4^{+3}' means 'three bars after Figure 4', or 'the third bar of Figure 4' (taking the first bar to be that in which the figure itself appears); while, conversely, 'Fig. 8^{-1}' means 'one bar before Figure 8'.

Bar numbers are used only for references to the opening of a piece, before the appearance of the first rehearsal figure, or on the rare occasions when a score does not employ rehearsal figures at all.

Most of Tippett's essays were originally compiled in the now out-of-print collections *Moving into Aquarius* (2nd edn, St Albans: Paladin Books, 1974) and *Music of the Angels: Essays and Sketchbooks*, ed. Meirion Bowen (London: Eulenburg Books, 1980). Many, though not all, of these writings are included alongside others (some new) in the more recent *Tippett on Music*, ed. Meirion Bowen (Oxford: Clarendon Press, 1995). When an essay appearing in one of the earlier anthologies and *Tippett on Music* is cited, footnote references will be given to both volumes, though any quoted material will normally be from the earlier version of the text if there is any variation.

1 'Only half rebelling': tonal strategies, folksong and 'Englishness' in Tippett's Concerto for Double String Orchestra

DAVID CLARKE

One of the greatest challenges facing musicologists is that of adequately interpreting the interpenetration of a composer's life and works. As the division of labour between music analysts and music historians makes plain (notwithstanding the potential deconstruction of this order by the emerging 'new' or 'critical' musicologies), explanation of the precise arrangement of actual notes and sounds in a musical work and reconstruction of the historical and biographical contingencies of its composition tend to resist conflation into a single narrative activity. I raise this dichotomy less to resolve than to explore it, in relation to Tippett's Concerto for Double String Orchestra (1938–9) and its status as the first work in the composer's *œuvre* to reveal his full creative stature. Decisive in the piece's aesthetic merit – happily reflected in its continuing popularity with audiences – is its cogent synthesis of a variety of musical influences that impinged on Tippett during the long process of his artistic maturation. Yet the dynamics of these musical forces, played out in the abstract inner space of an autonomous musical work, have their external counterpart in Tippett's socially rooted encounters with individual people – whom he knew either directly or through their writings – and with debates that shaped English musical culture at the time of his student years and the decade or so thereafter. In what follows I examine aspects of both the musical language of the Double Concerto and the historical and biographical context from which it emerged, in the belief that these separate accounts may be mutually illuminating. But the two resulting narratives will want to remain exactly that. Hence while I shall venture to examine possible points of contact between them, their discreteness will also need to be respected.

1

A potential interrelationship between these stories is none the less suggested by a cluster of issues that motivates the telling of both. These centre around Tippett's attitude towards folksong and towards the exponents of a pastoral aesthetic within the so-called English 'musical renaissance' in the first part of the twentieth century. The movement, of which Vaughan Williams was the figurehead, is known for having commandeered both folksong and a legacy of Tudor music as part of a discourse around 'Englishness' fuelled by anxieties over the hegemony of the Austro-German tradition within British musical life. It might be tempting to dismiss the influence on Tippett of the pastoral inclinations of his forebears. After all, he is known as a figure of more cosmopolitan leanings who learned German in order to read Goethe, who succumbed entirely to the music of Beethoven in his younger days, and whose later style reflects a receptiveness to the soundworlds of European modernism. Yet nearly all principal commentators on Tippett at some point confirm the view that, in Stephen Banfield's words, the composer was 'only half rebelling against Vaughan Williams and Holst in the 1930s':[1] both Ian Kemp and Arnold Whittall, for example, draw attention to folk-related elements in the Concerto for Double String Orchestra.[2] In this essay I shall attempt to investigate further Tippett's ambiguous connection with English pastoralism and the folksong traditions of the British Isles, and evaluate its implications for his compositional practice in the period of his first maturity.[3] Although there will not be space

1 Stephen Banfield, Introduction to *The Blackwell History of Music in Britain: The Twentieth Century*, ed. Stephen Banfield (Oxford, and Cambridge, Massachusetts: Blackwell, 1995), 3.

2 See Ian Kemp, *Tippett: The Composer and his Music* (London: Eulenburg Books, 1984), 138, 142–3, 146; Arnold Whittall, *The Music of Britten and Tippett: Studies in Themes and Techniques* (Cambridge: Cambridge University Press, 1982), 54.

3 This account needs also to be seen in the context of a broader musicological reassessment of English pastoralism and the folksong revival. For example, a timely essay which sets the agenda for a re-evaluation of Vaughan Williams can be found in Alain Frogley's 'Constructing Englishness in music: national character and the reception of Ralph Vaughan Williams', in *Vaughan Williams Studies*, ed. Alain Frogley (Cambridge: Cambridge University Press, 1996), 1–22; see also the chapters by Hugh Cobbe, Julian Onderdonk and Anthony Pople in the same volume. Paul Harrington's 'Holst and Vaughan Williams: radical pastoral', in *Music and the Politics of Culture*, ed. Christopher Norris (London: Lawrence and Wishart, 1989), 106–27, addresses the influence of William Morris's socialism on both composers. Frogley underlines the role of this essay and others in offering a potential corrective to the casting of Vaughan Williams 'as a cosy Establishment figure playing opposite the left-wing young bloods of

to pursue all relevant avenues of inquiry, I hope nevertheless to introduce some new perspectives on the matter, both by piecing together items of evidence available from Tippett's own writings and elsewhere, and through an analysis of certain tonal strategies adopted within the Concerto for Double String Orchestra. To focus on tonality is not to belittle the relevance of other facets of the work, not least the originality of its rhythmic structures and their relationship to the English madrigal and consort fantasia styles; but as these have been discussed elsewhere, I will confine my argument to the less well explored issue of the Concerto's refashioning of a diatonic language. First, however, to matters of context.

I

At least five protagonists ought properly to feature in the complete historical account of Tippett's relationship with English pastoralism. Two of these, Vaughan Williams and Holst, were prominent figures on the staff of the Royal College of Music (one of the key institutions associated with the English musical renaissance) when Tippett was a student there between 1923 and 1928.[4] Two others, Francesca Allinson and Jeffrey Mark, were personal friends also dating back to his student days. They had strong interests in folk music of the British Isles, and it is probably not coincidental that they were the dedicatees of the two early published works by Tippett that feature folk-type material: the Sonata No. 1 for Piano (1936–8) and the Concerto for Double String Orchestra respectively. The fifth protagonist, Cecil Sharp, is significant because aspects of his construction (to use today's language) of English folk music were challenged in research by Allinson with which Tippett was also associated. Limitations of space, however, mean that not all these figures will receive their due here. Perhaps perversely, I will say little about the Percy Grainger-like figure of Jeffrey Mark, precisely because his significance for Tippett requires far fuller com-

Tippett and Britten in the 1930s' (Frogley, 'Constructing Englishness', 13). The present study attempts to demonstrate the need for a complementary reappraisal on Tippett's side of this perceived divide. For a recent reconsideration of Britten's stance towards English pastoralism see Philip Brett, 'Toeing the line', *The Musical Times* 137, No. 1843 (September 1996), 7–13.

4 See Robert Stradling and Meirion Hughes's account of the place of the RCM in the cultural politics of the time, in their book, *The English Musical Renaissance 1860–1940: Construction and Deconstruction* (London and New York: Routledge, 1993), especially part I, 'The history and politics of renaissance', 11–92.

mentary than is possible in this essay. Suffice it to say for now that his researches into Northumbrian and Scottish folk music, as well as his related activities as a composer and his belief in having found 'a new model for dia-tonicism', were in various ways influential on the composition of the Concerto for Double String Orchestra.[5]

Vaughan Williams and Holst also warrant greater coverage than is possible here, though what does call for comment is the way in which Tippett seemed to have projected onto them the different aspects of a per-sonal ambivalence towards Englishness and English music. On the one hand, Vaughan Williams was a focus of anxious sentiments, possibly because of his position as a key figure of the contemporary cultural establishment. Tippett writes in his autobiography, 'at the RCM and sub-sequently, in English musical life in general, I found an anti-intellectualism which disturbed and irritated me. The Vaughan Williams School was a part of this.'[6] Tippett avoided studying composition with Vaughan Williams both for this reason and because 'his pupils simply wrote feeble, watered down V. W.'[7] This association of Englishness with intellectual and technical laxity is reinforced when Tippett later writes of his own development: 'it's the technical equipment that is growing intellectually maturer *& conse-quently un-English*, as per Bax – V. W. & Ireland etc.'[8] On the other hand, Holst is a figure whom Tippett admired with less reservation, perhaps because the former shared with Stravinsky a 'rootedness in national *and* European traditions'.[9] Tippett's enthusiastic comments about *The Hymn of Jesus*, in which he sang as a student, also reveal that he was attuned to the

5 See Michael Tippett, *Those Twentieth Century Blues: An Autobiography* (London: Hutchinson, 1991), 45–6; and Kemp, *Tippett*, 488–9 n. 12.
6 Tippett, *Those Twentieth Century Blues*, 16. 7 Ibid., 15.
8 Letter to Francesca Allinson, dated March 1941; quoted in ibid., 136 (emphasis mine). It is important to add the caveat that Tippett's self-distancing from Vaughan Williams on an artistic level does not seem to have been matched by any personal antipathy. Kemp (*Tippett*, 44) states that 'in general Vaughan Williams was a warm and fatherly figure with whom [Tippett] got on well enough' – evidenced, one might surmise, by the fact that Vaughan Williams spoke up for Tippett at the latter's trial as a conscientious objector in 1943. Nor should it be overlooked that Tippett mounted Vaughan Williams's opera *The Shepherds of the Delectable Mountains* as his first music-theatrical venture at Oxted in 1927.
9 Michael Tippett, 'Holst', in *Tippett on Music*, ed. Meirion Bowen (Oxford: Clarendon Press, 1995), 75 (emphasis added). This essay is closely modelled on an earlier article by Tippett, 'Holst: figure of our time', *The Listener* 60 (1958), 800.

cultural vibrancy of the period: 'for those of us embarking on a musical career at that time, it was all part of the exciting spectrum of English musical life – later to be described as a "second Renaissance" in English music'.[10]

Tippett's stance towards these various aspects of English musical culture was in fact far from one of rejection. We might surmise that his reservations were directed less to the actual sound the music made, so to speak, than to its perceived technical limitations and ideological connotations.[11] Regarding folk music in particular, he seems to have reached a position during the course of the 1930s where both its potential for integration into a high-art aesthetic and its socio-cultural meanings could be reassessed and implemented. It is in this latter respect that his liaison with Francesca Allinson was important, and for this reason that she will become a focus for this study. Allinson, whom Tippett first came to know through his cousin, Phyllis Kemp, was a musician and aspirant writer, and although for a while she had a significant role in the composer's personal life,[12] it is her researches into folk music that are a more direct concern for our present purposes. Two further, related elements also feature in this story: a genre and a book. The genre was ballad opera, in which Tippett was involved practically as a composer and arranger in the late 1920s and 1930s; the book was a monograph by Allinson entitled *The Irish Contribution to English Traditional Tunes*, left uncompleted at the time of her tragic suicide in 1945.[13]

10 Tippett, 'Holst', in *Tippett on Music*, 71. 11 See Kemp, *Tippett*, 68–70.

12 For more details see: ibid., 25; Tippett, *Those Twentieth Century Blues*, 17, 41–2, 56, 163–87; and my 'Tippett in and out of "Those Twentieth Century Blues": the context and significance of an autobiography', *Music & Letters* 74/3 (1993), 399–411.

13 The monograph is briefly mentioned by Kemp (see *Tippett*, 69, 488 n. 2), but much of the following discussion is based on direct consultation of the original manuscript of the unpublished text, lodged in the Vaughan Williams Memorial Library of the English Folk Dance and Song Society. The MS comprises three sections, all unfoliated: (1) an exchange of six letters between Tippett and Maud Karpeles (dated between 17 November 1964 and 28 January 1965), which documents the process that led to Allinson's manuscript being unearthed and presented to the library; (2) a looseleaf typescript of sections of the monograph itself, bearing the annotation 'master copy'; (3) a music MS book comprising groups of folk tunes to which Allinson refers in the text.

As implied, the typescript is incomplete. A table of contents lists seven chapters, but only the first two, accounting for a substantial part of the document, are presented in their entirety; extracts from the remaining chapters

A number of Tippett's early musico-dramatic ventures, all of which entail grass-roots community involvement, adopt ballad opera as their basic model. In this preoccupation *The Beggar's Opera* looms large. Tippett knew the work from his early days in London, and when he wanted to produce a ballad opera for his second season at Oxted he sought out an eighteenth-century edition of an opera in the same genre, *The Village Opera*. He made his own version of the piece, significantly recomposing part of it. Other ballad or folksong operas followed, with varying degrees of original compositional involvement. *The Beggar's Opera* itself and *Robin Hood* were produced at the Boosbeck work-camps in 1933 and 1934 respectively, and Allinson sang the role of Lucy in the former. *Robert of Sicily* was a play for children produced in 1938, for which Allinson 'helped . . . find the right [folk] tunes'[14] (a sequel, *Seven at One Stroke*, followed the next year, but appears to have been musically less consequential[15]).

The fact that ballad opera was the chief outlet for Tippett's interest in folk music might raise the question of whether the songs purveyed by the genre constituted 'authentic' folk material. However, the assumptions behind such reservations were exactly part of what Tippett and Allinson wanted to challenge, refuting certain ideological notions of purity that were at the heart of the English folksong revival, as most prominently promulgated by Cecil Sharp and Vaughan Williams. Sharp, in his seminal book *English Folk-song: Some Conclusions,* dismissed the folksongs which appear in *The Beggar's Opera* as 'well-nigh worthless' because of the 'devastating

form the rest of the typescript. In his correspondence with Karpeles, Tippett mentions the possible existence of a further copy which he describes as 'cleaner' and 'perhaps more definitive', but at that time it seems not to have come to light. A further collection of papers relating to the monograph was found during Tippett's final house-move; at the time of writing this study the supplementary material was still privately held, and I am indebted to Meirion Bowen for making it available to me. Unfortunately the newly surfaced material does little to fill in the gaps in the main MS: there are a few, non-consecutive pages of the seventh chapter, earlier drafts of fragments of chapters found in the main MS, another version of the tune book, and an index of tunes cited. More significant, however, are three differently typed transcriptions of comments on the book made by Vaughan Williams, and two letters from Oxford University Press: one to Allinson (dated 19 September 1944), and one to Tippett (dated 4 November 1947). From this correspondence it is clear that Allinson had sent a draft of at least part of the monograph for consideration for publication, and that Tippett did begin to follow up the process after her death, albeit to no avail.

14 Tippett, *Those Twentieth Century Blues,* 57. 15 See Kemp, *Tippett,* 84.

hand of the editing musician'.[16] This was indicative of a more general aversion to traditional songs transmitted through the published page, which he contrasted against a putatively more authentic folksong transmitted entirely orally – an opposition which idealised both folksong and folksinger. Although Sharp later slightly qualified his original formulation of this opposition as a difference between urban and rural cultures (in the light of comments from Vaughan Williams, as it turns out), he nevertheless retained the romantic notion of the unlettered peasant artist:

> Strictly speaking . . . the real antithesis is not between the music of the town and that of the country, but between that which is the product of the spontaneous and intuitive exercise of untrained faculties, and that which is due to the conscious and intentional use of faculties which have been especially cultivated and developed for the purpose.[17]

In her monograph *The Irish Contribution to English Traditional Tunes* – a project onto which Tippett was in some way co-opted – Allinson counters Sharp's claim that the edited, published tunes of the early English tradition are any less 'authentic' than those transmitted orally: 'we may be thankful', she writes, 'that cultivated society in general, pu[bl]ishers and makers of ballad opera in particular, valued our traditional tunes and knew how to put them to active use – a problem which we to-day are hard set to solve'.[18] The presence of such published songs within the traditional repertory is seen by her not as corruption of a pure 'peasant' song, but rather as indicating that 'they were sung by all classes of people and not by the peasantry alone'.[19] Whereas Sharp distinguished between earlier published collections of traditional tunes, such as William Chappell's *Popular Music of the Olden Time,* and the songs he collected in the field, Allinson makes an alternative interpretative demarcation, which in fact constitutes her book's main thesis. She holds that a distinction obtains *within* the collections made by late nineteenth-century collectors such as Sharp: a distinction between tunes 'that faithfully carry on the old tradition' (i.e. of the published songbook and ballad opera) and those characterised by 'the strangeness of their melodic line, of their form and of the emotions that they evoke'.[20] In short,

16 Cecil Sharp, *English Folk-song: Some Conclusions,* 1st edn (London: Simpkin/Novello, 1907), 114, 116; also quoted in chapter 2 of Allinson's monograph. 17 Sharp, *English Folk-song,* 4. 18 Allinson, chapter 2.
19 Ibid. 20 Ibid.

she construes the latter group as being of fundamentally different, specifically Irish, provenance, having entered the repertory during the late eighteenth and nineteenth centuries when large numbers of Irish labourers emigrated to England. Technically, this distinction is manifested, in Allinson's view, in the modal characteristics of the tunes as well as their tendency to fall into ABBA or ABBC form.[21] Thus, she argues not only that one portion of the peasant songs collected by Sharp and others provides a living stylistic link with the tunes published in previous centuries, but also that the complementary portion develops from a Celtic tradition. Her challenge to Sharp's beliefs (and the whole nationalist edifice built on it) that these songs represented pure, quintessential Englishness is therefore forthright.[22]

Quite how far Tippett's role in Allinson's investigation extended is a matter of conjecture. In a letter to Maud Karpeles[23] he retrospectively describes himself as having been 'a kind of sitting collaborator' – which is probably accurate. On the one hand, it seems unlikely that he participated in the actual writing process. None of the annotations on Allinson's typescript is in his hand; indeed work on the text probably took place during the years of the Second World War, when Allinson moved out of London and the two kept in touch largely by letter.[24] On the other hand, Tippett was clearly interested in the issues and the manner of their argument: certain of his letters to Allinson include suggestions regarding both the content and the form of the monograph, as well as references to both '*our* contention' and '*our* book'[25] – all of which suggest at least a measure of identification with the project. The latter comment might indicate an intention to become more actively involved in the book's production, and

21 The question of the tunes' form is also reported by Kemp (*Tippett*, 69), who additionally recounts Allinson's refutation of Sharp's assertion that quintuple and septuple metres constituted essential features of English folksong. For references to both these features in Tippett's correspondence see Tippett, *Those Twentieth Century Blues*, 127, 148.

22 Vaughan Willliams certainly seemed to have thought so. His comments on the draft monograph (found with the supplementary portion of the MS – see note 13 above) begin: 'this is not a merely academic question, the whole edifice of English music depends on it'. He continues: 'we cannot view this matter in a calm, detached manner, our very musical life seems to depend on it'.

23 Part of the exchange described in n. 13 above.

24 The address on the manuscript tune book accompanying the typescript is that of the Mill House, West Wickham, where Allinson is mentioned as residing in letters dating from the 1940s; see Tippett, *Those Twentieth Century Blues*, 141, 152. 25 Ibid., 127, 129 (emphasis added).

from Allinson's request in her final letter to Tippett to 'give it the finishing touches & see it into print'[26] we may infer a level of familiarity with its contents and progress. As is known, however, he never did complete it: in the end (that is, after twenty years) he presented the unfinished manuscript to the Vaughan Williams Memorial Library in Cecil Sharp House, London – the ironies of which have not been lost in accounts of the story.[27]

Whether Allinson's thesis regarding the provenance of English folk tunes was indeed correct is a moot point. In his correspondence with Karpeles, Tippett retrospectively admits to being persuaded that the theory was wrong (although, in mitigation, Karpeles's response stresses the problems of studying the folk music of a bilingual country).[28] What remains noteworthy none the less is the monograph's questioning of Sharp's romanticised view of folk music, and hence, implicitly, the entire hegemony of the English folk revival[29] and its associated school of composing. It is significant, though, that the Allinson–Tippett critique entails not a dismissal of the folksong enterprise, but an attempt to reconceive it from within. This finds a parallel in Tippett's attitude towards English musical traditions, which are not to be rejected in favour of some kind of internationalist agenda, but to be embraced without specious, nostalgic distinctions between urban and rural cultures. He defines his stance in a letter written to Allinson in 1941 regarding the folksong monograph:

> we shall probably eventually get a sort of ladder – the roots in romantic, immediate expression – what Sharp went to find – & the heaven of the ladder will be the classical, artistic, turned, articulated stuff. And what we shall seek to show is the elements wh[ich] were at work to form it: such as

26 Ibid., 185.
27 See ibid., 57. Although Tippett admitted to being 'rather dilatory about it', the correspondence found in the supplementary portion of the MS (see n. 13 above) suggests that he did at least make an attempt to follow up the possibilities for publication. Given the incomplete nature of the MS, it may well have been a case of providing rather more than 'finishing touches'.
28 Tippett–Karpeles correspondence (see n. 13 above), 25 and 28 January 1965.
29 Perhaps anticipating aspects of more recent critical studies, for example: Georgina Boyes, *The Imagined Village: Culture, Ideology and the English Folk Revival* (Manchester and New York: Manchester University Press, 1993); Dave Harker, *Fakesong: The Manufacture of British 'Folksong' – 1700 to the Present Day* (Milton Keynes and Philadelphia: Open University Press, 1985); and Stradling and Hughes, *The English Musical Renaissance*.

the necessary formulation of dancing, the influence of poetic forms, the artistic feeling in the composer. The B[eggar's] O[pera] is a good English work of art because it faces both ways – it protests against the excessive influence of the foreigner & the romantic inchoate expressiveness of the Sharp 'natural' peasant. Hence again we erect it (& it doesn't matter altogether how factual all this is) as a standard for our day. There *must* be cross-currents in art & tension – & again now there are 2 ways to face (if not 3!) – against the German *Schwermut*, against the jazz-nostalgia, against the Celtic Twilight. Positively, on the other hand, for roots in the 'town' & 'country' streams of English tradition, for balance between them, for full artistic integrity – & a historical immediate sense of the good models.

...It is not the 'country', as such, that we define against the 'town'. It is the nostalgic, vague hovering with the excellent quality of folk-expressiveness, as opposed to the *consciously* artistic articulation of it. Sharp was probably stymied before it. It got him on his weak, undeveloped side – so he either toned it up with jokey fortes, or tried to present it under the guise of the irrational peasant. We show, if we can, that in an articulated mastered form, it is just good, English, & highly presentable, differing in no necessary inferiority, or superiority, from the gay stuff. What we refuse is inchoate subjectiveness (except as folklore) & Sharp's subterfuges & lack of integrity, let alone maturity.[30]

Despite its obscurities, this statement gives a strong indication of where Tippett sees himself in relation to certain of the dominant discourses of contemporary English musical culture. On the one hand his is a position of non-alignment with any prevailing ideology: Sharp is castigated for his suspect view of the 'natural' peasant (no doubt for Tippett a further example of English intellectual flaccidity); Germanic modes of expression (a reference perhaps to Elgar and Richard Strauss) are also to be resisted; but 'jazz-nostalgia' (Walton and Lambert are presumably intended here) and the 'Celtic twilight' (Bax) are not seen as viable alternatives either. On the other hand, Tippett's position is still defined in relation to, rather than avoidance of, these ideologies – the key phrase is 'tension against'. His metaphor of a ladder as a mediating notion between orally transmitted folksong and 'classical, artistic, turned, articulated' musical material in fact suggests a value placed on a synthesis, emerging perhaps from the 'cross-currents' and 'tension' to which he refers. Particularly significant in this respect is his representation of *The Beggar's Opera* as an ideal model, exemplifying a dis-

30 Tippett, *Those Twentieth Century Blues*, 128 (original emphases).

tinctive Englishness – where 'English' does not equal naive, inchoate or lacking integrity.

II

Such a synthesis, I would contend, is exactly what Tippett achieves in his Concerto for Double String Orchestra. Adapting his reading of *The Beggar's Opera*, we may observe similar characteristics in the Concerto: it protests against a 'romantic inchoate' folk-expressiveness attributable to the English pastoral idiom, but nevertheless draws on its expressive immediacy within an interplay of materials serving the higher goal of a 'turned, articulate', quasi-symphonic artwork. But if folk-materials are immanently subjected to the critical rigour of a quintessentially Beethovenian formal archetype, the opposite tendency also obtains. The Concerto 'protests against the excessive influence of the foreigner' in a critique both of 'German *Schwermut*' (suggesting an aesthetic of *gravitas*, related perhaps to a post-Wagnerian chromatic vocabulary) and of totalising Germanic conceptions of tonal unity.

Tracing the operation of these processes brings us to our second, technically orientated narrative, whose contents, as indicated at the outset, will need to follow their own course if they are to establish any meaningful relationship with the first. That said, we may begin (as we hope to end) with the matter of the connection between technical strategies and national musical characteristics. Apposite here is a comment by Yehudi Menuhin, citing the hypothesis of an unnamed Scandinavian musicologist that

> the English nature during the two centuries of tonic-dominant supremacy (*Teu*tonic-dominant-domination in short?) never came to terms with these fixed tonal positions. Unlike the rest of Europe, they never surrendered their soul to this rigid principle which, served and adulated by *gleichgeschaltete* millions with no distinction between rural and urban, had produced by the nineteenth century such a giant as Beethoven.[31]

Tippett gives a clue to how the Double Concerto resists the notion of a single, all-embracing tonic when, having stated 'we don't use tonality by

31 Yehudi Menuhin, in 'Tributes and reminiscences', in Ian Kemp (ed.), *Michael Tippett: A Symposium on his 60th Birthday* (London: Faber & Faber, 1965), 60.

setting out to write a piece in a set key. We use it much more for colour', he continues:

> [The Concerto] is mostly in A to start with, a kind of model [sic.: modal?] A minor. The middle movement is in a kind of D. In the last movement, the normal way of ending would have been to end in A, but I deliberately turned the music towards the tonality of C, just because I wanted this broader sound.[32]

The peculiar sonic properties of a tonality are thus posited as subverting the unifying relational principle of a governing tonal order. Interestingly, Tippett relates this strategy to two other works, both of which have their place in the English musical renaissance: Tallis's forty-part motet, *Spem in alium* and Holst's *The Hymn of Jesus*. His comment that both works 'play with musical space'[33] could, if read literally, be taken to refer simply to the handling of their polychoral forces. However, it may also allude to a mediation between spatial play in the real, physical performing environment and a play in phenomenological space whereby a triadic sonority may strive for emancipation by claiming territory outside that defined by the governing tonality. This is certainly so in *Spem in alium* where at the word 'respice' a massive A major chord for all forty voices breaks free of the 'tonic' Mixolydian G: a decisive moment of structural articulation.[34] In *The Hymn of Jesus* a similar gesture can be typically found at the beginning of the second section: when the chorus sing 'Glory to thee, Father' the prevailing tonality of C is dramatically supplanted by a chord of E major. In both examples the foreign harmony is not available for resolution into the overall governing tonality by way of a conventional functional progression predicated on the circle of fifths. In the case of Tallis and his contemporaries this arises from the ambivalent relationship of triads to modes (a conflict between a harmonic lexicon and an essentially melodic syntax) whose sonic effects clearly became attractive to composers of the second English musical renaissance.

The tonal strategy employed by Tippett at the end of his Double

32 Michael Tippett, 'The composer speaks' (Tippett in interview with Ian Kemp and Malcolm Rayment), *Audio and Record Review* (February 1963), 27.
33 Tippett, 'Holst', in *Tippett on Music*, 75.
34 This is probably the passage Tippett had in mind in his not entirely accurately recalled description in 'The composer speaks', 27.

Concerto can perhaps be seen as a projection of the principles described here onto the wider canvas of a complete piece. The closing, C major passage (beginning at Fig. 40^{+7}; the principal melody is quoted in Ex. 1.3(c), below) has a richness and depth contrasting with the brighter, more intense soundworld of A and its relatives which is initially in the ascendant. Here again we have a conflation of the categories of space and sonority as the resonant close claims different terrain in the work's tonal topography. However, Tippett's statement that he 'turned the music towards the tonality of C, just because [he] wanted this broader sound' is a touch disingenuous if this is intended to imply some absolute sonic quality of C major itself. While sonority functions – both in this work and in Tippett's music at large – as an agent of emancipation from the totalising impulse that is often a concomitant of the will to structure, these two tendencies are in fact mediated here. On the one hand, Tippett indeed exploits string sonorities that are quasi-inherent to particular keys: the shift from A to C could almost be construed as an exchange of the characteristic sonic qualities of the upper strings of the violin for those of the lower strings of the viola and cello. On the other hand, much of the significance of the final swerve to C derives from the meaning that this tonality acquires when perceived *in relation to* A. Furthermore, the gesture does not come out of the blue. It is the consummation of an interplay between sonorities in and around C and A that is ingrained into the piece, amounting in effect to a double tonal structure.[35]

35 The association or polarisation of these particular tonalities assumes a virtually archetypal significance within Tippett's *œuvre*, most notably in the final act of *The Midsummer Marriage*, in the Second Symphony, and in *Byzantium*. See Whittall, *The Music of Britten and Tippett*, 140; Whittall, '*Byzantium*: Tippett, Yeats and the limitations of affinity', *Music & Letters* 74/3 (1993), 395–7; and my *Language, Form, and Structure in the Music of Michael Tippett*, 2 vols. (New York and London: Garland Publishing, 1989), vol. I, 81–2.

In a much larger context, double tonicity has been an increasingly conspicuous subject of analytical inquiry, particularly in relation to nineteenth-century music. See, for example: Robert Bailey, 'An analytical study of the sketches and drafts', in his *Wagner: Prelude and Transfiguration from Tristan and Isolde*, Norton Critical Scores (New York and London: W. W. Norton, 1985), 113–46; Edward Cone, 'Ambiguity and reinterpretation in Chopin', in *Chopin Studies 2*, ed. John Rink and Jim Samson (Cambridge: Cambridge University Press, 1994), 140–60; William Kinderman, 'Dramatic recapitulation in Wagner's *Götterdämmerung*', *19th Century Music* 4/2 (1980), 101–12; Harald Krebs, 'Alternatives to monotonality in early nineteenth-century music', *Journal of*

This tonal dualism is especially active in the outer sections of the Concerto's sonata-form first movement. Specifically, it obtains between two tonal constellations or systems, one based on A, E and D, the other on C, G and F. The polarity thus established creates a tension against – or a critique of – the concept of unity inherent in classical tonality and its basis in the circle of fifths. This polarity is prefigured in the very first phrase of the movement,[36] and is graphed in Ex. 1.1. As Ex. 1.1(a) shows, if octave doublings an octave higher and lower are disregarded, the opening eight bars can be seen to comprise a two-voice texture, and although the formidable rhythmic and contrapuntal independence of the lines renders any notion of unequivocal harmonic 'progression' somewhat specious, it is nevertheless possible to discern indicators of harmonic functions which, however ambiguously implied and allusively executed, remain essential to the overall coherence of the material. These are shown in Ex. 1.1(b) and (c) – analyses stratified so as to reveal the discrete operation of the A–E–D and C–G–F constellations.

In the first of these analyses, A is shown to be asserted by an implied overall I–V–I motion articulated at the beginning, middle and end of the complete phrase; the linear descent in the treble, which fills in the melodic gap from A to E of bars 1–2, reinforces this harmonic allusion, even if it does not quite mesh in with it contrapuntally. The initial, generative treble motion from tonic to dominant pitches is mirrored by the entry of the second orchestra on the subdominant of A, which makes a momentary tonal allusion to D. It seems quite likely that this reflects Tippett's implementation of d'Indy's model of tonality, in which motion sharpwards around the circle of fifths, 'vers la clarté' is seen as complemented by motion

Music Theory 25/1 (1981), 1–16; Christopher Lewis, 'Mirrors and metaphors: reflections on Schoenberg and nineteenth-century tonality', *19th Century Music* 11/1 (Summer 1987), 26–42; and David Loeb, 'Dual-key movements', in *Schenker Studies*, ed. Hedi Siegel (Cambridge: Cambridge University Press, 1990), 76–83. While it would be overly essentialist to construe the various instances of 'non-monotonality' discussed in these (and a number of other) studies as representatives of an identical phenomenon, the picture developed through this literature nevertheless suggests that tonal processes had begun to be significantly unshackled from a unifying imperative in certain areas of the repertory following Beethoven.

36 As indeed are many other facets of the movement's content and structure. For a fuller account of this, and of the Concerto's tonal structure see chapter 1 of Clarke, *Language, Form, and Structure*, vol. I, 23–47.

Ex. 1.1 Concerto for Double String Orchestra, first movement, bars 1–8

flatwards, 'vers l'obscurité'.[37] But in a manoeuvre that is entirely idiosyncratic, Tippett extends the subdominant orientation in a process charted in Ex. 1.1(d). This effectively generates the C–G–F constellation, whose tonalities are, appropriately, often plagally inferred, as shown in Ex. 1.1(c). (In general, the tonal centre D seems to play a mediating role between the two systems – as shown here, and as reflected by its function as the tonic of the work's central movement.)

While the discreteness of these strata is still embryonic at this stage (palpable mainly as a tension arising from such vertical non-congruences as the treble motion C–F in the second four-bar subphrase against the prolonged V–I motion of A underneath), it is soon made more overtly manifest. The G major second group, beginning at Fig. 2^{+7}, could be seen as a representative of the C–G–F system, posited against the A–E–D system in a manner analogous to, though more complex than, the polarisation between single tonalities in a classical sonata-form exposition. Evidence for this conception comes immediately after the second group (Fig. 4^{+2}), when the return of the opening material of the movement, transposed to E, is felt as wrenching back to the earlier soundworld – and hence to the previous system – only now more intensely voiced, due to the transposition sharpwards.

The use of sonorous qualities to highlight the contrast between the different systems is important. The more strongly the second group projects its identity, the more it tends to eschew the sparser, linear textures of its predecessor in favour of a deeper, more resonant and harmonically orientated soundworld. Its character exemplifies most fully the *Allegro con brio* tempo designation of the movement as a whole, whereas the more austere identity of the opening first-group material is perhaps more appropriately described by the original, but subsequently deleted *Allegro con fuoco* marking found in the pencil manuscript of the score.[38] Significantly, the coda (Fig. 13^{+5} onwards), alternating between harmonic representatives of both tonal systems, synthesises both qualities – a moment of equilibrium in a process which aptly illustrates Tippett's reference to the 'play on images and tones that was in my forebears'.[39]

37 The importance of d'Indy's *Cours de composition musicale* (3 vols. (Paris: Durand,1909)) for Tippett's understanding of tonality is discussed by Kemp: see *Tippett*, 89–90, 146–7. 38 British Library Add. MS 61750.
39 Tippett, 'The composer speaks', 27.

If A is the governing tonic of the A–E–D system, it would be tempting to attribute an analogous role to C in relation to its system. Such an interpretation is certainly supported by the tonal progress of the work as a whole, although in the first movement G is the predominant representative of the flatter system. Since it is most strongly asserted in the second group of the exposition, however, it would be elegant to interpret this as a dominant – of the C- rather than the A-based system. This reading could be supported by a number of moments elsewhere in the movement, where C is subtly allied with A in a manner that suggests the two centres as parallel tonics. Three examples will suffice. First, in the counterstatement succeeding the initial statement, A and C act as complementary melodic centres from which the headmotif of the opening theme is developed antiphonally and in contrary motion (Ex. 1.2(a)). Secondly, having initially asserted A major, the jubilant passage immediately before Fig. 1 is pulled towards C's orbit: Ex. 1.2(b) fictitiously shows the implied arrival in C, which in the actual music is subverted by a sudden *sforzando* deflection towards V of E. Thirdly, A's return at the recapitulation (Fig. 8^{-1}) is prefaced by a strong prolongation of a bass C (Ex. 1.2(c)), whose function hovers ambiguously between that of a putative tonic (with a root position status denied to A itself at the recapitulation proper) and a prolonged secondary dominant within a harmonic progression back to A. While the equivocation surrounding C's status in these last two examples might seem to weaken its claim to any kind of tonic function, it might conversely be argued that this is exactly what enables it to be characterised as the tonic of a world running parallel to the A system, rather than occupying the same plane. Through being implied rather than overtly stated as a tonic, C is able to side-step claims made upon it by A as a prolongation within a uni-dimensional hierarchy of relationships based on the circle of fifths. Seen in this context, the potency of C's eventual radically more corporeal presentation of the end of the work can be more fully understood.

III

As we have seen, the tonal procedures described above relate to principles Tippett himself observed in the music of both his sixteenth- and twentieth-century English forebears. I would also argue that the com-

Ex. 1.2 Association of pitch centres A and C (octave doublings omitted)

(a)

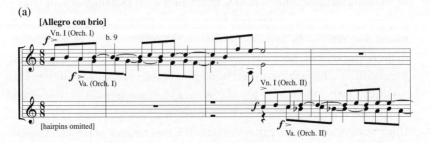

(b)

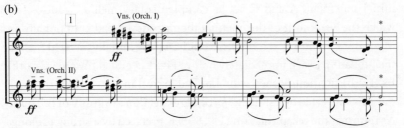

(c)

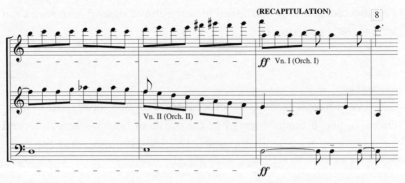

Ex. 1.3 Unifying function of pentatonic set (dynamics, expression markings and octave doublings omitted)

(a) First movement: beginning of first group

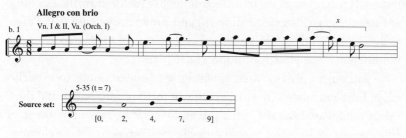

(b) First movement: beginning of second group

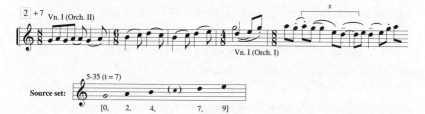

(c) Third movement: final section

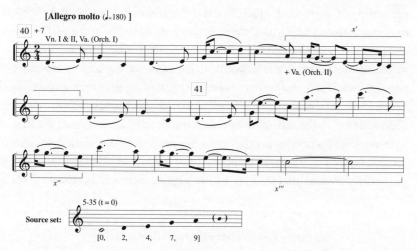

19

poser's tactic, which has fundamentally to do with the application of aspects of a modal harmonic system to dissolve and reconceive a tonal one, has a comparable relationship with folksong materials. However, if in this respect Tippett invokes the traditions of English pastoralism, the execution of his strategy yields a rather different end-product, due both to the more radical and thoroughgoing structural exploitation of the materials, and to the different ideological disposition which drives it.

Although only two themes within the Double Concerto explicitly adopt folksong models (the main theme of the slow movement, and the C major tune that closes the entire piece), many of its remaining thematic constituents are based on related melodic configurations, whose common source is the pentatonic scale. One vital contribution made by the pentatonic set to the work's larger-scale structure is its mediation of the dual tonal constellations outlined above. This becomes especially clear in the relationship between the principal themes of the first and second groups, demonstrated in Ex. 1.3. Part (a) of this example shows how the opening four-bar phrase of the treble draws its pitch classes from the pentachord A–B–D–E–G: the pitch-class set [0,2,4,7,9], or 5-35 in Allen Forte's inventory.[40] Significantly, the pcs 'missing' from the full seven-note diatonic collection, C or C♯, and F or F♯, are those necessary to define the major/minor modality of the tonic A. This ambiguity is exploited to the full in all the other components of the phrase (namely, the bass voice of bars 1-4 and both voices of bars 5-8, as is evident in Ex. 1.1 (a)), and allows for the generation of the tonal dualism. But it is the actual, rather than the absent elements of the set which bind together the first- and second-group themes, and thus interlock the tonal constellations. As Ex. 1.3(b) demonstrates, the second-group theme draws not only on the same set, but also on the same pcs – an invariant principle particularly evident in the final segment, which has an identical motivic profile (labelled x) to that of the first-group theme. (The added C in the second theme, functioning as an unaccented passing note, does not decisively alter the essentially pentatonic disposition, though it could be seen to represent a slight shift of balance in a dialectic between pentatonicism and diatonicism whose significance will be touched on

40 Allen Forte, *The Structure of Atonal Music* (New Haven and London: Yale University Press, 1973). For a glossary of some of the terminology used in Forte's pitch-class set theory see the Appendix to the present volume, pp. 223–4.

presently.) In short, the two themes are unified by an identical pentatonic pc collection, but the tonal centre, or modal final, is different for each, thus changing the meaning of the elements of each set in relation to one another.

The set [0,2,4,7,9] and subsets taken from it permeate the thematic content of the Double Concerto,[41] but perhaps one of the most significant manifestations is in the final C major theme. As Ex. 1.3(c) reveals, with the exception of a single unaccented passing note, this tune draws on the same pentatonic set as the two themes just discussed, only transposed down a fifth. If these successive transposition levels are seen as an analogue of a large-scale dominant–tonic motion,[42] this perhaps explains why the final theme is imbued with such a strong sense of arrival home. And this connection also makes it clear just how early is the journey's starting point, namely at the very opening of the work, where the 'dominant' pentatonic set of the C system is embedded into the tonic theme of the A system.

Just as we may assume that Tippett was unlikely to have marshalled this pentatonic material out of thin air, so we may also speculate whether the exploitation of its structural properties – that is, as a resource of syntax as well as vocabulary – is related to an attitude of active inquiry towards folksong that would have been fostered by his collaborative work with Francesca Allinson. Significantly, the pentatonic scale does feature in Allinson's monograph: she identifies it as one of the distinctive features of Irish tunes, and it thus becomes a crucial marker in her argument about the Irish provenance of certain English traditional melodies. She describes two features of the 'Gaelic sequence' (her term for the pentatonic scale) as especially pertinent: 'firstly, the omission of the 6th and 3rd degree, and secondly, the tension which the interval of the 4th exerts'. The latter

> operates between every other note of the gaelic sequence, between C & G, B♭ & F, G & D, F & C. Thus the tension of the interval of the 4th and also that of the flattened 7th (which consists of two joined 4ths) dominates tunes where the gaelic sequence is much in evidence. The overwhelming impression of

41 For a fuller discussion and further illustrations of this point see Clarke, *Language, Form and Structure*, vol. I, 36–8; vol. II, 6–8.

42 The theoretical notion adopted here has a connection with the far more extended analysis of transposition levels of diatonic (or extended diatonic) sets in emulation of tonal principles, given in Anthony Pople's analysis of Tippett's *Fantasia Concertante on a Theme of Corelli* on pp. 48–51 of the present volume.

melancholy and yearning which the Irish tunes make is largely due to this tension of the 4th.

As we have observed, both these features are exploited for their generative potential in the opening theme of the Double Concerto: the absent third and sixth scale degrees open up a space for both tonal constellations, while a chain of perfect fourths (or interval class 5) leads into the C–G–F region. Moreover, as if to underline its structural function, this interval class is distilled in the crotchet countermelody that accompanies the theme at the recapitulation, beginning at Fig. 8^{-1} (see Ex. 1.2(c)).

Aspects of Allinson's argument are modelled on an account of the pentatonic scale in Scottish Highland music given in Annie Gilchrist's article of 1911, 'Note on the modal system of Gaelic tunes'.[43] In particular, Allinson adapts Gilchrist's hypothesis that Gaelic Highland tunes which fill in the gaps of their pentatonic structure to form six- or seven-note modes do so in part under the influence of Lowland music, which in turn 'approximates in its seven-note construction to the folk-music of England'.[44] Following suit, Allinson describes the metamorphosis of pentatonic Irish tunes into the diatonic profile of English traditional melodies 'built upon the structure of the common chord', and explores in some detail the anglicisation of the characteristic turns of phrase of the original melodies.

In this context the contrast between certain melodies in the Double Concerto might be given a new reading. Nowhere is the distinction between pentatonic and diatonic structures more sharply pronounced than in the last movement, between the closing C major theme (Ex. 1.3(c)) and the lyrical second-group melody which first appears in the cellos in A♭ major at Fig. 25^{-6} (Ex. 1.4). Essential to the latter are melodic features 'built upon the structure of the common chord': the interval of a sixth, linear scalic figuration, and a strong polarity between tonic and sharpened leading note. Could it be that Tippett is here playing out an opposition between two principles of melodic organisation which he encountered – either directly or vicariously – through his association with Allinson's research? A further tantalising connection is suggested in the Gilchrist article to which Allinson makes reference. Gilchrist in effect describes how the same pentatonic

43 *Journal of the Folk-Song Society* 4/3, No. 16 (1911), 150–3.
44 Gilchrist, 'Note on the modal system', 150; see also p. 152.

Ex. 1.4 Third movement: diatonically constructed second-group theme

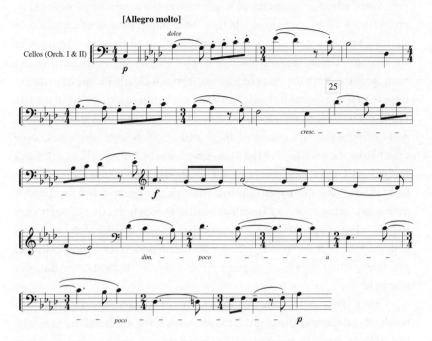

collection can be rotated to produce five modes each with a different tonic or final. This kind of possibility is exactly that exploited by Tippett between first and second groups at the beginning of the Double Concerto; indeed Gilchrist's tabulation of the various modal permutations around a single pentatonic set, together with their various 'filled-in' diatonic counterparts, could almost have functioned as a resource for the tonal/modal organisation of the work.[45]

IV

Paradoxically, these potentially most direct of connections between aspects of the Concerto's immanent structure and discourses external to it are also the most conjectural. There is no direct evidence that Tippett read

45 I refer here to a tabulated diagram in ibid., facing p. 152.

Gilchrist's article through his association with Allinson's work. We do not even know whether he discussed issues such as the 'Gaelic sequence' and its properties with her, let alone whether these might have been consciously adapted within a compositional strategy. Added to this are questions of chronology. Given that Allinson was probably engaged in writing her monograph during the years of the war, it would clearly be questionable to impute to it any causal influence on a work composed by Tippett in the late 1930s. Nevertheless, we may assume that the formation of Allinson's ideas, and her probable discussion of these with Tippett, extended back some time before the text itself of the monograph was begun – perhaps at least as far back as Tippett's production of *The Beggar's Opera* at Boosbeck in the early 1930s.[46] It is quite plausible that through this process, and through his own work using folksong (in other words, through praxis), Tippett may have developed a generalised, or syncretistic understanding of the technical construction of folk-melody, which when mediated in later compositional practice yielded details of content comparable with facets of Allinson's research.

Even if it were the case that such points of contact were the fortuitous result of independent thought by both parties, the connections none the less remain open to meaningful interpretation – in the same way that Tippett retrospectively draws a significant link between his tonal strategies in the Double Concerto and the play of tonal spaces in Tallis's *Spem in alium*, a piece which he conducted at Morley College in the early 1940s (that is, post-dating the completion of the former); or in the same way that other commentators have endorsed a connection between the cross-rhythmic fantasia style of the Concerto and the fantasias of Gibbons, which Tippett only came to know subsequently. In all cases these are more than abstract or formal comparisons. They situate the piece within a hermeneutic network of mutually illuminating historical and cultural interpretants, and open up the possibility of further readings.

One such reading pertains to the changed socio-cultural significance of the folk-materials applied in the Double Concerto, as compared with those of Tippett's ballad opera praxis. Whereas the folk-music content of the latter was presumably strongly bound up with the social and practical

46 Kemp (*Tippett*, 69) cites the 1930s as the period when this research took place.

contingencies of particular performing contexts, such as the Boosbeck work camps or the village community of Oxted, the folk-material in the Concerto is drawn into an interplay of musical materials within a more abstract symphonic framework (a shift of emphasis probably not unrelated to the sea-change in Tippett's political stance during the 1930s, from, broadly speaking, active involvement on the communist left to a pacifism detached from party-political alignment). The resulting synthesis in the Concerto could be construed as projecting a utopian vision where social differences (such as those between 'town' and 'country', or between 'turned, articulate' art music, and folk music) may be seen not as grounds for social division, but as cross-fertilising forces within an integrated whole. Nowhere does this point come across more strongly than in the final C major tune, where song, perhaps representing the collective voice of a community, finds its structurally salient place within the complex totality of the autonomous artwork. This is a different kind of folksong/art-music synthesis from that found in, say, the works of Bartók. Where Bartók uses such materials for their 'power of alienation' (to borrow Adorno's words),[47] Tippett's C major song is a potent gesture of a renewal: a renewal immanent in its very structural function as the consummative moment of a remodelled diatonicism. What Tippett shares with Bartók, however, is the adoption, or adaptation, of folk-material for the purposes of 'inner-musical cultural criticism', rather than 'nationalistic reaction' (again, Adorno's words).[48] Unlike the pastoral ruminations of Tippett's English forebears, often associated with a nostalgic searching for a rural idyll, the synthesis of the Double Concerto presents an image of a social order where 'cross-currents' between its constitutive forces make for an image of an invigorated future rather than a mythologised past. Yet what is also clear is that the critique of pastoralism within the piece entails a dialectical mediation rather than a wholesale rejection of the object of critique. To describe this as a kind of English *Aufhebung* would not be inappropriate to the cross-cultural currents involved – essentially the playing-off of national hegemonies against each other. Thus Tippett's moment of maturity as a composer – which is also the moment in which he finds his authentic identity – arrives when he

47 See Theodor Adorno, *Philosophy of Modern Music*, trans. Anne G. Mitchell and Wesley V. Bloomster (London: Sheed & Ward, 1973 (paperback edn, 1987)), 35–6 n. 5. 48 Ibid.

is able to re-articulate his Englishness (an Englishness no more or less bourgeois than modernism itself) through the galvanising forces of Austro-German musical thought processes, while making the Germanic his own through the critical distance afforded by being English. Here, then, we have not so much a half-rebellion as an extremely fruitful double one.

2 From pastiche to free composition: R. O. Morris, Tippett, and the development of pitch resources in the *Fantasia Concertante on a Theme of Corelli*

ANTHONY POPLE

I

Presenting a musical analysis of Tippett's *Fantasia Concertante on a Theme of Corelli* (1953), or of any other work for that matter, brings a number of discernible objects into juxtaposition. In particular, one musician's conception of the piece is set alongside its written score: the analyst's musical understanding is rationalised as explanations of how he or she comprehends certain passages, and these explanations are communicated through various verbal and graphical constructions around the score itself. In this process, the score is taken to represent a common ground between the author of the analysis and those who may read it; beyond this, further common ground is assumed in the shape of concepts from music theory which mediate (explicitly or otherwise) the analyst's introspections – whether these introspections be about the experience of reading the score, or about the experience of listening to a performance, or about the imaginary listening experience that often accompanies score-reading. The rather obvious objections that such experiences cannot literally have been shared, and that the concepts of music theory may not carry the same nuances of meaning for all parties involved, seem in general to be overridden by a belief that in practice there is a tangible communality that permits musicians to accomplish something in this way.

The composer, too, is generally drawn into this network. Indeed, listeners may readily feel that they understand a musical work through some kind of empathy with the composer, a process of imagination to which explicit analysis is hardly essential. Engaging in addition with a third party's understanding as expressed through written analysis enlarges the

framework to the point at which an imaginary dialogue becomes a three-way interaction. If the analysis attempts some kind of 'authenticity' by claiming that it works with particular concepts from music theory which are likely to have been shared by the composer, then the connections become more complex still. And if the musical work at the centre of all this is itself based on another musical work – as is the case with Tippett's *Fantasia Concertante* – then the network is that much further extended. Moreover, while all that has been said thus far could apply to works as diverse as Bach's organ concertos after Vivaldi and Lutosławski's *Variations on a Theme by Paganini*, the introduction of R. O. Morris's ideas to the picture brings a particularly rich set of complications.

Morris, forgotten as a composer, is remembered as a teacher whose activities were significantly responsible for the widespread adoption in Britain of a method of musical training through pastiche composition, known somewhat misleadingly to generations of students as 'harmony and counterpoint'. Morris's first book, *Contrapuntal Technique in the Sixteenth Century* (1922), which is analytical in its orientation, was arguably his only original contribution to music theory. His subsequent books on figured bass, counterpoint, form and harmony relied heavily on existing approaches, with an emphasis on 'practicality', which ultimately amounts to a lack of formality and a continual appeal – interestingly enough, in the context of the present discussion – to 'common sense'. My intention in this chapter is to follow a trail from Morris's injunction to student composers, in the first chapter of *Contrapuntal Technique,* to the effect that they should *imitate* what they find in English music of the so-called 'Golden Age'.[1] The idea behind this method of teaching was, evidently, that at a certain stage the student should, in some unspecified fashion, move beyond pastiche into original composition. The evidence of Tippett's reported habits while a student at the Royal College of Music might be taken to suggest he was familiar with Morris's book and accepted its precepts,[2] and if aspiring

1 R. O. Morris, *Contrapuntal Technique in the Sixteenth Century* (London: Oxford University Press, 1922), 3–4.

2 Compare Ian Kemp, *Tippett: The Composer and his Music* (London: Eulenburg Books, 1984), 14–15, and Morris, *Contrapuntal Technique,* 6. Surprisingly, albeit seventy years or so after the event, the composer himself denied this (private communication from Meirion Bowen).

composers were amenable to such advice in the England of the 1920s this was perhaps due in part to the fact that style reference was widely recognised as a strategy in the music of Holst, Warlock, Vaughan Williams and others. In the folklore of English musical pedagogy, Morris's principle is still encountered today in the notion that one should learn to 'obey the rules' before one can 'break them'.

As is well known, Tippett had actually completed his training at the RCM and set out on a composer's career before turning to Morris for tuition. His decision to study privately with Morris in 1930, two years after graduating, is easy to read as an act of desperation, but if so it was surely a successful gamble, for all authorities on Tippett's music agree that his maturity as a composer stems from this period. Whatever ideas Tippett may have picked up from Morris, they would seem above all to have been enabling, productive, perhaps even utilitarian. For example, it is interesting to note that critics in general maintain that style reference, if not outright pastiche, is a key to the understanding of Tippett's subsequent work. The received interpretation of the spiritual settings in *A Child of our Time* – that, to borrow Ian Kemp's words, they are 'the contemporary equivalent' of the congregational chorales in Bach's Passions[3] – is but one example of this. Tippett himself recorded a crucial musical encounter that lay behind this:

> [When] I heard a singer on the radio sing the Negro spiritual, *Steal Away* ... I was ... moved ... in some way beyond what the musical phrase in itself warranted. I realised that in England or America everyone would be moved in this way ... But it was not until after the world war ... that I could test in performance the fact that the Negro spiritual presented no expressional barriers anywhere in Europe.[4]

Tippett's account gives further details that serve to sustain Kemp's critical interpretation; at the same time, the composer's vivid recollection makes it clear that he chose to use the spirituals in his oratorio as a direct consequence of his own firm belief in the reality of shared musical experience.

3 Kemp, *Tippett*, 158.
4 Michael Tippett, 'T. S. Eliot and *A Child of our Time*', in *Music of the Angels: Essays and Sketchbooks*, ed. Meirion Bowen (London: Eulenburg Books, 1980), 121; *Tippett on Music*, ed. Meirion Bowen (Oxford: Clarendon Press, 1995), 112.

Table 2.1. Formal outline of *Fantasia concertante*, to Fig. 21[+4]

Location	Tempo marking	Source
bars 1–12	*Adagio*	Corelli, Op. 6 No. 2, I: bars 40–51
Fig. 4	*Vivace*	Corelli, Op. 6 No. 2, I: bars 52–60
Fig. 5	*Andante – Allegretto appassionato*	variation 1 of *Adagio*
Fig. 9	*Vivace*	variation 1 of *Vivace*
Fig. 10	*Allegretto*	variation 2 of *Adagio*
Fig. 14	*Vivace*	variation 2 of *Vivace*
Fig. 16	*Doppio meno mosso (Allegretto)*	first free variation of *Adagio*
Fig. 19	*Poco più tranquillo (Andante)*	second free variation of *Adagio*

II

Writing of the *Fantasia Concertante*, David Matthews has suggested that 'Corelli's theme begins the piece and the ensuing variations *gradually move over from Corelli's world into Tippett's*.'[5] This description – which correlates well with R. O. Morris's principle of 'moving beyond pastiche' – may be expanded here through a first analytical 'construction around the score' (Table 2.1).

The first twelve bars of the work (*Adagio*) are readily seen to derive from Corelli, in that the music of the soloists and first orchestra is Corelli's, note for note (from his Op. 6 No. 2, first movement, bars 40–51) and the music of the second orchestra, though by Tippett himself, may be classed as pastiche, since according to the composer's programme note it was written in direct imitation of a continuo realisation.[6] After a contrasting *Vivace* (Fig. 4), which is also Corelli's, comes music which may be recognised as a variation on the first strain (Fig. 5ff.) and then the second (Fig. 9). Tippett's treatment of the first strain – a passage we shall come to investigate more closely below – is in line with the fourth of the methods of variation listed by Morris in *The Structure of Music*, whereby '[the] essential melodic

5 David Matthews, *Michael Tippett: An Introductory Study* (London: Faber & Faber, 1980), 60 (emphasis added).
6 Written for the first edition of the score (1953); quoted in Ian Kemp's preface to the Eulenburg edition (1985), viii.

outline [is] presented in a more decorative guise'.[7] The music which follows (Fig. 10ff., and then Fig. 14ff.) may be heard as a second variation,[8] although at Fig. 14 (in Ian Kemp's words) the music moves 'into a different world entirely'.[9] It takes only a small investment in the idea of musical communality to equate this with the 'world' identified by David Matthews as Tippett's.

What is it that makes 'Tippett's world' different from Corelli's in this work? And how can it be that Tippett manages to project this difference by way of a 'gradual moving over' – a kind of musical journey? One may reasonably assume that to do so requires of the composer a special kind of self-awareness, and a special kind of technical self-control. It is in this spirit that I interpret a gradual expansion of pitch resources and pitch successions that is evident from the theme through the first few variations. This expansion emerges below from an investigation which uses accepted analytical methods as heuristics that inform a systematic study of recognisable harmonic entities and linear motions, which are compared across the theme and variations. The result is a model of pitch resource and pitch succession which may perhaps be specific to this piece, or – more likely, I think – may be construed as an aspect of 'Tippett's world', as identified by Matthews: specifically, as an aspect of the musical language of the works composed in the orbit of *The Midsummer Marriage* (1946–52). A more firmly grounded assertion of this belief must, however, await investigations which lie beyond the scope of this chapter.

7 Morris, *The Structure of Music: An Outline for Students* (London: Oxford University Press, 1935), 72. The entire variation reappears at the end of the work, with its first strain virtually unaltered (Fig. 89ff.); the second strain is transposed so as to end the *Fantasia* with a prolongation of the tonic triad of F major. This section (Fig. 93) is perhaps best seen to derive from the *opening* of Corelli's movement.

8 This variation is less easy to categorise according to Morris's schemata, but may perhaps be said to follow the second method on his list, in which the 'melodic outline' is preserved but the 'rhythmical conformation' is altered: the repeating semiquaver pulsation of the soloists and *Concerto Grosso,* with the tempo increased to exactly half that of the *Vivace,* allows the 6/8 metre of the *Concerto Terzo's* material to sound as a continuation of the *Vivace's* 3/4. The metrical conflict within the variation may be understood as an elaboration of the hemiola pattern in the tenth and eleventh bars of the theme.

9 Kemp, *Tippett,* 303.

By 'models of pitch resource and pitch succession' I mean to circum-
scribe a constellation of music-theoretic concepts that includes such things
as scales, modes, pitch-class sets and set classes. Many distinctions may be
drawn among such models: first of all, perhaps, according to the presence or
absence of functional distinctions among their elements. For example, an
unordered pc set makes no such distinction at all – which is to say that each
of its constituent pcs is regarded as being of exactly equivalent status in the
set. In scalar or modal models, on the other hand, the characterisation of
some pitches as stable and others as unstable in linear musical motion
creates a two-way functional partition among the elements of the mode or
scale.[10] Beyond this, two related but distinct types of bi-partition are dis-
cernible. If each unstable element is adjacent to a stable one, the functional
bi-partition within the model translates throughout the gamut into a nor-
mative description of linear pitch succession; furthermore, the aggregate of
the stable elements is conceived as harmonically stable (Ex. 2.1(a)).
Schenker's discussion of 'diatony' in *Free Composition* attempts to establish
a scalar model of this kind, though it should be emphasised that for
Schenker it is the harmonic stability rather than the scalar collection that is
primary.[11] On the other hand, there are models of pitch resource in which
the modelling of pitch succession is weak, because the stable elements are so
small in number, or so unevenly spaced, that a number of the unstable ele-
ments have no adjacent stable elements that serve to define a norm of linear
motion; Morris's illustration of the church modes in *Contrapuntal
Technique* belongs in this category (Ex. 2.1b).[12] Broadly speaking, to assert
that a piece 'uses' a scale is to say among other things that it follows highly
structured norms of linear motion in the context of recognisable har-
monies. In 'modal' music, on the other hand, constraints on linear motion
are at their strongest when the modal centre (or 'final') is involved, and if

10 Note-by-note formulae for musical motion may actually be axiomatic to a
theoretical system, as in the work of Yavorsky (see Gordon D. McQuere,
'Concepts of analysis in the theories of B. L. Yavorsky', *The Music Review*
41/4 (1980), 278–88), but they are more commonly generalised in the
linear presentation of an axiomatic collection in the form of a scale or
mode.
11 See Heinrich Schenker, *Free Composition (Der freie Satz)*, trans. and ed.
Ernst Oster, 2 vols. (New York: Longman, 1979), vol. I, 11–12; vol. II, Fig. 4.
12 Morris, *Contrapuntal Technique*, Ex. 1 (after p. 74).

Ex. 2.1 (a) Stable and unstable elements of major scale; (b) Illustration of the church modes, from R. O. Morris, *Contrapuntal Technique in the Sixteenth Century*; by permission of Oxford University Press

(a)

(b)

harmonic norms are observed then these are, strictly speaking, independent of the modal basis.

Placed in a chromatic context, a scalar-harmonic model effectively forms a tri-partition of the 12-pc aggregate, distinguishing between (i) the pcs of the stable harmonic prototype, (ii) other scalar but unstable pcs and

(iii) pcs not in the scale. This raises the possibility that in triadically tonal music other harmonic functions besides tonic minor and major triads may be modelled in this way – for example, the dominant seventh:[13]

harmonic prototype:	C				E			G			Bb	
scalar gamut:	C		D		E	F		G		A	Bb	
chromatic aggregate:	C	Db	D	Eb	E	F	F#	G	Ab	A	Bb	B

If the model is modally conceived, however, the lack of an embedded harmonic stability may mean that only a two-way partition between modal and non-modal pcs can be maintained. In some styles, the aggregate of the modal pcs may itself emerge in some form as a harmonic prototype – Skryabin's 'mystic' chord is a well known example:

modal pcs (stable):	C		D		E		F#			A	Bb	
chromatic aggregate:	C	Db	D	Eb	E	F	F#	G	Ab	A	Bb	B

Functioning in works such as *Prometheus* both as a stable sonority and as the pitch resource for linear melodic motion, the modal collection (C, D, E, F#, A, Bb) emerges from the texture by virtue of its status as an integral entity at various levels of transposition within the chromatic aggregate.[14]

13 The layered model presented here owes something to Fred Lerdahl's concept of 'Tonal pitch space' (*Music Perception* 5/3 (1988), 315–49). Lerdahl's ideas themselves have a number of antecedents, including the 'alphabet' notation of the music psychologists Diana Deutsch and John Feroe (see their article 'The internal representation of pitch sequences in tonal music', *Psychological Review* 88/6 (1981), 503–22). Another related study is James Marra's discussion of possible notations for linearly presented chromatic gamuts, in which the pcs of major and minor scales, and within them the pcs of major and minor triads, are tagged as functional ('The tonal chromatic scale as a model for functional chromaticism', *Music Perception* 4/1 (1986), 69–84). Marra offers his notations as improvements on previous models from the writings of Allen Forte, William Drabkin, Roger Sessions and Ebenezer Prout, which, he contests, deal only with the major.

14 Pieter C. van den Toorn, in *The Music of Igor Stravinsky* (New Haven: Yale University Press, 1983), employs a multi-layered notation, which in some ways anticipates Lerdahl's description of 'tonal pitch space', in order to set out the conceptual prioritisation of certain elements within octatonic pc collections (e.g. triads at ic3, and tritone dyads) and to illustrate their alignment with details of specific musical passages. For discussion of similarities between Stravinsky's early octatonic music and Skryabin's music of the *Prometheus* period, see Anthony Pople, *Skryabin and Stravinsky 1908–1914: Studies in Theory and Analysis* (New York and London: Garland Publishing, 1989).

Let us, for the time being, pursue this distinction a little further. If scalar-harmonic types of chord are recognised in modal music, then this will arise as a matter of style reference, independent of the systematic basis of the mode, assuming that the pcs of the corresponding harmonic proto-types are not identified as linearly stable in the model. Similarly, perceived linear motion may allow the mode as an entity to be recognised within a more chromatic context, even if such motion is itself arbitrary with respect to the modal basis. The 'worlds' of Tippett's *Fantasia Concertante* are among those in which this grey area between scalar and modal conceptions is especially pertinent. It is perhaps important to emphasise at this point that such scalar and modal conceptions are interpretations – no more, no less. That said, the interpretation offered in the following pages may be summarised in the broadest terms as one in which a modal description is applied to the 'scalar-harmonic' Corelli theme, providing a framework that allows the distinction between stable and unstable elements to be studied as it develops through the ensuing variations. 'Tippett's world' emerges at a point when the balance of explanatory power shifts in favour of the modal view: however, third-based harmonies remain as points of reference, and a cumulative study of these allows the modal basis to be more fully described. In analysis of the music that follows the entry into 'Tippett's world', the plausibility of interpreting an internal articulation within the emergent modal basis is itself open to scrutiny: in other words, the grey area is no longer merely that between scales and modes but extends to that which lies between modal and set-class models. This in turn raises a number of theo-retical issues.

III

Strictly speaking, a musical analysis does not describe a process of lis-tening in real time, any more than it describes a process of composition. Indeed, since analysis may actually seek to inform future listening, it need not always be subservient to established ways of hearing. None the less, the tangled relationship between the two remains one of the fascinations of reading and writing analyses. One way of conceiving this relationship is in terms of top-down and bottom-up processes: prior knowledge provides a context for immediate perception, and immediate perceptions can be

absorbed through interpretation into ramified knowledge. Just as prior and ramified knowledge can include not only that which comes from music theory but also the listener's accumulated memory of what has happened in this piece thus far, so it is with immediate perception, which can equally be an analytical encounter with small-scale musical detail or a tiny moment of re-hearing freshly informed by analysis. This is the underlying rationale behind the interlocking deployment here of different kinds of analytical interpretation. For example, the recognition of a sequence of theme and variations is essentially synoptic and 'prior': it generates a perception of broad structural parallels across a passage in which the 'teaching machine' aspect of the music – what Marvin Minsky identifies as a piece of music's ability, through the exposition of themes and so forth, to train listeners how to listen to it[15] – is apparent in the *Fantasia Concertante*'s development of style from 'Corelli's world' to Tippett's. This in turn is something that can best be appreciated in ways that respect the chronological order of events in the music and the cumulative process of interpretation that goes with it.

At the very opening of the piece, one can locate oneself in 'Corelli's world', anchoring the lower-level recognitions of harmonic entities and linear motion firmly in existing knowledge of tonal music. I have chosen to express this through a reductive analysis of Corelli's *Adagio* which owes much to the Schenkerian analytical tradition but seeks also to generate a segmentation of the theme that can be used as an input to other kinds of analysis (Ex. 2.2). The initial judgement is to give primacy to 5/3, 6/3, 7 and 6/5 chords for the purpose of recognising close-focus foreground prolongations. As can be seen, the reading then immediately incorporates a number of first-order groupings of these recognisable harmonic events, such as the progression in Corelli's bar 41 and the various quasi-V–I progressions in bars 45–8, so as to establish coherent linear motion in two structural voices. This in turn allows three second-order groupings to be isolated at the next level of reduction through the recognition of certain linear patterns (sixth-progressions, etc.). From this a three-voice structure could be readily asserted through principles congruent with the Schenkerian concept of unfolding.

But by this point my interpretation retains the Schenkerian view only as a foothold, seeing it as a staging post in the narrative traversal of a

15 Marvin Minsky, *Music, Mind, and Meaning* [AI memo No. 616] (Cambridge, Massachusetts: MIT Artificial Intelligence Laboratory, 1981).

Ex. 2.2 Corelli theme, with Schenker-tradition analysis

Ex. 2.3 Harmony notes (o) and non-harmony notes (•) within the segments (i–xxi) defined by the analysis in Ex. 2.2

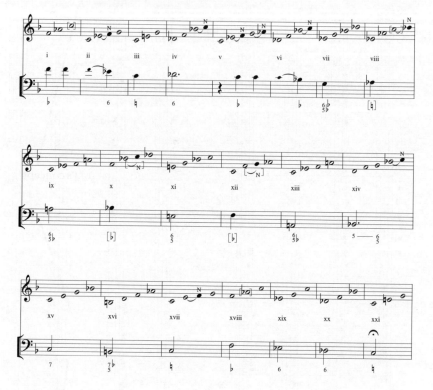

network of interpreted structures. Thus the harmonic recognitions underlying the first level of this analysis are understood to generate a segmentation of the score in which each of twenty-one segments (i–xxi) has a recognisable stable harmony within its pc aggregate (Ex. 2.3). This means that the pc content of each segment is conceptually partitioned in the manner described above for a scalar model of pitch resource and pitch succession – though, unlike the abstract models, none of these segments contains the complete diatonic gamut. These bi-partitioned sets may be notated, as we take our leave of Schenker, by using open noteheads for stable pcs and filled-in noteheads for other pcs involved in those neighbour-note motions actually encountered empirically in each segment. (This is recorded by the annotation 'N', together with a slur linking the filled-in notehead with an associated stable pc.)

The same segmentation may be applied to Tippett's pastiche 'continuo realisation' and the two variations on the *Adagio*, in accordance with the high-level recognition of a theme-and-variations format – in which the variations follow what R. O. Morris calls 'the methods whereby the tune itself, or a complete section of it, [is] preserved more or less intact'.[16] The analytical procedure thus models how the recognition of chords, the partitioning this engenders, and indeed the harmonic archetypes themselves – all established in 'Corelli's world' – are carried onward by a function of musical memory as the piece is heard, shadowing the expanding resources in the variations and thus generating a framework in which allusions to the initial harmonic archetypes are constantly heard as the stylistic journey towards 'Tippett's world' proceeds. (Clearly, this principle is close to Arnold Whittall's concept of the 'higher consonance' in the later Tippett, whereby triadic elements within a harmonic aggregate are heard to retain some kind of style-referential primacy without being understood to have privileged status in terms of dissonance treatment or harmonic progression.[17]) A consolidation of the data on stable and unstable pcs from the eighty-four segments which emerge from this procedure thus follows as the next stage, rationalising the interpretation in line with this assumed process of memory.[18]

To begin with, what emerges is that the size of the sets tends to increase as the process of pastiche and variation goes on. In addition, the organisation of the bi-partitioned aggregates changes, so that a majority of

16 Morris, *The Structure of Music*, 72.
17 Arnold Whittall, *The Music of Britten and Tippett: Studies in Themes and Techniques*, 2nd edn (Cambridge: Cambridge University Press, 1990), 5–6.
18 In the variations, the triadic and other conventional harmonies on which the Corelli analysis is based are not always to be reconciled with the motion of the instrumental parts through conjunct and disjunct intervals within the aggregate. My interpretation has been guided in this respect principally by considerations of linear motion – concerning notes approached and/or quitted by step, for example – rather than by attempts to recognise expanded triadic harmonies as such. A rigorous specification of the procedure followed across the theme and variations, if this were desired, would be far from concise: for example, the 4-chord in the sixth bar of the theme is not resolved within the same segment – nor are the 9-chords in the seventh and eighth bars – but referential triadic harmonies may nevertheless be inferred at these points, and these recognitions may be shown in the conventional way (using square brackets); on the other hand, such interpretations are not necessarily possible in the variations, because their harmonic basis is not assumed to be restricted to 5/3, 6/3, 7 and 6/5 chords.

39

Ex. 2.4 Development of pitch resources in segments i, ii and xx: in Corelli's theme, then Tippett's 'continuo' (Tc), first variation (V1) and second variation (V2); segments iii–xix and xxi proceed similarly

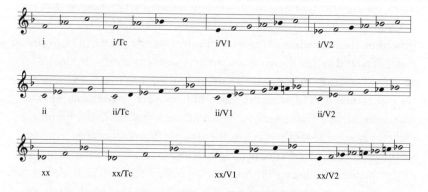

the pcs are classed as 'stable' even in these larger sets (see Ex. 2.4). Viewed empirically, this accumulation of pcs to the stable prototypes within each segment is by no means a precise or consistent matter, but the trend is generally observable. For example, in segment i the Corelli original has only the three pcs of the F minor 5/3 triad (F, A♭, C); Tippett's orchestral 'continuo' (Tc) introduces an unstable B♭; the first variation (V1) adds a further unstable pc, E♮, and a stable G. Finally in the second variation (V2) the B♭ becomes stable while the G is downgraded to instability; the E♮ is not present, but a stable E♭ accrues in its place. Similarly, segment ii develops from the C minor triad of Corelli's world (with unstable F) towards a sonority in which F and B♭ have attained stability. At the other end of the thematic material, the Corellian B♭ minor triad of segment xx has gathered an A♭ to itself by the time of Tippett's second variation, along with a number of unstable pcs. In general, these larger pc aggregates emerge as expansions of conventional prototypes – the stable pcs as expansions of three- and four-note harmonies, and the larger gamuts as expansions of diatonic collections. It is interesting to compare this phenomenon with Morris's comments on the harmonic combination of non-triadic elements in sixteenth-century English music:

> [The] tendency of the English school is towards a bolder and more rugged type of harmony than foreign composers allowed themselves ... In [an

Ex. 2.5 Pitch resources in segments i, ii and xx consolidated across the theme, 'continuo' and first two variations (cf. Ex. 2.4)

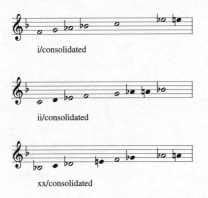

i/consolidated

ii/consolidated

xx/consolidated

example from Byrd's Mass in Four Parts] the accented passing note (E♭) in the alto is taken in orthodox fashion ... but its double clash against the D of the cantus and the B of the tenor creates a very aggressive dissonance. [An example from *O That Most Rare Breast*] is similar in character; the combination of D, A, E, B, and G into a single chord is remarkable even for Byrd.[19]

On the basis that the process of such development in the *Fantasia Concertante* is cumulative, one may consolidate the observations for each segment across the Corelli-to-Tippett sequence. Ex. 2.5 illustrates this for the three segments examined above: any pc that acquires stability at some point as the segment develops is shown as stable in the consolidation; others that have been identified as unstable are also shown. Thus in the case of segment i, both the stable E♭ from the second variation and the unstable E♮ from the first variation are shown.

Further patterns emerge when the fates of similar segments are followed in tandem. Deciding which segments are 'similar', however, is itself a matter of interpretation that proceeds from prior knowledge. At the very least, segments originating in the same sonority, such as the F minor triad (segments i, xii and xviii – see Ex. 2.3) would seem to meet this condition. Three further segments originate in the C minor triad (ii, v and xix) and

19 Morris, *Contrapuntal Technique*, 70–1.

Table 2.2. Consolidation of pitch resources (cf. Ex. 2.3)

origin: F minor triad													
harmonic prototype	F				Ab				C				
modal pcs (stable)	F		G		Ab		Bb		C	Db		Eb	
observed gamut	F		G		Ab		Bb		C	Db		Eb	E♮
origin: C minor triad													
harmonic prototype	C				Eb				G				
modal pcs (stable)	C		D		Eb		F		G	Ab		Bb	
observed gamut	C		D		Eb	E♮	F	F#	G	Ab	A♮	Bb	B♮
origin: B♭ minor triad													
harmonic prototype	Bb				Db				F				
modal pcs (stable)	Bb		C		Db		Eb		F	Gb	G♮	Ab	A♮
observed gamut	Bb		C		Db		Eb	E♮	F	Gb	G♮	Ab	A♮
origin: C as V of F minor													
harmonic prototype	C					E♮			G				
harmonic prototype	C					E♮			G			Bb	
modal pcs (stable)	C	Db		D#	Eb	E♮	F		G	Ab		Bb	
observed gamut	C	Db		D#	Eb	E♮	F		G	Ab	A♮	Bb	B♮

four in the B♭ minor triad (iv, vi, x and xx); five emerge from C as dominant of F minor (iii, xi, xv, xvii, xxi). The cumulative results from these – consolidated both across the Corelli-to-Tippett sequence and across the group of segments concerned – are as shown in Table 2.2.

Following this process, however, a number of segments remain as singletons, such as the consolidated segment vii, deriving from E♭ as dominant; and its resolution, segment viii, deriving from an A♭ major triad. Conceivably, these segments may be drawn into the wider picture in a number of ways: the interpretative route followed here is to find similarity among segments originating in the most familiar harmonies. As shown in Ex. 2.6, the chosen categories are: (a) minor triads, aligned by transposition with I in F minor prior to consolidation; (b) major triads, similarly aligned with I in F major; (c) dominant-function harmonies with minor-mode resolution, aligned with V in F minor (segment xvi is included here, being interpreted as based on a dominant *minor* ninth chord, despite its major resolution); and (d) dominant-function harmonies with major-mode resolution, aligned to V in F major. (This results in some harmonic functions, notably the subdominant, being subsumed.) Finally, the tonic- and dominant-derived models are combined for minor and major, as shown in

Ex. 2.6 Cross-segment consolidation of pitch resources, by local harmonic function

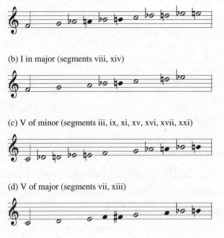

(a) I in minor (segments i, ii, iv, v, vi, x, xii, xviii, xix, xx)

(b) I in major (segments viii, xiv)

(c) V of minor (segments iii, ix, xi, xv, xvi, xvii, xxi)

(d) V of major (segments vii, xiii)

Table 2.3 (the major model is now transposed to E♭, the reasons for which will be discussed presently).

Some aspects of these models are reassuringly familiar – reassuring, since the interpretative route followed here has been an attempt to work always from plausible prior knowledge towards a new accumulation. Most obvious, perhaps, is the fact that the minor-modal pcs comprise the aggregate of the rising and falling forms of the 'melodic' minor scale. Notably, the whole tenor of this argument bears comparison with R. O. Morris's summary assessment of the prevalence of particular *ficta* (i.e. non-diatonic) pitches in sixteenth-century cadence forms, which leads him to the conclusion that the six principal modes were effectively reduced to two, through the blurring of distinctions between Ionian, Lydian and Mixolydian modes on the one hand, and Aeolian and Dorian modes on the other.[20]

More unexpected is the close correspondence that holds between the minor and major models when they are aligned transpositionally – hence the transposition of major models from an F to an E♭ centre in Table 2.3.

20 Ibid., 10–14. In Morris's view the Phrygian mode retained its independence.

Table 2.3. Conflation of tonic- and dominant-derived models in major and minor

I and V in minor (cf. Ex. 2.6 (a) and (c))

	F	G	Ab	Ah	Bb	Bh	C	Db	Dh	Eb	Eh
harmonic prototype	**F**		Ab				C				
harmonic prototype		G			Bb		C				Eh
modal pcs (stable)	F	G	Ab		Bb		C	Db	Dh	Eb	Eh
observed gamut	F	G	Ab	Ah	Bb	Bh	C	Db	Dh	Eb	Eh

I and V in major (cf. Ex. 2.6 (b) and (d))

	F	G	Ab	Ah	Bb	Bh	C	Db	Dh	Eb	Eh
harmonic prototype		G			Bb					Eb	
harmonic prototype	F		Ab		Bb				Dh		
modal pcs (stable)	F	G	Ab		Bb		C	Db	Dh	**Eb**	
observed gamut	F	G	Ab	Ah	Bb		C	Db	Dh	**Eb**	Eh

Further rewriting the two aggregates in each model as collections of pc integers (transposed again, so that $C=0$, $Db=1$, etc.)[21] not only makes possible their subsequent consideration in terms of set-classes, but also allows the closeness of the inclusion relations between the four of them to emerge more clearly – see Table 2.4. Specifically, sets adjacent in size differ by only one element (successively, pcs 11, 4 and 6). To move beyond this coincidence and identify a single underlying minor-major model, however, might be thought to represent a degree of rationalisation that would divorce the model from its empirical basis in recognisable conventional harmonies. Moreover, although the bi-partitions within the minor- and major-mode models have their systematic origins in an empirical distinction between linearly stable and unstable pcs, it is difficult to maintain that it is this kind of partition that is exemplified categorically in the models themselves, because the consolidation of data renders them already so abstract. If, as the details of the eighty-four segments suggest, the functional

21 Allen Forte, *The Structure of Atonal Music* (New Haven: Yale University Press, 1973). For a glossary of certain of the terms used in Forte's pitch-class set theory see the Appendix to the present volume, pp. 223–4.

Though the classification of pc sets employed in this analysis follows Forte in most essentials, the suffixes A and B are additionally used, where necessary, to distinguish prime and inverse set-classes, and levels of transposition are indicated in parentheses. The referential forms of A-suffixed and inversionally symmetrical set-classes are in almost all cases identical with Forte's; where differences occur they affect only the transposition integer, and arise because the computer program employed in the preparation of this study encodes pc sets as binary numbers for more efficient determination of the most 'left-packed' rotation in cases of ambiguity.

Table 2.4. Modal pcs and gamuts (cf. Table 2.3.) expressed as pc sets

stable pcs (B♭ major)	8-23	(t = 7)	[0, 2, 3, 5, 7, 8, 9, **10**]	
stable pcs (C minor)	9-7A	(t = 7)	[**0**, 2, 3, 5, 7, 8, 9, 10, 11]	
gamut (B♭ major)	10-5	(t = 7)	[0, 2, 3, 4, 5, 7, 8, 9, **10**, 11]	
gamut (C minor)	11-1	(t = 2)	[**0**, 2, 3, 4, 5, 6, 7, 8, 9, 10, 11]	

bi-partition within segments tends to break down as the piece proceeds, then this would seem to lead towards two possible interpretations of these aggregates. On the one hand, a scalar-harmonic model might construe the aggregate of the stable pcs as a harmonically stable entity, and the pc aggregate of the entire segment as an enclosing gamut – both of these being conceptually enclosed within the 12-pc chromatic aggregate. On the other hand, one or other of the pc aggregates that emerge in the models could be conceived as modal, so that the only partition embodied in each case is the bi-partition between the modal pcs and the other elements of the total chromatic. (In the latter case, there is a further question of which aggregate should be regarded as the modal collection: for example, in the major model especially, should 8-23 be regarded as a modal pc collection, and 10-5 as an imperfect representative of the 12-pc aggregate that encloses it; or, should the larger collection itself be regarded as a mode? Neither solution can justifiably be preferred *a priori*, which leaves the pragmatics of the situation even further exposed.)

Among the various set classes identified in Table 2.4, set classes 8-23, 10-5 and 11-1 represent aggregates, beyond the diatonic set class 7-35, taken from the interval class (ic) 5 cycle (the 'circle of fifths'). This was a musical structure with significant affective associations for Tippett, stemming in this instance not from R. O. Morris but from Vincent d'Indy, who held that modulation through ascending fifths was comparable to an ascent towards light, whereas modulation through descending fifths was like a descent towards darkness.[22] Such modulations relate straightforwardly to the set classes listed above, since the aggregate of two successive sets of 7-35

22 Vincent d'Indy, *Cours de composition musicale*, cited in Tippett, 'Music and life', in *Music of the Angels*, 31–3; see also Kemp, *Tippett*, 89-90. Morris was himself an admirer of d'Indy, as evidenced by his remarks on the French composer's String Quartet in E, Op. 45 (*Contrapuntal Technique*, 59).

lying a perfect fifth apart – such as might be found in diatonic music modulating through that interval in either direction – is a set of class 8-23, and so on. While individual pc sets of these kinds are highly recognisable owing to their extended diatonicism, the inclusion relations between any two such set classes are in all cases ambiguous, even if the sets are adjacent in size: each set of class 8-23, for example, contains two distinct sets of class 7-35. This ambiguity follows from the regular structure of the ic5 cycle, but presents certain pragmatic obstacles to analysis, since it will always be impossible to judge which transposition of a referential collection (whether of 8-23 or 10-5, say, as discussed above) is represented by one of its ic5-cyclic subsets that might be found empirically in subsequent analysis. In contrast, each set of type 8-23 has only one superset of class 9-7A, and the same holds between 9-7A and 10-5. Thus each set of class 9-7A uniquely determines a subset of class 8-23. Conversely, each set of class 8-23, corresponding to one of the twelve transpositions of the major-mode model, is uniquely related to a superset of class 9-7A, which is a component of the minor-mode model that has its tonic at ic2 higher (cf. Table 2.4). This superset includes the pc adjacent to and above the tonic pc in major – a scale degree which, spelled as ♯$\hat{1}$, is frequently encountered in expanded dominant-quality harmonies in the major mode. Although in the present context all the set classes identified above must be regarded as potential agents of interpretation, the uniqueness of the inclusion relations involving 9-7A allows it a referential status in both major- and minor-mode models, suggesting that this is a set class with considerable practical value for analysis of this music.

IV

Experience with the score confirms the value of these extended diatonic sets as agents of recognition. This is particularly true of the divisions on a ground (Fig. 25ff.); also of the passage likened by Tippett to a Puccini aria (Fig. 39ff.);[23] and of the *alla pastorale* section in 6/8 (Fig. 78$^{+2}$ ff.). The passage at Fig. 14ff. is especially fascinating, because it is this passage – a second variation on the *Vivace* strain of Corelli's theme – that has been identified with the entry into 'Tippett's world'.

23 See Meirion Bowen, *Michael Tippett*, 1st edn (London: Robson Books, 1982), 100; 2nd edn (London: Robson Books, 1997), 156.

Ex. 2.7 *Fantasia Concertante*, Fig. 14ff., with segmentation

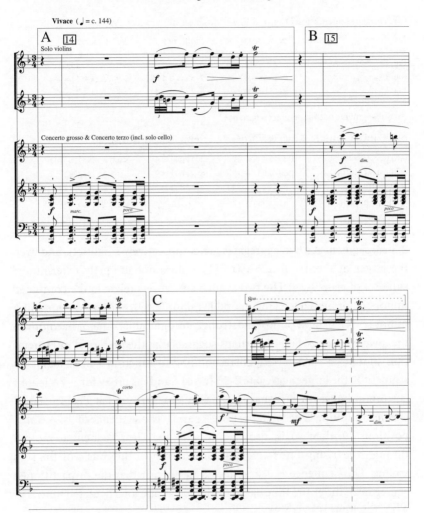

It is interesting to correlate the recognition of basic harmonic proto-types in this variation with a set-class analysis of the pc content. A segmentation into three three-bar units – following the articulation of Corelli's *Vivace* and the first variation on it (at Fig. 9), which is presented here in the lower strings of the two orchestras – generates three bi-partitioned aggregates, identified as A, B and C in Ex. 2.7. As shown in Table

47

Table 2.5. Analysis of segmentation of Ex. 2.7

(a) Primary segmentation of second *Vivace* variation, aligned to 9–7A

Location	Segment	pc aggregate	Stable pcs	9–7A superset(s)
Fig. 14	A	6-Z25A (t=11)	5-23B (t=0)	⇒ 9-7A (t=4, 9)
Fig. 15	B	8-23 (t=4)	7-35 (t=11)	⇒ 9-7A (t=4)
Fig. 15[+4]	C	9-11B (t=0)	8-22A (t=4)	⇒ 9-7A (t=2)

(b) Subsegments within primary segment C

Identification	pc aggregate	Stable pcs	9–7A superset(s)
violas, cellos	4-27B (t=6)	4-27B (t=6)	⇒ 9-7A (t=2, 4, 11)
orchestral violins	6-Z26 (t=9)	6-Z26 (t=9)	⇒ 9-7A (t=2, 9)
solo violins	6-Z25A (t=1)	5-23B (t=2)	⇒ 9-7A (t=6, 11)
last bar (all insts.)	5-Z12 (t=4)	3-10 (t=4)	⇒ 9-7A (t=2, 9)

2.5(a), segment A's two aggregates are comparatively small sets, and even the larger of them – 6-Z25A (t=11) – does not uniquely determine a superset of class 9-7A. The two available 9-7A sets relate in the combined minor-major model to C major and D minor (t=9), and to G major and A minor (t=4); in light of this, the strongly recognisable C major harmony in the lower strings at Fig. 14 perhaps suggests that the preferred interpretation should be 9-7A (t=9), corresponding to function I in C major. In segment B, the larger aggregate 8-23 (t=4) stands as proxy for 9-7A (t=4), corresponding with the quasi-tonic G major harmony at Fig. 15 (albeit over a continuing C pedal in the lowest parts). The sequence of 9-7A transpositions (9, then 4) is also in line with the clear sequential motion through the 'rising fifths' ic5 cycle that is seen in the music of the solo violins. This sequence is also reflected in the fact that the bi-partitioned aggregate of the entire nine bars, considered as one unarticulated unit, is 9-9 (t=4) within 10-5 (t=9).

The aggregates from segment C, however, do not correspond to this progression. While the set of stable pcs, 8-22A (t=4), is a subset of 9-7A (t=2), this transposition level, corresponding to F major and/or G minor, is actually two positions *back* in the ic5 cycle from that of segment B. But segment C encompasses a number of components which may be separately recognised within the texture; and as Table 2.5(b) shows, two of these – the solo violins and the lower strings – are in alignment with the sequentially

'expected' transposition (t=11) of 9-7A, while the orchestral violins lie firmly within the 'flatward' region, which is confirmed by the aggregate of the final bar.[24] Thus, in this reading, the music of Fig. 15$^{+4}$, while ostensibly continuing the 'sharpward' progression of the previous six bars through a style reference to a recognisable harmonic prototype (D^7), also promotes a 'flatward' shift through the inclusion relations of its pc content with the set class 9-7A. The succession of events within segment C articulates this through the expansion of pitch resource at Fig. 15$^{+5}$ and the subsequent stasis on an embellished trichord (B♭, E, G) which lies within the most flatward diatonic set thus far exposed. Moreover, an overall modal rationale for the variation is provided by the general model, in that, while the shift from 9-7A (t=4) to 9-7A (t=2) is associated with a straightforward change of mode from G major to G minor, and while the recognition of a D^7 harmony correlates with this tonal interpretation, 9-7A (t=2) is also associated in the combined minor-major model with F major, in accordance with the harmonic function of Corelli's original *Vivace* – namely a (here much expanded) dominant of F, as expressed in Tippett's variation by the continuing pedal C.

Complete or partial representatives of set class 9-7A may also be recognised in the music of the following twenty bars or so, which at a formal level may be understood as constituting two free variations on the *Adagio* strain of the Corelli (Figs. 16ff. and 19ff.). This reading of the form depends on three specific observations: (i) that the theme introduced by the orchestral violins at Fig. 15 is heard imitatively in the upper orchestral strings at Figs. 16 and 19, recalling similar appearances of a four-note motive at the start of the Corelli theme; (ii) that the outline phrasing of Corelli's passage is recalled by a recognisable hemiola effect at Fig. 18$^{+2}$ and Fig. 21$^{+2}$, where the rate of movement – of the faster notes as well as the underlying pulse – is halved, with triplets replacing sextuplets; and (iii) that a *Vivace* in three sections (though each of five bars, not three) follows at Fig. 22, in accordance with the theme and earlier variations.

The first free variation (Ex. 2.8) may be segmented into a succession

24 This violin theme may be construed as a style reference to the opening of Elgar's *Introduction and Allegro* – a work in the English tradition whose scoring is not dissimilar to that of the *Fantasia Concertante*. It may also, however, be considered a development of the solo violin configuration from Fig. 13$^{+2}$.

Ex. 2.8 *Fantasia Concertante*, Fig. 16ff., with segmentation (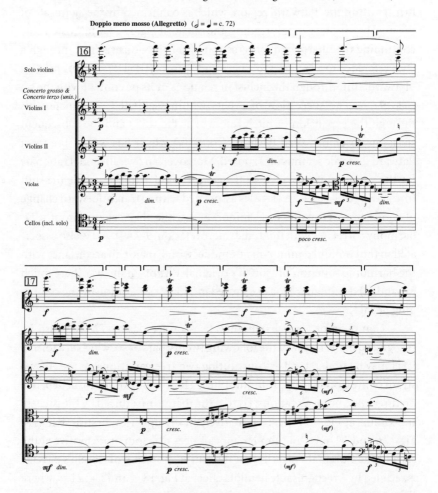)

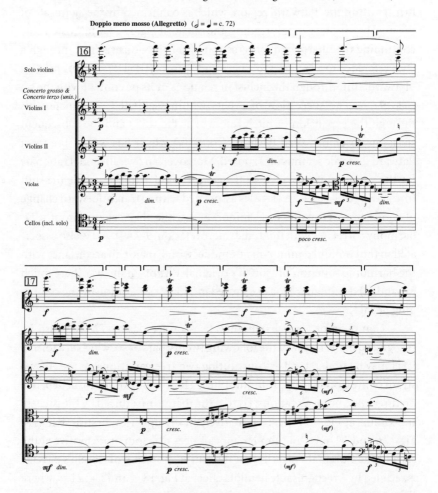

of sets – only some of them explicitly bi-partitioned – in alignment with members of the set class 9-7A (Table 2.6). The successive transposition levels of these 9-7A-type sets include a number of flatward and sharpward shifts (± 5), and also several shifts of ± 2 (corresponding to exchanges between major and minor); but some of the other transpositional shifts are less expected from the style-referential component of the model, such as the motions through ics 1 and 6. At the same time, the model can claim some success in disentangling the written-out hemiola in the three bars following

Ex. 2.8 (*cont.*)

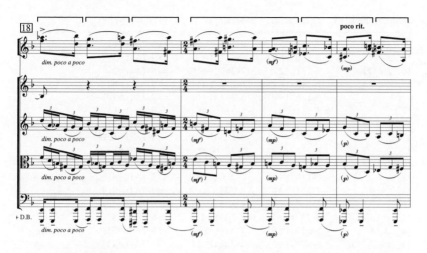

Fig. 18$^{+2}$, as the music wrenches itself towards the dominant of G major at Fig. 19. This marks the beginning of the second 'free variation', which is amenable to a similar segmentation (Table 2.7). Once again, there is a mix of 'expected' and 'unexpected' modal shifts, and while the style-referential component of the model correlates well for the most part with such analogically embedded harmonic prototypes as may be observed, the climactic moments at Fig. 21 work loose from this constraint. None the less, almost all of the pc configurations identified through this segmentation of the variation are interpretable within the extended modal framework of set class 9-7A.

The exception is the very last crotchet of the variation: at this point, each of the orchestral parts converges through an easily recognisable cadential pattern onto a member of the G major triad, yet it is not possible to correlate the pc content in every detail with the general model derived from observations of such harmonies in the preceding music. But, since the success of the model (*as* a model) depends on the extent to which the harmonic prototypes may be recognised in the more complex passages, as well as on their direct correlation with the larger pc collections, one should not by any means conclude simply that the model is 'wrong', for it merely seeks explanatory force in a critical context that includes, for example, Anthony Milner's adverse suggestion that the *Fantasia Concertante* is weakened by

Table 2.6. First free variation, Fig. 16 to Fig. 18$^{+4}$

Location (fig.)	pc aggregate	Stable pcs	9–7A superset(s)
16 & 16$^{+2}$	9-9 (t=2)	8-22A (t=2)	⇒ 9-7A (t=0)
16$^{+3}$♩	8-18B (t=9)	7-32A (t=9)	⇒ 9-7A (t=5)
16$^{+3}$♩ & 17♩.	9-12 (t=2)	7-26B (t=10)	⇒ 9-7A (t=2)
17♪	7-14B (t=11)	6-Z26 (t=11)	⇒ 9-7A (t=4)
17♪	5-28A (t=0)	5-28A (t=0)	⇒ 9-7A (t=10)
17♪	7-34 (t=4)	7-34 (t=4)	⇒ 9-7A (t=0)
17$^{+2}$♩.	8-23 (t=9)	5-35 (t=5)	⇒ 9-7A (t=9)
17$^{+2}$♩.	9-3B (t=9)	6-27A (t=0)	⇒ 9-7A (t=8,11)
17$^{+3}$♩	8-22A (t=4)	7-35 (t=4)	⇒ 9-7A (t=2)
17$^{+3}$♩	7-32A (t=11)	7-32A (t=11)	⇒ 9-7A (t=7)
18♩	8-13B (t=2)	7-25B (t=2)	⇒ 9-7A (t=4)
18♩	7-35 (t=4)	6-Z25A (t=4)	⇒ 9-7A (t=2,9)
18♩	6-Z28 (t=5)	6-Z28 (t=5)	⇒ 9-7A (t=10)
18$^{+2}$ & 18$^{+3}$♩	9-7A (t=4)	9-7A (t=4)	⇒ 9-7A (t=4)
18$^{+3}$ & 18$^{+4}$♩	8-22B (t=9)	7-34 (t=9)	⇒ 9-7A (t=5)
18$^{+4}$♩	6-Z28 (t=6)	6-Z28 (t=6)	⇒ 9-7A (t=11)

the phenomenon of embellishments obscuring an underlying pattern.[25] Seeking a transcendental solution to the technical difficulty, one might appropriate Tippett's Jungian world-view to argue that the act of reduction does not so much 'reveal' the structure behind the embellishment as identify two elements of complementary status within a composed synthesis. In other words, reduction reveals the ornament – in this case the cadential motions of the individual parts – just as much as it reveals the underlying structure. The word 'reveal' is admittedly awkward in this context, since musical analysis can claim no such power, but there is no doubt that through analysis some kind of complex recognition occurs, and is recorded. It might be thought feasible, then, to chart one's comprehension of this music primarily through the succession of recognised formulae – whether they be style-referential turns of phrase, such as those seen at this moment in the *Fantasia Concertante*, where the strict application of the piece-derived model 'breaks down'; or whether they be piece-specific configurations – including those that might be called 'themes' or 'motives' – defined in the preceding music (actually, in this piece the main 'theme',

25 Anthony Milner, 'Style', in *Michael Tippett: A Symposium on his 60th Birthday*, ed. Ian Kemp (London: Faber & Faber, 1965), 226.

Table 2.7. Second free variation, Fig. 19 to Fig. 21[+4]

Location (fig.)	pc aggregate	Stable pcs	9–7A superset(s)
19	8-22A (t=6)	8-22A (t=6)	⇒ 9-7A (t=4)
19[+2]	9-7A (t=6)	9-7A (t=6)	⇒ 9-7A (t=6)
19[+3]♩	7-32A (t=1)	7-32A (t=1)	⇒ 9-7A (t=9)
19[+3]♩ & 20♩.	10-5 (t=6)	9-7A (t=6)	⇒ 9-7A (t=6)
20♪	6-Z29 (t=9)	6-Z29 (t=9)	⇒ 9-7A (t=8, 11)
20♩	8-17 (t=3)	7-11B (t=4)	⇒ 9-7A (t=4)
20[+2]♩	7-35 (t=3)	7-35 (t=3)	⇒ 9-7A (t=1, 8)
20[+2]♩	7-35 (t=5)	7-35 (t=5)	⇒ 9-7A (t=3, 10)
20[+3]♩	7-11B (t=1)	7-11B (t=1)	⇒ 9-7A (t=1)
20[+3]♩	7-34 (t=8)	7-34 (t=8)	⇒ 9-7A (t=4)
20[+3]♪	6-Z28 (t=6)	6-Z28 (t=6)	⇒ 9-7A (t=11)
20[+3]♪ & 21♩	9-7A (t=8)	9-7A (t=8)	⇒ 9-7A (t=8)
21♩	7-32B (t=8)	7-32B (t=8)	⇒ 9-7A (t=1)
21♪	7-31A (t=10)	7-31A (t=10)	⇒ 9-7A (t=9)
21♪	7-32B (t=10)	7-32B (t=10)	⇒ 9-7A (t=3)
21[+2] & 21[+3]	9-7A (t=5)	8-23 (t=5)	⇒ 9-7A (t=5)
21[+4]♩	7-35 (t=2)	7-35 (t=2)	⇒ 9-7A (t=0, 7)
21[+4]♩	10-3 (t=2)	?? 7-32B (t=11)	?? 9-7A (t=4)

being borrowed, is not piece-specific, but it is used as if it were so). But at the same time, from the complementary point of view, one would expect such formulae to take their place within some kind of rational, learnable, musical metric (since 'Man has measured the heavens with a telescope'[26]) – such as the model of pitch resource and pitch succession which has been developed in this chapter, or, in the sphere of rhythm, something 'metric' in the specifically musical sense.

R. O. Morris's ideas on rhythm and phrasing, as found in *Contrapuntal Technique in the Sixteenth Century* and *The Structure of Music*, are indeed capable of such an interpretation; and Ian Kemp's discussion of rhythm and phrasing in Tippett's early works,[27] though not based directly on Morris, gives an indication of how the concepts outlined in Morris's writings may be said to constitute a hierarchic theory in which patterns of stress observed at one level may be orientated by means of the next. This is particularly evident in the way Morris's discussion in the later book

26 Tippett, *A Child of our Time*, No. 2: 'The argument'.
27 Kemp, *Tippett*, 97–117.

of 'how periods and sections are built up'[28] begins with examples of 'the unit (or figure)' that correspond precisely with the principle of agogic accent outlined in his theory of sixteenth-century style.[29] The 'unit' (or 'figure') is, precisely, a formulaic element, whose orientation in music Morris goes on to explain through a series of levels of phrase structure extending ultimately to categories used in the analysis of musical form. In the sphere of pitch, however, Morris is less thoroughly organised: the tone of his remarks on Mixolydian dissonance treatment in *Contrapuntal Technique* suggests, albeit perhaps for pedagogical reasons, more a celebration of freedom than an attempt to define a metric for pitch-relations.[30] If this was something Tippett had to develop for himself, given the imperfectly coherent ideas of his teacher, and his own generally independent and eclectic spirit, then we might expect it to have become central to the changes of style which are evident to those who know his compositions. And if it is the formulae as much as the metric that constitute the constant in this process of change, then it is equally on the former that we should perhaps concentrate – thus to some extent rethinking the accepted post-Schenkerian analytical priorities – if we wish to express more fully than hitherto our comprehension of Tippett's music.

28 Morris, *The Structure of Music*, chapter 2.
29 Morris, *Contrapuntal Technique*, chapter 3.
30 There is one example in Morris's *Foundations of Practical Harmony and Counterpoint* (London: Macmillan, 1925) which may be construed as a multi-level analysis, but this approach is generally absent from his work.

3 'Is there a choice at all?' *King Priam* and motives for analysis

ARNOLD WHITTALL

I

Tippett's article, 'At work on *King Priam*' was written in November 1960 when, as he said, 'I am now ... about to begin the music to Helen's [Act III] monologue.'[1] Of the opera's genesis, he writes that 'at the very beginning there was a series of scenic titles, like eight ages of man: Birth, Boyhood, Young Love, Warriors, Women, Judgment, Mercy, Death. In each of these the characters (now one, now the other) are presented with some problem of choice and action, but in the early scenes given little knowledge. Yet the tragedy flows from one such choice, honourably made: Priam and Hecuba at the cradle of Paris.'[2]

With these words, Tippett provided an interpretation of the opera's essential subject-matter to which he himself often returned, and which all subsequent commentators have noted and accepted, usually in conjunction with the composer's remarks on the kind of music his choice of subject led him to devise: 'everything in *King Priam* is designed to enforce clarity, concision, speed, powerful declamation and even deliberate abruptness of transitions'.[3] One of the topics I will consider in due course is the possible relation, or tension, between a tragedy that 'flows' from a single choice, 'honourably made', and music that includes lack of flow, 'abruptness of transition', among its most prominent features. But it is, of course, a critical banality of considerable proportions to wax lyrical about the fact that the process of composition itself involves choice – as banal as to remark on the inescapability of decision-making (however predetermined or 'pre-programmed' such decisions might often be) in everyday life. Leonard Meyer's definition of style in

1 *The Score* No. 28 (January 1961), 66. 2 Ibid., 59. 3 Ibid., 63.

music as 'a replication of patterning . . . that results from a series of choices made within some set of constraints'[4] is not likely to strike most readers as a profoundly original or radical observation. It merits scrutiny for all that, especially in the context of the music of *King Priam* (1958–61), which by general agreement represents a change of style for Tippett, and therefore a shift in the components of that 'set of constraints' that can be seen as functioning behind the various choices of which the opera is made up.

We can turn again to Tippett himself for an insight into how he saw the conjunction of choice and constraint within the new style of his second opera. In an interview published at the time of the *Priam* premiere in May 1962 he declared that 'every opera presents a challenge and a stimulus to find the musical form appropriate to its subject. The subject of *King Priam* is concerned with the problem of moral choice. At certain moments in the opera one or other of the characters wrestles, alone, with the particular problem facing him.' At this point in the interview Tippett's perspective shifts abruptly from the character to the composer, since it turns out that the 'particular problem facing' the character is this: 'what form of aria does he sing?'[5] Tippett pursues the matter almost as if the character were choosing his own genre and writing his own music: 'Let me give an example. Paris and Helen are adulterous lovers, and in a different opera from the same source-material their love could find expression in a duet. But in *King Priam* such descriptive arias are impossible. On the contrary, Helen leaves Paris alone with his moral problem: should he run away with her and provoke a war?' Tippett goes on to observe that 'Paris sings not so much an aria as a monologue . . . The music then has to match the monologue: which means it is declamatory rather than lyrical.'[6] The oppositions Tippett sets up here – aria, monologue: lyricism, declamation – are the ones he returns to again and again in his discussions of *King Priam*. He does occasionally allow for interchangeability, as in the comment that 'the first big aria, or monologue, of the opera is that of Priam in the second scene of the first act'.[7]

4 Leonard Meyer, *Style and Music: Theory, History and Ideology* (Philadelphia: University of Pennsylvania Press, 1989), 3.
5 Michael Tippett, '*King Priam*: some questions answered', *Opera* 13/5 (1962), 298.
6 Ibid., 298–9.
7 Michael Tippett, 'The resonance of Troy: essays and commentaries on *King Priam*', in *Music of the Angels: Essays and Sketchbooks*, ed. Meirion Bowen (London: Eulenburg Books, 1980), 233; *Tippett on Music*, ed. Meirion Bowen (Oxford: Clarendon Press, 1995), 218.

But he usually remains faithful to the implications of the statement in his first commentary on the work that 'since all is declamation rather than line, there are not arias in the opera so much as monologues – static moments of self-questioning, or the questioning of fate, formally somewhat similar to the monologues in *Hamlet*.[8] Even in this remark, however, the possibility of some overlap or intersection between contrasting forms and styles is not completely ruled out, and that is as it should be, not least because, in the essay 'Too many choices', Tippett observes that 'the deep relationship between all dualities is a problem of abiding fascination for me. I return to it again and again.'[9]

That essay, 'Too many choices', has never seemed to me to be one of Tippett's more lucid literary efforts, and although its date and its content give it obvious relevance to my present topic, I am not keen to place any more weight on it than Ian Kemp does in his classic account of content and context in *King Priam*.[10] One must nevertheless take seriously the possibility of the connection between the essay's core statement and Tippett's stylistic development as a composer: 'for in our one world of no more frontiers there are too many choices offered for any one person to accept them all. And so the person who becomes aware of the matter has ever to take stock of his position to see how he is to behave satisfactorily in society at all.'[11] 'Taking stock' in order to determine 'how he is to behave satisfactorily' is precisely what Paris does in his Act I monologue. In what follows I therefore approach a reading of this monologue by way of some more general analytical observations.

II

The comment of Tippett's with which I began – that the opera's tragedy flows from Priam's decision that the infant Paris should be killed – could (given the work's dependence on textural discontinuities) be ironic. It could also suggest that the flow is promoted by generative processes and continuities which the texture conceals, or problematises, but does not

8 Tippett, 'At work on *King Priam*', 62.
9 In *Moving into Aquarius*, 2nd edn (St Albans: Paladin Books, 1974), 132; *Tippett on Music*, 296.
10 Ian Kemp, *Tippett: The Composer and his Music*, revised edn (Oxford: Oxford University Press, 1987), 322–70.
11 'Too many choices', in *Moving into Aquarius*, 138–9; *Tippett on Music*, 301.

Ex. 3.1 *King Priam*, Act I scene 1

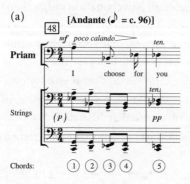

(a)

(b)

(i) Priam 3-3
[0 1, 4]

(ii) Chord 1 4-27 contains:
[0 2, 5, 8] [0 2, 6] [0 3, 7]

(iii) Chord 2 4-14
[0 2, 3, 7]

(iv) Chord 3 4-22
[0 2, 4, 7]

(v) Chord 4 4-23
[0 2, 5, 7]

(vi) Chord 5 4-12
[0 2, 3, 6]
[0 1, 4]

eliminate. Following this line, we might expect the crucial generative statement to be Priam's early declaration to the baby Paris, 'I choose for you' (Ex. 3.1): and we might therefore expect this statement to lay down certain principles and precedents for the music to come. One way into the analysis of this passage is to note that Tippett chooses to end it with a chord that can be described in two ways: as a minor ninth on C with the fifth omitted, or as a

projection of set class 4-12 [0,2,3,6][12] (see Ex. 3.1(b,vi)). These descriptions identify tonal and post-tonal prototypes, and although Ex. 3.1(a) might seem to suggest that the opera's music has stronger connections with traditional tonal harmony than with post-tonal alternatives, the wider context indicates otherwise. The remainder of the present discussion will therefore be primarily concerned with post-tonal characteristics.

Given Tippett's dislike of system and rigidity, it comes as no surprise to discover that each and every use of the word 'choice', or 'choose' in *King Priam* does not elicit a presentation of set class 4-12, or of the [0,1,4] subset to which Priam actually sings 'I choose for you' (see Ex. 3.1(b,i)). So, if we wish to attribute generative potential to this event, we need to generalise retrospectively, in the light of an examination of other salient harmonic structures in the opera. One result of this process is the observation that set class 4-12 can itself generate two very different types of subset: the whole tone trichord [0,2,6]; and what I'll term the anti-whole-tone trichords [0,3,6] and [0,1,4] – collections from which interval class 2 (ic2) is absent. That operation does not exhaust the tetrachord's potential; nor is 4-12 the only tetrachord from the total of twenty-nine which might be parsed in this way. But these qualifications need not weaken the significance of the particular properties which I have identified, and what this interpretation offers is a possible basis for textural and topical differentiation which a post-tonal composer could exploit consistently in order to bring dramatic and musical flow into significant alignment. Tippett is not exactly such a composer, since he seems to value spontaneity over such literal consistency. Nevertheless, not least because of the way such notions of harmonic character as I have begun to outline interact with some of his most deeply cherished harmonic procedures, he is not exactly *not* such a composer, either.

Set class 4-12 is one of only eight of the total of twenty-nine tetrachords not to include ic5 (the perfect fourth, or fifth), a factor which clearly restricts its potential where Tippett is concerned, since his instinctive preference is for chords which are rooted in traditional hierarchies, even if they also resist the wider implications of such hierarchies. It could therefore be proposed that the two trichord types derivable from chord 5 of Ex. 3.1 are of less generative significance than the difference between that chord

12 For a glossary of set-theoretical terminology see the Appendix to this volume, pp. 223–4.

and chord 1 – set class 4-27 [0,2,5,8]. As Ex. 3.1(b,ii) shows, this tetrachord embraces both the whole-tone trichord [0,2,6] and the major/minor trichord [0,3,7] with its crucial perfect fifth. It might also be noted that in chords 2 to 4 it is ic5 and not the whole-tone trichord which predominates, even though neither of the anti-whole-tone trichords, [0,3,6] or [0,1,4], is to be found in those chords.

I suggested above that Tippett is not exactly the kind of composer we expect to work systematically with a binary distinction between whole-tone and non-whole-tone materials. Nor, I feel sure, is he exactly the kind of composer to work consciously and strictly with the binary opposition between chords which include ic5 and those which exclude it. But that does not mean that the differences between such structures, as they affect motivic process and harmony, are of no account in his work. Analysts must choose the types of sonority they regard as salient to the work in question, and put together an interpretation of their function and significance. But what form is that interpretation to take? We will presumably not be content with a print-out listing all possible occurrences of such sonorities in the score, in order to promote the idea that there is indeed a musical flow to parallel the flow of the tragic action. We will want to move from parallels to interactions, to explore the possible semantic connotations of salient sonorities in *King Priam*, and to consider whether they have a meaning which is not exhausted by their purely musical identity. At this stage, then, I propose to test a very basic hypothesis which brings these various concerns together. The claim is that music giving prominence to tritones – ic6 – can be associated with such topics as war, death and doubt, while music giving prominence to perfect fourths and fifths – ic5 – can be associated with the topics of love, beauty and hope. This formula could scarcely be more provocatively reductive, and I hope it will be clear from the following discussion that the testing of the hypothesis is as much a matter of questioning as of confirmation. Tensions between the 'background' of the hypothesis and the actual musical 'foreground' are as likely to occur as are instances of neat conformity.

III

In Paris's Act I monologue, Tippett sets the question 'Is there a choice at all?' to the whole-tone trichord [0,2,6], ordered as falling tritone followed

Ex. 3.2 Paris's monologue: use of the whole-tone trichord [0,2,6]

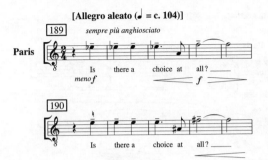

by rising minor sixth and repeated in sequence, the second statement a half-tone above the first (Figs. 189 and 190; Ex. 3.2). The constraint is striking, and so, before considering its possible function within the monologue, I will look briefly at earlier passages from the opera which might be thought to provide a precedent.

In Act I scene 2 Tippett sets the boy Paris's phrase 'I choose the life in Troy, For I belong to Troy, I know' to a whole-tone tetrachord [0,2,4,6] (Ex. 3.3). The dialogue between voice and orchestra at this point can be read as a dialogue between perfect-fifth-avoiding melody and perfect-fifth-exploiting harmony, but that simple opposition is rendered ambiguous in various ways: for example, the principal pitches underpinning the successive, fifth-based higher consonances in the violas outline a whole-tone line (G, F, B) which is drawn from the whole-tone scale complementing that represented in the vocal line. At the same time, however, that G, F, B 'bass line' harmonises the vocal melody as a basic F major/B major progression. As for the oboe counter-melody, its principal pitch, B♭, fits into Paris's whole-tone scale, but its overall character, outlining and decorating the seventh chord C, G, B♭, directs it first towards the F-tonality of the second viola chord; subsequently, by way of enharmonic transformation to A♯, it becomes an element in the B major higher consonance with which the phrase ends.

An interpretation seeking to maximise the closeness of fit between music and drama at this point would presumably emphasise the fact that Paris's vocal line on its own is redolent of doom and death. We might even comment on the irony inherent in that innocent phrase, 'I choose the life in

Ex. 3.3 *King Priam*, Act I scene 2

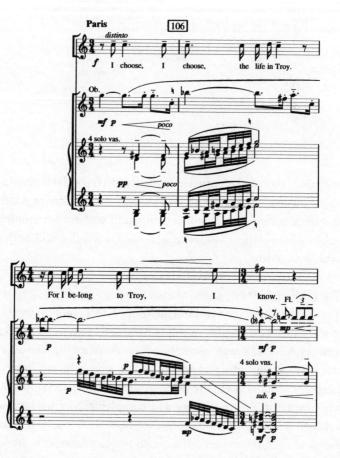

Troy', when the eventual reality will be a death which Paris cannot choose to avoid. By contrast, the fifth-based instrumental music, an eloquent presence throughout this scene, seems to represent humanity, beauty, love – qualities which are the essence of the positive. (Tippett's recourse to this music thirty years later in *The Rose Lake* (1991–3) may also serve to confirm such associations.) To put the vocal and instrumental parts of Ex. 3.3 together, then, is to create a tension, a polarity, through the superimposition and combination of materials of distinctly different character: a

whole-tone vocal line which outlines a tritone, in conjunction with fifth-based higher consonances. It is as if the notions of love and war, beauty and death, are inextricably intertwined.

If we pursue the possibility that such integration is significant, we could explore the opera's use of tritone/fifth combination in its purest form, by way of the [0,1,6] trichord. Ex. 3.4 selects and interprets five contexts in which [0,1,6] seems salient: parts (a) and (b) show two widely separated phrases of Priam's – 'A father and a King', and 'Let it mean my death'; part (c) is the first vocal phrase of Paris's Act I monologue, 'Carried on the wind of love': part (d) comprises what we might term the Helen/Paris tetrachord [0,1,5,6]; and part (e) is the sonority with which the opera ends, a complex which can be read not only as a conflation of [0,1,6] trichords but also as an amalgam of whole-tone elements.

Clearly, this selection is the iceberg's merest tip. Equally clearly, we could make much of the different orderings of the [0,1,6] trichord involved, since some statements include ic5 and some do not. Pursuing this line, we might quite rapidly reach the conclusion that what Ex. 3.4 shows is not so much a series of musical statements with a shared dramatic or textual meaning, as a series of statements in which similarities are the product of a stylistic consistency that is essentially if not entirely musical. There may or may not be significant similarities of meaning, and these similarities may or may not matter. But the very sense, suggested in outline by Ex. 3.4, of musical impulses and continuities exceeding and outdoing the requirements of dramatic content, is a useful reminder of the perils of analytical essentialism, especially when it chooses the path of proposing equivalence between a musical statement and some other kind of statement.

IV

Against this background, I will now consider some aspects of Paris's Act I monologue in greater detail. A formalist analysis which gives priority to organically evolving musical features gains impetus and relevance from what is (for Tippett) an extraordinary set-class consistency at the opening of the monologue (Ex. 3.5). Although there is only one interval, the perfect fourth, in common between the two string lines at Fig. 179, both lines can be reduced to the same unordered tetrachord, set class 4-13 [0,1,3,6] in

Ex. 3.4 Significant appearances of the [0,1,6] trichord

(a)

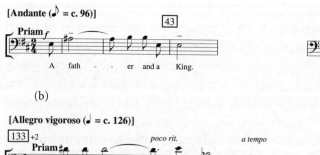

[Andante (\flat = c. 96)]

43

Priam *f*

A fath - - er and a King.

[0, 1, 6]

(b)

[Allegro vigoroso (\bullet = c. 126)]

133 +2 *poco rit.* *a tempo*

Priam

Let it mean_____ my death

[0, 1, 6]

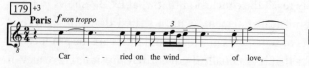

(c)

[Allegro aleato]

179 +3

Paris *f non troppo*

Car - - ried on the wind_____ of love,_____

[0, 1, 3, 6]

(d)

[Andante con moto (\bullet = c. 54)]

168 Paris Helen

ten. *p*

He - len Pa - ris.

[0, 1, 5, 6]

(e)

[Andante – adagio (\bullet = c. 50)]

608 +5 (Curtain)

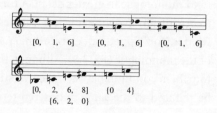

[0, 1, 6] [0, 1, 6] [0, 1, 6]

[0, 2, 6, 8] {0 4}
{6, 2, 0}

Ex. 3.5 Paris's monologue (opening)

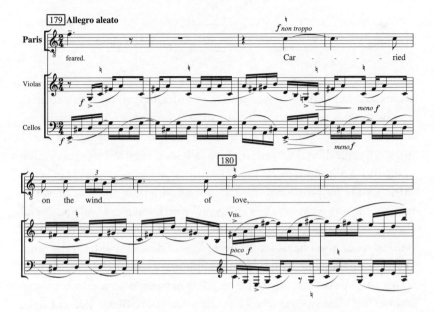

transpositions a perfect fourth apart: C#, D, E, G in the cellos, F#, G, A, C in the violas. Then, as we have seen in Ex. 3.4(c), the first vocal phrase employs a third transposition of [0,1,3,6] – B, C, D, F – completing a pattern of fourth-relations between the 'zeros' of the three unordered collections: C#, F#, B. At the same time, the first eight bars can be heard in terms of a chromatically-inflected E (minor) tonality, or modality, with a bass line that moves up (in outline) from E to G, and on to C at Fig. 180. The relatively regular rhythm and ostinato-like repetitions of small groups of pitches in the accompaniment certainly suggests that the Stravinskian aura so potent in Tippett's earlier music has by no means disappeared in the 'new world' of *King Priam*. The question of how useful it might be to interpret the whole monologue in terms of such tonal associations is beyond the scope of the present discussion, although it should be noted that one important factor in the monologue's later stages is a sense of crisis attendant on the return to elements of that initial 'tonality' (see especially Fig. 192).

If, instead, we allow ourselves to continue being 'carried on the wind' of pitch-class set analysis, we can account for the way in which Tippett

Ex. 3.6 Paris's monologue (continued)

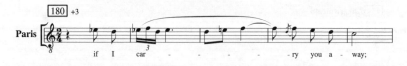

begins to develop the string lines in the third, and then the fifth and sixth bars of this passage in terms of derivations from the original tetrachords: so, at Fig. 179[+5−6] the viola's G♯, B, C and F♯ form the close relative 4-Z15 [0,1,4,6], while the A, D, B and G♯ which follows at Fig. 180[−1] is a reassertion of the [0,1,3,6] prototype. At the same time, however, we should not get so carried away by post-tonal abstractions as to ignore the role of voice-leading: the way in which C, F♯ and A move up by step to D, G♯ and B, and also the way in which the perfect fourth A–D at Fig. 180[−1] opens up new musical space in readiness for the next phase of development. Clearly, what I have termed 'organic evolution' – the application to melody of logical processes which go beyond the simple recycling of basic motivic elements – can counter set-class invariances as much as support them. For example, Tippett sets the second vocal phrase, 'if I carry you away', to a five-note collection, F, E, E♭, D, C (Ex. 3.6), and this impresses me more for the way it gives a new context to the boundary pitches of the first vocal phrase, C and F, than for its role as a set-class variant or derivation – 5-2 [0,1,2,3,5] – from [0,1,3,6] in which the common subset [0,1,3] would need to be of special significance. The shared triplet flourish, the descent from F to C balancing the first phrase's ascent: these are the elements of organically evolving inter-relationship.

Proceeding on this level of technical detail makes it possible to play off contrasting plots against each other. For example, the vocal setting of 'another's wife! a city's Queen!' between Figs. 181 and 182 (Ex. 3.7) could be analysed in terms of the derivation of the overall [0,1,6] trichord from the monologue's generative [0,1,3,6] – into which argument the [0,1,6] and [0,2,6] cells in the accompanying cello line could also be brought. Alternatively, the ascending fifth of 'another's wife!' could be separated from the ascending tritone of 'a city's Queen!' in order to develop the argument that these particular intervals tend to point in different dramatic directions, as my boldly reductive hypothesis about the contrasting textual

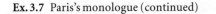

Ex. 3.7 Paris's monologue (continued)

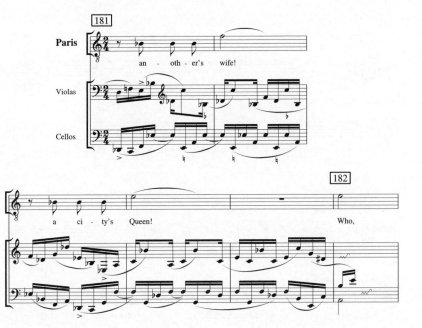

associations of fifths and tritones was intended to suggest – in which case the equivocation between [0,1,6] to [0,2,6] in the accompaniment will be seen to reflect to the shift from fifth to tritone in the voice.

If the music of the monologue up to this point is interpreted as an evolution, a flowing away from the E-centred sets of the initial proposition, the evolution from the brief stability of the bass A at Fig. 182 is given new impetus by the musical treatment of the closely aligned concepts of 'war' and 'Helen' (Ex. 3.8(a)). Whereas Tippett sets the words 'Who will escape the avenging war?' to a tritone-spanning line in which whole-tone elements are the most prominent (D, E, F♯, A♯), the words which follow, 'O Helen, Helen, can we choose that?' are allocated a descending octave divided into two fourth-spanning tetrachords, [0,1,3,5] and [0,2,3,5]. Set class [0,1,3,5] reappears within the setting of 'You will answer, Helen' (Ex. 3.8(b)), although the G-centred vocal line is increasingly destabilised by the tonal shifts evident in the accompaniment (not quoted). Thereafter the most salient factor in the vocal line is not its motivic substructure but its overall

Ex. 3.8 Paris's monologue (continued)

(a)

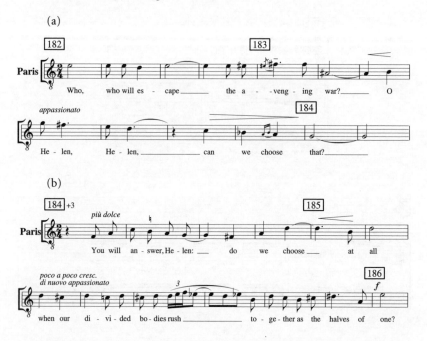

(b)

contour, the hard-won ascent from D to the E which is re-established at Fig. 186 (Ex. 3.8(b)). At the same time, a predominance of triadic/ic5-embracing patterns in the orchestra serves to remove any clear focus from whole-tone elements.

In his various comments on Paris's monologue Tippett is at pains to play down what I might term the 'love' topic. For example, he states that Paris's 'problem of choice issues musically . . . in a monologue of self-questioning, a questioning of fate, and life's meaning. There is no description of the emotions of his love at all'; and again, 'this . . . is no lyric love aria but a probing monologue, in the temper of Hamlet's monologues in the play'.[13] I would nevertheless like to argue that one aspect of the meaning of Paris's monologue lies in the contrast it offers between the impulsive celebration of love (often with perfect fourths or fifths or complete triads prominent) and the fevered doubts and questionings that cluster around

13 Tippett, 'The resonance of Troy', 225, 230; *Tippett on Music*, 211, 215 (punctuation slightly modified).

Ex. 3.9 Paris's monologue (continued)

(a)

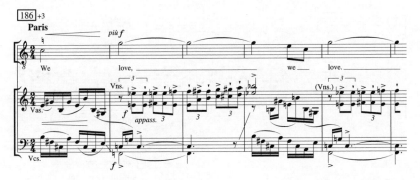

(b)

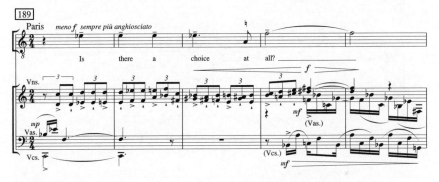

the idea of choice, which tend towards tritonally focused and/or whole-tone collections. In other words, there is a polarity or field of force, within which the music of the monologue moves – a field of force which involves the interaction of music and text as well as certain essentially musical procedures.

The correspondence between textual and musical polarities is especially clear in the vocal line when we compare the fifth/triadic outline of the repeated setting of the words 'We love' (between Figs. 186$^{+3}$ and 187) with the whole-tone trichord used for 'Is there a choice at all?' (Ex. 3.9). But what follows this polarity (still taking the vocal line in isolation from the orchestra) is a process of synthesis – at least when considered in set class terms. Paris's two final phrases, 'Answer, father Zeus', and 'divine lover! Answer'

Ex. 3.10 Paris's monologue (conclusion)

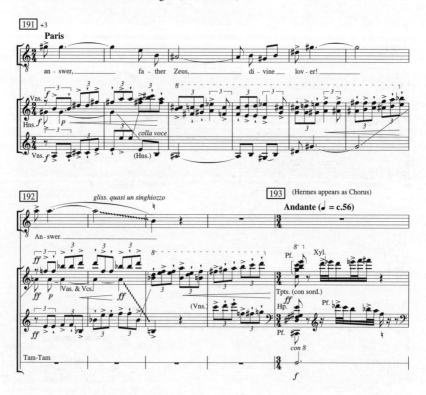

(Ex. 3.10), both employ forms of set class 4-Z29 [0,1,3,7]: B, A♯ G♯, E for the first phrase, G♯, A, B, D♯ for the second. And the final form of the orchestral motive at Fig. 192 has another [0,1,3,7]: F, E, D, B♭.

In these terms, then, it becomes possible to speak of the monologue as a whole as a 'progression' from one tetrachord – [0,1,3,6] – to another, [0,1,3,7]. We can also point out that, of these tetrachords, only the second embraces the [0,2,6] trichord of 'Is there a choice at all?', so that this crucial question continues to resonate in the succeeding phrases (Ex. 3.10), even though Tippett's orderings of [0,1,3,7] in the voice happen to exclude tritones and minor sixths completely.

What this analysis suggests is that the dialogue between doubt and confidence, the power of love and the apprehension of death, is intensified as the monologue proceeds; and the combination of closure with crisis at

the end seems the only possible outcome. Even if we feel that Paris grows in confidence as his line rises to its goal of A at Fig. 192, it is a very agitated kind of confidence, and the slide away from the A, which Tippett marks 'like a sob' (Ex. 3.10), suggests loss of control rather than triumphant decisiveness. Faced with the need to make a choice, Paris displays an almost pathetic desire for divine guidance, and the way in which the music drives on from A through B to the C\sharp which underpins the 'Hermes' chord at Fig. 193 reinforces the monologue's lack of unambiguous closure, the sense that the element of synthesis in the vocal line is insufficient to create a convincing degree of stability.

My narrative has already found it impossible to exclude the orchestral parts from the discussion, and what started out as a consideration of a monologue in which vocal line and instrumental counterpoints shared material has developed into a concern with the dialogue between voice and orchestra. The decisive change of figuration in the orchestral parts comes at Fig. 186$^{+4}$ (Ex. 3.9(a)), where the rising shape given to the violin lines, filling in the perfect-fifth interval, could be interpreted as a purely musical device to mark time without swamping the increasingly ardent vocal melody. If we then raise the interpretative stakes in order to attribute a semantic factor to the orchestral figure, we might boldly contend that it signifies human aspiration, the will to live and, in this context, the will to love. The presence of this figure when Paris sings 'Is there a choice at all?' (Ex. 3.9(b)) then reinforces the argument for the presence of an active dialogue between doubt and hope, and between aspects of positive and negative forces, that comes into dramatic focus with particular intensity at this point. As for the orchestral music from Fig. 191 (Ex. 3.10), it is as if the aim is to depict the tensions between Paris's increasing need for reassurance (note the almost blatant way in which the horn doubles the vocal line) and the divine decisiveness waiting in the wings. Anyone finding that reading contrived might be happier with the argument that Tippett seems most interested in exploiting musical tension – especially the still potent semitonal dissonance – in a more generally pervasive way than would be the case were he to continue a consistent stratification between Paris's fifth-avoiding doubts and the orchestra's fifth-exploiting affirmations. As it is, the music from Fig. 191 to Fig. 193 can be read as signifying that love remains uppermost in Paris's mind, even if he needs the guidance of Hermes in order to

find a way of *choosing* love with confidence, despite the curses of despair that will ring in his ears as Act I ends.

V

As Ian Kemp has wisely observed, 'by their nature and circumstances the characters [in the opera] are forced to make impossible decisions and live with the inevitably disastrous consequences'.[14] That might also be used to define the role of the Tippett analyst, making impossible decisions and living with the consequences. More importantly, however, Kemp's observation can lead us to an understanding of why an opera explicitly focusing on problems of choice and action should play down, or problematise, lyricism and textural continuity. What human beings would ideally like is freedom of choice in the full knowledge of what will actually happen, whichever choice is made. But the more unstable the world, the more difficult exercising choice responsibly becomes, and the harder it is to decide the grounds on which any choice should be made. If, in *King Priam*, declamation represents humanity under stress, discontinuity embodies the instability that creates stress: and that explains why musical aspirations to synthesis and integration, while undoubtedly present, fail to resolve the music's fundamental conflicts in the end.

This point prompts some more general conclusions pertaining to the critical interpretation of the opera. In a recent, highly significant study, *Nineteenth-Century Music and the German Romantic Ideology*, John Daverio writes as follows: 'in [Friedrich] Schlegel's view, the modern artist who was worthy of the name could not afford either to avoid or idealize the negativity of his or her historico-cultural situation, but rather should meet it head on . . . The creative genius was challenged to embed moments of negativity into the very fabric of an artwork, and what is more, to transform them poetically.'[15] Daverio's words remind me of David Clarke's description of the way in which 'the sublimity of the final moments of *The Mask of Time* asserts a transcendent humanity over negative experience through a partial assimilation of it', and Clarke refers to Tippett 'applying a 20th-

14 Kemp, *Tippett*, 355.
15 John Daverio, *Nineteenth-Century Music and the German Romantic Ideology* (New York: Schirmer Books, 1993), 33.

century realist and materialist consciousness to the 19th century's aspirations to the ideal and the absolute'.[16] The negative partially assimilated into a transcendent humanity; an interaction between twentieth-century realism and nineteenth-century idealism: such formulations can undoubtedly coexist with more technical concepts, even something as fundamental as the interaction between consonance and dissonance. But the technical concept I would like to stress here concerns the contrast between what Ernst Kurth termed 'leading motives' and 'developmental motives'. The relevance of Kurth to Tippett studies may be all the greater since, as Lee Rothfarb argues in his study of the theorist, Kurth owes much to one of Tippett's favoured thinkers, Carl Gustav Jung. As Rothfarb formulates the distinction between the two types of musical motive, leading motives, 'with their dramatic and psychological associations, are extrinsic to the musical process itself and amount to surface manifestations reflecting the drama. Developmental motives, on the other hand, are intrinsic to the musical structure and do not rely on extramusical meanings.'[17] The reductiveness of this statement is a reflection of the naivety of Kurth's actual analytical practice. Yet in the case of Wagner's *Tristan und Isolde*, which forms the main focus of Kurth's discussion, it is especially valuable for the present-day analyst to confront the whole question of how precisely the nature and function of leading motives may be defined, and how those motives relate to other materials, which, as Kurth attempts to argue, are 'intrinsic to the musical structure and do not rely on extramusical meanings'.

What we expect to find in Wagner is one dialogue, between leading and developmental motives, interacting with a second dialogue between formal continuity and formal disruption. Daverio refers to this topic when he comments that what Wagner termed 'rhetorical dialectics' (the direct confrontation between themes of diametrically opposite character) 'is saved from degenerating into mere disconnectedness through the applica-

16 David Clarke, 'Visionary images', *The Musical Times* 136, no.1823 (January 1995), 21, 20.

17 Lee Rothfarb, *Ernst Kurth as Theorist and Analyst* (Philadelphia: University of Pennsylvania Press, 1988), 68. It should be noted that one authoritative commentator on Kurth's work opines in reviewing Rothfarb's study that the parallels between Kurth and Jung are 'relatively trivial', and that Freud offers a 'more appropriate and comprehensive model': see Bryan Hyer, 'Musical hysteria', *19th Century Music* 14/1 (1990), 90.

tion of mediating procedures'.[18] In *King Priam*, by contrast, it appears that 'rhetorical dialectics' have the upper hand. Yet that essentially textural, formal emphasis on ensuring that 'themes of diametrically opposite character confront each other' is offset – complemented, even – by shared elements in the thematic substructure of the kind that analysis of unordered pitch-class collections can reveal. Tippett's distinctively twentieth-century modernism is not only one in which 'moments of negativity are embedded in the very fabric of the artwork', as Schlegel decreed: it is one in which the thematic fabric, to the extent that it assimilates elements of cellular consistency, further erodes the already tenuous distinction between leading and developmental motives. The extrinsic and the intrinsic resist separation from each other, and even if we might wish to argue that this lack of absolute separation is true of all opera, even Wagner, the emphasis in Tippett on interaction rather than separation seems to provide a particularly important key to the meaning of a music drama which is not only post-tonal but also all-thematic.

The more all-thematic a work, the more pointless it might appear to attempt to ground a discussion of that work's thematicism in the presence or absence, emphasis or otherwise, of a pair of intervals. My hypothesis of the complementary interaction of elements involving tritones and perfect fourths or fifths is a device whose function it is to trigger a narrative in which the embedding of those elements in an immense variety of ever-changing contexts is acknowledged – a narrative which may not be literally inconceivable but which would grow rapidly to immense, unmanageable proportions. Without some such trigger, no substantial technical narrative that engages the post-tonal dimension of *King Priam* is possible. I am therefore suggesting that in order to 'behave satisfactorily' in present society, the analyst must choose. In itself this is to say very little, since to analyse is, however basically, to choose. But are there too many choices for the analyst, or too few? For myself, I find it difficult to decide, and look to some musicological Hermes for guidance!

Tippett himself may have been profoundly uninterested in such technical polarities as I have outlined; yet his description of the nature of the drama that is *King Priam*, identifying a 'core-topic' ('the mysterious nature

18 Daverio, *German Romantic Ideology*, 189.

of human choice') and the particular subjects of each scene (the 'eight ages of man') which elaborate that topic, is itself an instance of a simple basic concept triggering its own elaboration. To discuss the music of *King Priam* in terms of degrees of focus on chords, motives and pitch-class collections which cluster round the tritone/perfect fifth nexus allows for a tremendous play of choice – a constraint that is positively permissive with respect to the opportunities that remain for preserving ambiguity and irony, while not rejecting synthesis completely.

It might be locating the source of one final irony to observe that the chord which Tippett appears to identify with death in Act I of the opera (Figs. 34 and 107; Ex. 3.11(a)) is almost provocatively alien to the kind of structural matters which have concerned me in this essay. Perhaps the absence of the 05/06 complex from this chord points to a conscious contrast between the initial establishment of the idea and its eventual working out, under the direct observation of Hermes. The chord we hear when Hermes first appears, and elsewhere, is one of Tippett's favourite bitonal constructions (Ex. 3.11(b)), and I am inclined to regard it as a projection of [0,1,6] and [0,2,6] collections which happens to embrace the death-chord collection in a way that gives us no licence to infer some subtle semiotic strategy on Tippett's part. But the possibility that the [0,1,6] trichord, in itself, is an icon of ironic ambiguity, an expression of the 'partial assimilation' of negative experience into transcendent humanity, could be felt to receive some support from other instances of its use. In particular, is it too fanciful to see Hermes, the messenger of the gods and the celebrator of music, as having a hand in signing off Tippett's final composition, *The Rose Lake* (Ex. 3.11(c))?

In a tribute to Gustav Holst, Tippett writes of that composer as managing 'the sort of odd intermingling of disparate ingredients which, when also properly cohesive, attests to the quality of a vision'.[19] *King Priam* is a bold, resourceful exploration of how a proper cohesiveness may be determined under the pressure of the need to represent the opposing yet interacting impulses of love and war. Ian Kemp has provided a particularly penetrating account of the opera as a 'unity of pluralities',[20] in which ambiguity needs to be kept at bay if a damaging incoherence is to be resisted. As Kemp puts it, 'what a character was, thought and did had to be

19 Michael Tippett, 'Holst', in *Tippett on Music*, 75. 20 Kemp, *Tippett*, 340.

Ex. 3.11 Chordal connections:

(a) *King Priam*: 'death' chord

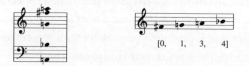

[0, 1, 3, 4]

(b) *King Priam*: 'Hermes' chord

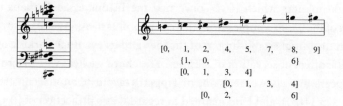

[0, 1, 2, 4, 5, 7, 8, 9]
{1, 0, 6}
[0, 1, 3, 4]
 [0, 1, 3, 4]
 [0, 2, 6]

(c) final chord of *The Rose Lake*

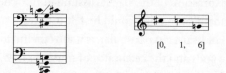

[0, 1, 6]

conveyed instantly, with music which both left no doubt about its own meaning and could not be confused with that of another character'.[21] At the same time, Kemp acknowledges the 'ambivalence' of a gesture like that which launches the Trojans' ensemble near the end of Act II. Here, while there is an equation between 'monstrous contours' and 'bloodlust', 'the music all the same is exciting and even exalting'.[22] This conjunction goes to the heart of the opera's use of generic and topical associations, for it seems

21 Ibid., 335. 22 Ibid., 337.

that the role Tippett assigned to the perfect fifth in a post-tonal context is the strongest evidence we have of his refusal to let irony and ambiguity destroy all optimism, all dreams of Utopia. As a post-romantic modernist, Tippett is led to problematise the synthesis of old and new. *King Priam* is a uniquely powerful product of that remarkable creative initiative, and, in the end, as the essay 'Too many choices' puts it, it is the 'abiding fascination' of possible deep relationships 'between all dualities' which prompts the composer.[23] All the more reason, then, for that fascination to prompt the analyst too.

23 See n. 9, above.

4 Tippett's Second Symphony, Stravinsky and the language of neoclassicism: towards a critical framework

KENNETH GLOAG

Tippett's Second Symphony occupies a unique, significant, yet also somewhat problematical position within the composer's stylistic development. The symphony (1956–7) is often referred to as 'transitional', as leading from the tonal focus and lyricism of *The Midsummer Marriage* (1946–52) to the new structural and stylistic direction of *King Priam* (1958–61). According to Ian Kemp, 'between *The Midsummer Marriage* and Symphony No. 2 Tippett's style changed, but not so rapidly as to conceal the evidence of organic development. Between the Symphony and *King Priam* however a change occurred of such rapidity that to many commentators of the time it seemed to lack necessity.'[1] What renders this transitional position more problematical is the individual identity and integrity of the work. The particular realisation of the Beethovenian symphonic model (Tippett's 'historical archetype'[2]) and the obvious sense of harmonic polarity at

1 Ian Kemp, *Tippett: The Composer and his Music* (London: Eulenburg Books, 1984), 322.
2 Tippett discusses this term, in conjunction with its counterpart, 'notional archetype', in his essay 'Archetypes of concert music', in *Tippett on Music*, ed. Meirion Bowen (Oxford: Clarendon Press, 1995), 89–108. The following extract (p. 89) presents an insight into both his own approach to the symphonic model and the relevance of the historical archetype:

> I feel that much of the confusion that may arise when a contemporary instrumental work is called a 'symphony' is due to the fact that we have habitually two differing uses of the word, implying two contrasting conceptions. Further, we are generally unaware of this division in use, and pass from one conception to the other unawares.
>
> What is meant by a symphony? Firstly, it implies a *historical archetype* from which we depart and return – for example, the so-called middle-period symphonies of Beethoven. Secondly, there is the *notional archetype*, permitting

several structurally significant points create a soundworld which is both highly specific and unique.

What further problematises the situation of the work is its striking reference to an apparent Stravinskian neoclassical praxis, a factor which is highlighted, together with the Symphony's transitional position, by Tippett himself: 'by the time I returned to the problem of orchestral music with my Symphony No. 2 . . . I had completed a long opera, *The Midsummer Marriage*. Although I found the symphonic problems as intractable as ever, the work became a sort of turning-point. On the surface, the work seemed like a more concentrated example of neo-classicism.'[3] This reference to neoclassicism is developed in most of the literature on the Second Symphony, while the problems of the term's definition and its relevance as a stylistic and/or critical category are carefully avoided. In response to this

endless variations to the end of time – for example, the Mahler symphonies, or those of Charles Ives or Lutosławski. The older view was that the Mahler symphonies did not conform to our historical archetype of the moment. Alternatively, we might say that Mahler (or Ives or Lutosławski) gave the symphony new and valid forms; and in so doing, we momentarily abandon the conception of a historical archetype for that of a notional archetype.

The first part of this essay is modelled on the chapter Tippett contributed to *The Orchestral Composer's Point of View: Essays on Twentieth-Century Music by Those Who Wrote It*, ed. Robert Hines (Norman, Oklahoma: University of Oklahoma Press, 1970), 203–19; the passage corresponding to that quoted here is on p. 204.

For further discussion of 'historical' and 'notional' archetypes, and Tippett's relation to historically handed-down material see the chapter by Alastair Borthwick in the present volume, pp. 117–44.

3 *Tippett on Music*, 93. It is perhaps significant that Stravinsky again features in the transition between Tippett's first two operas, with *Agon* (1953–4), a work which at times seems to cast a large shadow of influence across contemporary British music, being a crucial factor in the shaping of *King Priam*. Writing of the personal importance to him of John Minchinton, the dedicatee of the Second Symphony, Tippett states:

John directed a number of enterprising concerts, including a lot of pre-classical and contemporary music. Particularly stimulating for me was his conducting of a late work of Stravinsky, *Agon*, in 1958, which was germane to my current compositional enterprise, *King Priam*. From Stravinsky's instrumentation I derived some clues as to how to deploy an operatic orchestra in an entirely new way – treating solo instruments as equals both within the ensemble and against the voices on stage, writing for heterogeneous mixtures of instruments.

(Michael Tippett, *Those Twentieth Century Blues: An Autobiography* (London: Hutchinson, 1991), 226.)

absence of rigorous scrutiny (and leaving aside the question of whether the composition of a four-movement symphony in the mid-1950s was in itself a neoclassical gesture) I wish to begin to explore two interrelated issues: the relevance of the term neoclassicism for the stylistic definition of the work; and the secondary, but more specific relationship between Tippett and Stravinsky.

I

Any viable understanding of neoclassicism must involve a relationship to a sense of a past, a quality which is a constant presence in Tippett's music, and which manifests itself in radically different contexts. This immediately opens up the possibility of an interpretation of neoclassicism, one effectively raised by Geraint Lewis:

> It is curious that the unique nature of [Tippett's] neo-classicism is rarely properly acknowledged. His synthesis of Beethovenian structural archetypes allied to the forms and dialectic of English Renaissance, Restoration and Hanoverian music is the result of an intense and truly classicizing impulse. If stylistic terminology becomes sufficiently blurred to allow Stravinsky's Bachian *Dumbarton Oaks* concerto as a 'neo-*classical*' work, then Tippett's (Handelian) *A Child of our Time* and (Purcellian) *Boyhood's End* can surely be allied almost as easily, in a general sense, to the same category.[4]

However, if the unique quality of Tippett's neoclassicism is seldom acknowledged, perhaps this neglect reflects the extent of his complex and problematic relationship to neoclassicism. The dialectic between musical pasts and presents is a constant factor in his music, but this does not necessarily signify the presence and operation of a neoclassical language. This relationship is rendered more problematic in the Second Symphony by the fact that the reference point for Tippett's apparent neoclassicism is a musical language which has itself already been commonly defined as neoclassical – suggesting that the composer might be involved in a process of distancing from more recent musical languages as well as the recycling of musical pasts.

4 Geraint Lewis, 'Tippett: the breath of life – an approach to formal structure', *The Musical Times* 126, No. 1703 (January 1985), 19.

Within the context of the Second Symphony, reference is often made to the striking similarities with Stravinsky's Symphony in C (1939–40) and Symphony in Three Movements (1942–5). For example, Peter Dennison writes:

> After the musical luxuriance of *The Midsummer Marriage*, Tippett's musical style and technique moved towards a more astringent economy of means, a more violently disjunct melodic and harmonic language, and a concern for formal symmetries that gave it an affinity with neo-classical practice, and with Stravinsky in particular. This was anticipated in the Second Symphony … which emulated the neo-classicism of Stravinsky's *Symphony in Three Movements* and *Symphony in C*.[5]

While I will return to the question of the comparisons with the Stravinsky symphonies at a later stage, what is initially most noticeable about this description is that qualities such as 'astringent economy of means' and 'a more violently disjunct melodic and harmonic language' are casually assumed to be reflective of a neoclassical musical language and style. Perhaps more fundamentally, the question emerges of whether the Stravinsky works, as the potential source of Tippett's neoclassicism, can themselves continue to sustain a neoclassical definition. However, prior to a discussion of both these matters, the problematic nature of any clearly outlined interpretation of neoclassicism itself requires investigation.

The most systematic attempt to reconstruct the complex origins of neoclassicism and explore the problems of definition can be found in the work of Scott Messing. In a remarkably concise overview of the origins of the term and the musical qualities most commonly associated with it, he outlines the fundamental ambiguities which surround the issue:

> In pursuing a definition of neoclassicism, one soon finds two intriguing paradoxes: the presence of the term in studies of early twentieth-century music is so rife that most of the major figures composing during the first three decades of this century have been tied, loosely or umbilically, to it; yet a collation of usages produces such a variety of meaning that the expression seems to possess no syntactical weight whatsoever.[6]

5 Peter Dennison, 'Tippett and the new romanticism', in *Michael Tippett O.M.: A Celebration*, ed. Geraint Lewis (Tunbridge Wells: Baton Press, 1985), 178.
6 Scott Messing, 'Polemic as history: the case of neoclassicism', *Journal of Musicology* 9/4 (1991), 481.

Messing goes on to conclude that

> if the theoretical apparatuses that have illuminated twentieth-century styles
> have encouraged us to hold the term neoclassicism in contempt because of
> its ambiguity, it must be realised that the same frustrating lack of clarity in
> the word was the source of its attraction and the reason for its survival.
> Neoclassicism was the sign that accommodated both innovation and
> tradition in composition in the 1920s.[7]

This is a useful description, highlighting the obvious fact that the
attraction of the term is precisely its resistance to any readily identifiable
definition. Messing's conclusion that 'neoclassicism was the sign that
accommodated both innovation and tradition' is readily transferable to the
Tippett context, particularly to the symphonic model which reflects the
composer's own understanding of a 'historical archetype', and which pro-
vided him with a medium within which he was ultimately able to renovate
and redirect his own musical language. However, it is also possible, and
perhaps preferable, to read Messing's statement from a perspective which is
more historically specific if still theoretically vague. In other words, neo-
classicism as the 'sign which accommodated both innovation and tradition'
is, as suggested by Messing, still best situated within the music of the 1920s.
One thinks of works such as Stravinsky's *Pulcinella* (1919–20), Octet
(1922–3) and Serenade (1925), within which the distinction that can be
drawn between innovation and tradition is still located towards the surface
of the music. The later works of Stravinsky's neoclassical project, such as the
Symphony in Three Movements and Symphony in C, achieve their own
sense of distance from this earlier neoclassical model, a point to which I will
return in more detail below.

Work by Rudolf Stephan, which Geoffrey Chew explores in a recent
study of Stravinsky's *The Rake's Progress* (1943–51),[8] presents a more
specific attempt to outline the salient qualities of neoclassicism, using the
Russian formalist literary theory of Shklovsky and Tynyanov as a starting
point. Although this connection (elsewhere casually dismissed by Richard

7 Ibid., 497. For a more expanded version of Messing's work on neoclassicism see
 his *Neoclassicism in Music: From the Genesis of the Concept through the
 Schoenberg/Stravinsky Polemic* (Ann Arbor, Michigan: UMI Research Press,
 1988).
8 Geoffrey Chew, 'Pastoral and neoclassicism: a reinterpretation of Auden's and
 Stravinsky's *Rake's Progress*', *Cambridge Opera Journal* 5/3 (1993), 239–63.

Taruskin[9]) cannot be fully pursued here, its potential for the development of a more theoretically focused understanding of neoclassicism warrants some discussion. According to Stephan:

> The music of the past is not imitated [in Stravinsky's neoclassical works] but . . . 'defamiliarised', 'parodied'. The 'parody' (this is the new 'defamiliarised' form) presupposes the original version not only for the composer but each time also in the consciousness of the listener . . . Parody has the important, new task of preventing an 'automatic' hearing of the music . . . The concepts of 'parody', 'automaticism' and, especially, 'defamiliarisation' are . . . used here . . . in precisely definable, in musical terms . . . The breaking up and reordering of words and phrases [referred to by the Russian formalists in their theory] correspond to the apparently violent alteration of melodies, motives, figures, phrases and periods . . . The most important procedures of 'defamiliarisation' found in Stravinsky are the omission or insertion of fractions of a bar, bars, phrases, groups of bars or sections, the elision or extension of fractions of a bar or whole bars, etc. . . . From all this there arise consequences for the formal construction: bars, phrases or other units are newly combined after having been isolated, and in this way they change their function.[10]

Even if its analytical and technical implications are left aside, Stephan's statement remains a brilliant description of Stravinsky's music of the 1920s. The quality of parody, which one could relate to any number of works, emerges as a crucial stylistic and structural sign. Nevertheless, the concept of parody should be distinguished from comic origins and intent. As Massimo Mila indicates: 'parody should be understood as a spiritual category which, independent of a comic intent . . . makes use of the rethinking of a past style as of a mask to disguise the secrets of the inner life: to disguise them, not suppress or hide them'.[11] This distinction between parody and comic intent is further dramatised by Linda Hutcheon's assertion that

> we . . . need to restrict [the] focus [of a theory of parody] in the sense that parody's 'target' text is always another work of art or, more generally,

9 See Richard Taruskin, 'Back to whom? Neoclassicism as ideology', *19th Century Music* 16/3 (1993), 300.

10 Rudolf Stephan, 'Zur Deutung von Strawinskys Neoklassizismus', in *Musik-Konzepte* 34/35, *Igor Strawinsky* (Munich: Text + Kritik, 1984), 81–2; quoted in Chew, 'Pastoral and neoclassicism', 256–7.

11 Massimo Mila, *Guida musicale a* La carriera di un libertino *di Igor Stravinsky* (Venice, 1951), 25–6; quoted in Chew, 'Pastoral and neoclassicism', 256.

another form of coded discourse. I stress this basic fact because even the best works on parody tend to confuse it with satire, which, unlike parody, is both moral and social in its focus and ameliorative in its intention.[12]

Following Hutcheon, it is possible to conceive of an image of parody which, rather than being situated as a specific quality within an individual work, is constructed as a relationship between two or more works. Such an understanding leads to the beginnings of a possible intertextual paradigm between two musical texts, with one work standing in a condition of parody to another (the 'target' text) – a possibility which can be explored within and between the Tippett and Stravinsky examples, and one to which I will return at a later stage.

It is clear that the image of parody functioning as a stylistic mask is extremely powerful and provides a vivid reflection of Stravinsky's relationship to past styles and structural processes. However, perhaps the most important element in Stephan's description is that of 'defamiliarisation', a concept which can be assumed to be similar in some ways to the recontextualisation of Joseph Straus's understanding of Stravinskian neo-classicism.[13] (It is nevertheless debatable whether this sense of distancing or defamiliarisation from a past convention or style through a process of parody and/or irony remains a valid description of Stravinsky's work of the

12 Linda Hutcheon, 'Modern parody and Bakhtin', in *Rethinking Bakhtin: Extensions and Challenges*, ed. Gary Saul Morsen and Caryl Emerson (Evanston, Illinois: Northwestern University Press, 1989), 98.

13 Joseph Straus, *Remaking the Past: Musical Modernism and the Influence of the Tonal Tradition* (Cambridge, Massachusetts and London: Harvard University Press, 1990). Straus's work, as is well known, is predicated on a radical re-reading of Harold Bloom's theories of influence, as outlined in the latter's *The Anxiety of Influence: A Theory of Poetry* (New York: Oxford University Press, 1973); *A Map of Misreading* (New York: Oxford University Press, 1975); and *Agon: Towards a Theory of Revisionism* (New York: Oxford University Press, 1982).

Although the musical appropriation of Bloom could be considered as a critical path towards the clarification of the potential relationship between Tippett and Stravinsky, the present discussion can be interpreted as an alternative attempt at a consideration of parallels and intersections which defines its own critical and interpretative contexts. For examples of other critical applications of Bloom's work to music see Kevin Korsyn, 'Towards a new poetics of musical influence', *Music Analysis* 10/1–2 (1991), 3–72; Richard Taruskin, 'Revising revision', *Journal of the American Musicological Society* 46/1 (1993), 114–38; Lloyd Whitesell, 'Men with a past: music and the "Anxiety of Influence"', *19th Century Music* 18/2 (1994), 152–67; and Alan Street, 'Carnival', *Music Analysis* 13/2–3 (1994), 255–98.

Ex. 4.1 Tippett, Symphony No. 2: opening

1940s, a period within which a new sense of synthesis and reconciliation, rather than distance and defamiliarisation, emerges – a suggestion which will have large-scale implications for an understanding of the critical intersections between the Tippett and Stravinsky works.) A comparable understanding of parody is evident in Hutcheon's definition: 'parody is . . . repetition with critical distance, which marks difference rather than similarity'.[14] This image provides a valuable starting point for an understanding of both neoclassicism in general and Tippett's own reception of Stravinskian stylistic and syntactic gestures: I will argue that Tippett repeats Stravinskian elements while at the same time constructing a sense of 'critical distance' (defamiliarisation) from the inherited model (Hutcheon's 'target' text).

II

In order to bring these issues further into focus and begin to address more directly the relationship between the two composers, the discussion will now turn towards specific points of comparison between Tippett's Second Symphony and the music of Stravinsky. Ex. 4.1 presents the opening

14 Hutcheon, 'Modern parody and Bakhtin', 88. For more extended examples of Hutcheon's work on irony and parody see her *A Theory of Parody* (New York: Methuen, 1985); and *Irony's Edge: The Theory and Politics of Irony* (London: Routledge, 1994).

Ex. 4.2 Stravinsky, Symphony in Three Movements: opening

[+D. B. 8ve lower]
[Other orchestral doublings omitted]

moments of the Second Symphony. The texture here is conditioned by repeated Cs in the lower strings amplified by sustained Cs of the piano. This focus on C supports the horn parts, which begin with and return to the dyad G/D. The introduction of F# between bars 4 and 7 is the first indication of any potential shift away from, or challenge to, the centrality of C. Leaving aside questions of pitch, the orchestration, the rhythmic energy and the direct, impulsive sense of gesture all help produce an aural impression that is in some ways very similar to that of Stravinsky's Symphony in Three Movements. The Stravinsky symphony also opens with a very direct, emphatic gesture, consisting of an ascending motion from the initial G to A♭ which then falls back to G (Ex. 4.2). This gesture consequently provides a degree of focus on G and sets in place the main characteristics of the movement. However, such a focus is distinct from the sense of pitch centricity which is generated within the Tippett example. Stravinsky establishes G as an initial starting point, but it is notable that rather than returning to G the movement ends with a distinctive change of focus towards C. The formal significance of the initial figure is also different in both works. Although in the Stravinsky example the gesture is definitive and does reappear towards the end of the first movement (Figs. 105, 108), it is difficult to hear it as being either referential or generative.[15] As with the question of pitch centre, Tippett's treatment of his initial gesture is quite different, with the figure casting a shadow across the entire movement.

15 Cf. Eric Walter White: 'the first movement opens with a vigorous skirl and flourish. Unlike the motto at the beginning of the *Symphony in C*, this motto is not germinal and has only a very minor part to play' (*Stravinsky: The Composer and his Works*, 2nd edn (London and Boston: Faber & Faber, 1979), 431.)

The music of Ex. 4.1, as already suggested, provides a direct confirmation of the salient status of C. This pitch is grounded as the bass of the texture and provides a pitch-determined starting point for the movement, a view which is supported by Tippett's own much-quoted description of the initial impulse behind the work:

> About the time I was finishing 'The Midsummer Marriage' I was sitting one day in a small studio of Radio Lugano, looking out over the sunlit lake, listening to tapes of Vivaldi. Some pounding cello and bass C's, as I remember them, suddenly threw me from Vivaldi's world into my own, and marked the exact moment of conception of the 2nd Symphony. Vivaldi's pounding C's took on a kind of archetypal quality as though to say; here is where we must begin.[16]

This description, as well as confirming the status of C, again, through the reference to Vivaldi, corroborates previous comments concerning Tippett's continuing relationship to a sense of a past. However, it is difficult to relate the Second Symphony in any further way to Vivaldi; rather, as outlined above, it is the Stravinsky of the Symphony in Three Movements and Symphony in C who initially appears to provide both the historical and stylistic reference for Tippett's symphonic language.

The conclusion of the movement provides confirmation of the grounding of C, which now reappears as the final gesture. The sense of return is reinforced through the employment of the initial figure as the point of closure, a process which provides an affirmation of the status of C and of the gesture within the movement as a whole. However, C's centrality here is very distinct from Stravinsky's treatment of the 'tonic' in his Symphony in C. Ex. 4.3(a) presents the initial idea of the first movement of this work, within which the status of C as tonic is undermined or even denied. This seems to establish G as the pitch centre, the repeated Bs followed by a sustained G providing a strong dominant association. Although this gesture could be interpreted as dominant preparation for C, in the passage at Fig. 5ff., which indicates the beginnings of a 'first subject' of a sonata-form design and thus the point at which one might suspect C to be established, the bass line consists of an alternation of E and G rather than any real clarification of C (see Ex. 4.3(b)). The avoidance of C is still a factor

16 Sleeve note, Argo ZRG 535 (1967).

Ex. 4.3 Stravinsky, Symphony in C

(a) Opening

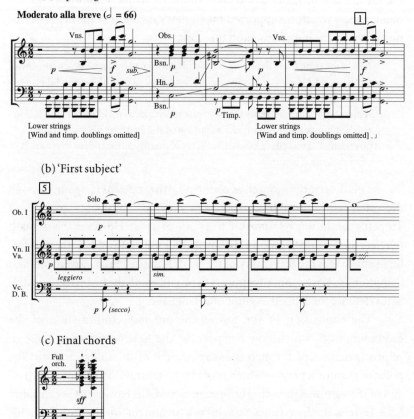

Lower strings
[Wind and timp. doublings omitted]

(b) 'First subject'

(c) Final chords

within the final chords of the movement (Ex. 4.3(c)), which involve E as a balance to the 'tonic' of C – the combination of these elements providing a final reflection of the balanced, polar relationship between them through-out the movement.[17] Thus, in contrast to the affirmation of C in the Tippett symphony, the status of C remains questioned even at the point of potential closure. According to Paul Griffiths, 'it is not that the specified note is an axis

17 For more detailed discussion of the relationship between these two pitches see Straus, *Remaking the Past*, 98–103.

and final instead of a tonic, but rather that it is a tonic in an unconventional sense, an ironic tonic'.[18] In other words, Stravinsky is subjecting the basic notion of a 'tonic' to a sense of ironic interrogation, undermining its expected functions and connotations. This conclusion reflects Stravinsky's wider play with stylistic conventions, but also connects with Stephan's description of neoclassicism, as outlined above. However, now it is a structural process rather than a stylistic identity which is subjected to the processes of parody/irony: the 'ironic tonic' becomes a mechanism for distancing the work from any potential inherited model or formal archetype.

The difference of the status of C in both works reflects two fundamentally differing understandings of the metaphor of polarity, a notion which is invoked in Stravinsky's much discussed claim that

> our chief concern is not so much what is known as tonality as what one might term the polar attraction of sound, of an interval, or even a complex of tones ... All music being nothing but a succession of impulses and repose, it is easy to see that the drawing together and separation of poles of attraction in a way determine the respiration of music.
>
> In view of the fact that our poles of attraction are no longer within the closed system which was the diatonic system, we can bring the poles together without being compelled to conform to the exigencies of tonality.[19]

In relating a concept of polarity to the context of Tippett's Second Symphony, David Clarke provides the following description:

> [Polarity] may be loosely described as the opposition between sharp and flat tonal fields ... [These] are of structural import for the ... symphony in a variety of ways. First, they aggregate a number of discrete tonal centres – C, D, A, E♭ and A♭ – which will ... assume a referential function. Secondly, both tonal fields reveal the intervals of a perfect 4th and 5th as an essential structural element of pitch activity. Thirdly, a polarity obtains between the tonal fields from which relative sharpness or flatness emerges as a functional

18 Paul Griffiths, *Stravinsky* (London: J. M. Dent and Sons, 1992), 123. Straus also refers to irony in relation to the sonata-form design of the first movement of the Symphony in C: 'The movement is not so much an example of sonata form as an ironic commentary on that form' (*Remaking the Past*, 103).

19 Igor Stravinsky, *Poetics of Music*, trans. Arthur Knodel and Ingolf Dahl (Cambridge, Massachusetts: Harvard University Press, 1947), 36–7.

Ex. 4.4 Tippett, Symphony No. 2, I: closing group of exposition (after David Clarke, *Language, Form, and Structure in the Music of Michael Tippett*, vol. II, Ex. 43)

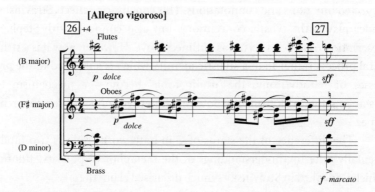

principle analogous to the dominant and subdominant functions of classical tonality.[20]

This description of polarity reflects a large-scale structural understanding of the concept, with the notion of a 'tonal field' appearing to represent a large area of structurally significant musical material. This view remains somewhat distinct from my own understanding of polarity within the Stravinskian context, which consists of a more basic juxtaposition of salient pitch elements, such as the ongoing alternation of C and F♯ in Part 2 of *Petrushka* (1910–11), or the repeated juxtaposition of E♭ and F in the first movement of *Dumbarton Oaks* (1937–8) to which I will refer again presently.[21]

Also notable within Clarke's description of polarity is the reference to the structural and syntactic significance of perfect fourths and fifths (ic5). For instance, the music of Ex. 4.4, which occurs as part of a 'closing group'

20 David Clarke, *Language, Form, and Structure in the Music of Michael Tippett*, 2 vols. (New York and London: Garland Publishing, 1989), vol. I, 82–3, 84.

21 For further detailed analytical interpretation of Stravinsky's 'metaphor of polarity' see my 'Structure, syntax and style in the music of Stravinsky', Ph.D. thesis (University of Exeter, 1995), 8–12. Other attempts to build analytical models upon interpretations of Stravinsky's statement include Marianne Kielan-Gilbert, 'Relationships of symmetrical pitch-class sets and Stravinsky's metaphor of polarity', *Perspectives of New Music* 21/1–2 (1982–3), 209–40; and Joseph Straus, 'Stravinsky's tonal axis', *Journal of Music Theory* 26/2 (1982), 261–90.

within the sonata design of the movement,[22] consists of the linear combination of B major and F♯ major elements within the flute and oboe parts. This functional deployment of the fifth relationship, rather than providing a reflection of the tonic–dominant polarity of the tonal language, still highlights the superficial appearance of a classicising tendency within the work, but one which is now freed from the functional associations and conventions which would support such an interpretation.[23] According to Clarke, 'we have moved a further stage away from unequivocal monotonality: now both centres are heard simultaneously as tonics; dominant and subdominant functions cease to be relevant'.[24] However, although the fifth (ic5) relationship is also highly prevalent within the Stravinskian context and, I suspect, the strongest point of potential contact between Tippettian and Stravinskian neoclassicism, the actual realisation of this relationship will be very different. The texture of this example is also notable, as it is framed by a static harmonic texture (see Figs. 26, 27, 28 and 29) which, in terms of its actual sonority and the way it provides a sense of structural discontinuity through the interruption of the flow of the music, is extremely reminiscent of Stravinsky's *Symphonies of Wind Instruments* (1920).

Of greater structural and syntactic significance, and the point of origin for the ic5 relationship, is the vertical harmony which is featured in bar 7 of the first movement (labelled 'Z' in Ex. 4.1): C–G–D–A–E–C♯, essentially a collection of fifth-related pcs which is imbued with tonal associations in the form of triadic subsets (A major, A minor, C major). This feature can obviously be related back to the Stravinskian context, the enclosure of the triadic subset within larger formations being a recurring element within Stravinsky's harmonic language, particularly in the neoclassical works. The collection of ic5-related pitches becomes germinal for the Tippett work as a whole and, through the accumulation of fifth relationships, the main integral source of a classicising tendency within it.[25]

This use of the fifth relationship, as suggested above, can also be directly referred back to the neoclassical context of Stravinsky. For instance,

22 See Clarke, *Language, Form, and Structure*, vol. II, 47, Ex. 74.

23 This potential separation between appearance and function is dramatised by Kofi Agawu in his 'Stravinsky's Mass and Stravinsky analysis', *Music Theory Spectrum* 11/2 (1989), 147. See also Gloag, 'Structure, syntax and style', 40–1.

24 Clarke, *Language, Form, and Structure*, vol. I, 94. 25 See ibid., 81–2.

Ex. 4.5 Stravinsky, Concerto in E♭, 'Dumbarton Oaks': opening

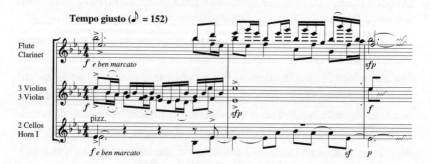

Ex. 4.5 quotes the opening gesture from *Dumbarton Oaks*, in which the texture, reflecting the neo-Baroque orientation of the material, is essentially linear. However, the first vertical alignment, consisting of E♭ and B♭, is repeated as the first vertical of the second bar, while in the third bar E♭ and B♭ are joined with the newly introduced F, producing an accumulation of ic5-related pitches as the crucial harmonic characteristic of the movement. This example represents the initial focus on the fifth relationship, as well as revealing the main polarity of the movement, between E♭ and F. It is the ongoing juxtaposition of these pitches throughout the movement which engenders a structural polarity, a process quite distinct from Clarke's understanding of polarity within the immediate Tippett context.

III

While these brief examples represent only the beginnings of a comparison, a certain sense of 'repetition with critical distance' emerges: structural processes (polarity) and syntactic details (the ic5 relationship) which have their origins in the Stravinskian context are explored on a larger scale within the immediate context of the Tippett symphony. In other words, structural processes which originate from within the Stravinskian context are repeated, but this sense of repetition is now enclosed within a process of defamiliarisation.

However, although these thoughts contain the potential for more detailed exploration, any more highly developed and exhaustive comparison may not be over-informative and might only serve to undermine the

individual integrity of the Second Symphony. As Louis Andriessen and Elmer Schönberger remind us, 'to say that a piece of music sounds like Stravinsky . . . does not really say very much'.[26] I suspect the relationship between Tippett and Stravinsky can best be situated on a larger and perhaps more abstract level. Andriessen and Schönberger, in a discussion of Stravinsky's broader influence, claim that this 'can be seen rather in a specific *attitude* towards already existing musical material. This attitude can be described as the (historical) realisation that music is about other music…'[27] Their reference to the 'other', through which music is constructed in relation to a past model but at the same time achieves a sense of distance (a process which is simultaneously both affirmative and critical), relates to the concept of critical distance or, perhaps more precisely, distance through defamiliarisation, which has become the recurring theme of this discussion.

This sense of distance/difference is also evident within the more exclusive context of Stravinsky. I raised earlier both the question of whether the Symphony in C and Symphony in Three Movements could themselves continue to sustain a pure neoclassical definition, and the possibility of a distancing between these works and the music of the 1920s. I suspect that the overview of Stravinsky's work from *Pulcinella* and the Octet to *The Rake's Progress* as one self-contained discrete stylistic unit is a crass simplification. A significant if highly subtle change gradually emerges around the mid 1930s, a change which directly problematises the neo-classical definition. Stephen Walsh, in a discussion of the Concerto for Two Pianos (1931–5), states that

> here Stravinsky seems less and less to be confronting us with the irreconcilable nature of classicism and modernism and more and more to be synthesising a sort of personal classicism out of precisely their reconciliation … It is no longer easy to be clear about which elements are classical and which merely appear so; or even to be sure whether the distinction still has any meaning. Neo-classicism dissolves into a classicised modernism, in Valéry's sense.[28]

26 Louis Andriessen and Elmer Schönberger, *The Apollonian Clockwork: On Stravinsky*, trans. Jeff Hamburg (Oxford: Oxford University Press, 1989), 100.
27 Ibid. (original emphasis).
28 Stephen Walsh, *The Music of Stravinsky* (Oxford: Oxford University Press, 1993), 175.

I believe that this description of the Concerto can be extended forward to include both the Symphony in Three Movements and the Symphony in C, and forward again to embrace Tippett's Second Symphony. These works still provide a model, but it is a model which itself problematises the neoclassical definition. Walsh's description of a neoclassicism which 'dissolves into a classicised modernism' may provide a more fruitful starting point for further consideration of the stylistic definition of the Second Symphony, enclosing as it does the essential modernity of the basic musical materials, while also reflecting the relationship to the gestures and conventions of the symphonic past and the now even more problematic relationship between Tippett and Stravinsky. If Tippett's Second Symphony reflects a degree of repetition of the Stravinskian models, this repetition is enclosed within a sense of difference – a process which highlights Tippett's assimilation of the Stravinskian neoclassical elements within his own evolving musical language, resulting in a symphonic construction which now begins to define its own critical condition as much as it still demands a degree of comparative interpretation.

5 Tippett, sequence and metaphor

CHRISTOPHER MARK

Arguments about the exact time and location of the birth of musical modernism will probably never be resolved. It seems generally agreed, however, that one of the most significant contributions to its development was the fourth movement of Arnold Schoenberg's String Quartet No. 2 (1907–8), where tonality is held in abeyance to a greater extent than in any previous work, albeit temporarily in terms of the quartet as a whole. But if the net effect of the music tellingly evokes Stefan George's 'air from another planet', some of the techniques employed, and much of the material, are not altogether alien, however transformed: the initial 'flickering figure'[1] is transposed around a segment of the circle of fifths, one of the staple processes of common-practice tonality; and the interval of the fifth itself, perhaps the quintessential tonal interval, becomes increasingly prominent melodically and harmonically. There is even a mock perfect cadence in C in the cello (bar 9), sardonic in its forceful *fortissimo* pizzicato and its conflict with the chord of harmonics in the upper instruments.

This kind of rejigging of common-practice materials and processes – whether, as here, from within the tradition that gave birth to them, or essentially from without, as in neoclassical Stravinsky – is as much a manifestation of the radical spirit of the early twentieth century as the invention of new materials and processes. Indeed, it can be argued that the essential point of incorporating elements of the musical past is to emphasise the modernity of the overall result. However, it is not always clear what the specific function of past techniques might be in a modernist context: are they operating symbolically or emblematically, as Stephen Walsh suggests is the case with Stravinsky?[2] or are they intended to aid comprehension, as

1 The description is Arnold Whittall's; see his *Schoenberg Chamber Music* (London: BBC Publications, 1972), 24.
2 Stephen Walsh, *The Music of Stravinsky* (Oxford: Oxford University Press, 1993), 102, 153–4, 170–5.

Alexander Goehr suggests is the case with the neoclassical aspects of serial Schoenberg?[3] or do they have more 'internal', structural *raisons d'être*? These questions are highly relevant to the abundantly allusive music of Michael Tippett, and in particular to his post-tonal output composed since *King Priam*. In addressing them I shall focus initially on his use of a pre-eminently tonal device: sequence.

The device of sequence epitomises both the goal-directed and the hierarchical nature of common-practice tonality. It is particularly prevalent in passages involving extension or elaboration; indeed, because of its inherently directed nature, it was (and still is) often pulled from the shelf by the less imaginative tonal composer as the stock response to a need for transitional or developmental activity. Whether the result is dull or masterly, however, the emphasis is on the underlying process rather than the material itself. Hence in Schenkerian analysis, harmonic and melodic sequences tend to be reduced to linear intervallic patterns and other means of prolonging harmonies at higher structural levels – as demonstrated by the examples from Allen Forte and Steven Gilbert's *Introduction to Schenkerian Analysis*[4] reproduced in Ex. 5.1: in (a) the foreground harmonic sequences are reduced to a 6–6–6–6 linear intervallic pattern prolonging I–V, while in (b) the melodic sequence between bar 6, beat 2 and bar 8, beat 1 is subsumed by the $\hat{4}$–$\hat{3}$–$\hat{2}$ portion of the fundamental line.

In his earliest acknowledged works, Tippett's way with sequence is essentially traditional. In the second number of *A Child of our Time* (1939–41), the alto aria entitled 'The argument', sequence is introduced in the vocal line after the first two-note phrase, providing the main action of the antecedent proper (Ex. 5.2). The underpinning harmony does not conform entirely with common-practice norms, though it does not move very far from them: the first move is to the relative major, G♭ (despite the key signature, the movement is in E♭ minor), in which key there is an imperfect cadence at Fig. $9^{+3/4}$, followed by a tonic cadence at Fig. 10^{-1}; the period

3 Alexander Goehr, 'Schoenberg and Karl Kraus: the idea behind the music', *Music Analysis* 4/1–2 (1985), 59–71.
4 (New York and London: W. W. Norton, 1982), 86, 150. The present transcription corrects the erroneous $\hat{2}$ over the final treble B♭ in the bottom system of the second example.

Ex. 5.1 Allen Forte and Steven Gilbert, *Introduction to Schenkerian Analysis*, by permission of W. W. Norton & Company Inc.

(a) Ex. 82

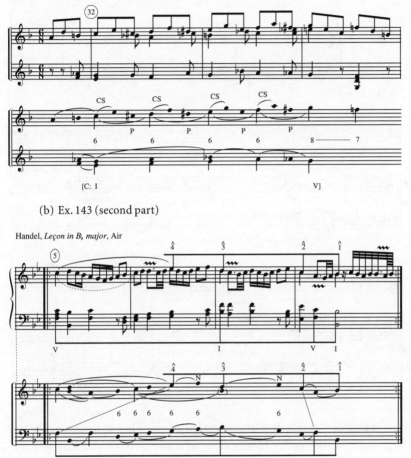

Beethoven, *Sonata for Piano and Cello*, Op. 5, No. 1, III

(b) Ex. 143 (second part)

Handel, *Leçon in B♭ major*, Air

closes with a plagal cadence in B♭ minor. The sequence delineates the cadences in G♭ and the voice's ascent to 'the heavens': the C♭ at Fig. 9 and the D♭ seven bars later point the way to the E♭ at Fig. 10^{+2}.

Even more straightforward is the literal sequence from Fig. 11 of this aria (not quoted) which underpins and paints the words 'driven the Gods.'

Ex. 5.2 *A Child of our Time*, No. 2: 'The argument' (alto solo)

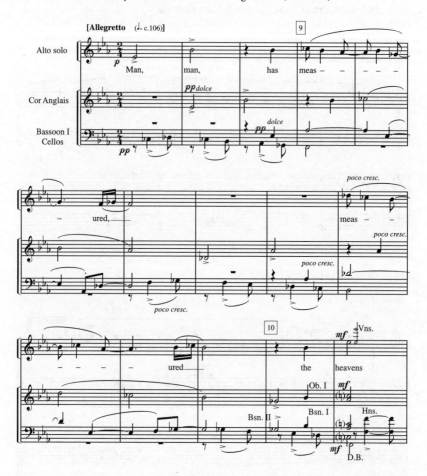

Less tractable though, and an indication of the Tippett to come, are the large-scale sequences (i.e. blocks of music immediately transposed with no other, or only slight, changes) in the opening chorus of Part 3, 'The cold deepens' (No. 26). The core of this movement consists of two choral sequences: the music between the beginning and Fig. 107 (choral parts quoted in Ex. 5.3(a)) is transposed up a fourth between the upbeat to Fig. 107$^{+2}$ and Fig. 108$^{+2}$; while the music between the upbeat to Fig. 109 and Fig. 110$^{+2}$ (the inception of which is quoted in Ex. 5.3(b)) is similarly transposed between the upbeat to Fig. 111 and Fig. 112$^{+3}$. These sequences are framed and linked by related orchestral material (not quoted) which is in

Ex. 5.3 *A Child of our Time*, No. 26: chorus

[Remaining orchestral parts omitted]

turn adumbrative (as at the very opening), developmental (as between the second and fifth bars of Fig. 108, where the immediately preceding melodic figure sung to the word 'deepens' is developed to effect a transition) and ruminative (as in the second and third bars of Fig. 110).

The first sequence seems again to be traditionally functional, setting in train the motion towards the first climax at Fig. 109: cadences onto G (Fig. 107, Ex. 5.3(a)) and C (Fig. 108) initiate a circle-of-fifths movement resulting in the F–B♭ minor (V-I) progression at 'The world' (Ex. 5.3(b)). The subsequent transposition of 'The world' at Fig. 111 continues the circle to E♭. It could be argued, indeed, that the whole movement is based on the circle of fifths – or, rather, the interaction of two segments of the circle of fifths, delineated by the harmonic start- and endpoints of the sequences and the orchestral introduction and coda – as graphed in Ex. 5.4. The first sequence involves movement flatwards from one segment of the circle of

Ex. 5.4 *A Child of our Time*, No. 26: fifths structure

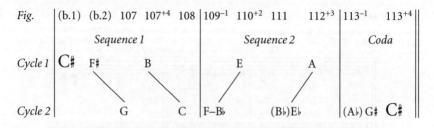

fifths to the other; the second sequence involves movement sharpwards. The coda is a further extension of the flatward segment until it meets the starting-point of the sharpward one.

This steadfastly formalist view is very neat, but it does not square entirely with how one experiences the music. In particular, the coda does not come across as the culmination that the diagram suggests. One reason for this is that the return of the opening material at the G♯ level from the quaver before Fig. 113 is somewhat disengaged from what precedes it (it replaces the developmental material of the sequential model, the music from the fourth bar of Fig. 110, which itself appears rather abruptly), so that discontinuity occurs at the very moment we would expect maximum continuity, given the organicist cues of the movement up to that point. This is not to accuse Tippett of a lack of competence: rather, I suggest that he has, at least in this context, a limited interest in traditional notions of coherence, even though so much of his music of this period seems to grow out of common-practice principles. What seems significant is the material rather than the process: the sonorous depiction of 'cold', 'descends', and (through the symbol of decorative counterpoint) 'the jewel of great price'. The sequences exist to enable the portrayal of these notions to make its maximum effect through assertion. And transposition rather than repetition is employed simply because transposition – particularly upwards, as here – has greater rhetorical impact.

My first example from the rather different environment of post-tonal Tippett is the music between Figs. 59 and 62 in his Symphony No. 3 (1970–2), quoted in Ex. 5.5.[5] This is the opening of 'Arrest V', i.e. the fifth

5 The parts for untuned percussion are omitted.

Ex. 5.5 Symphony No. 3, Part 1, 'Arrest V'

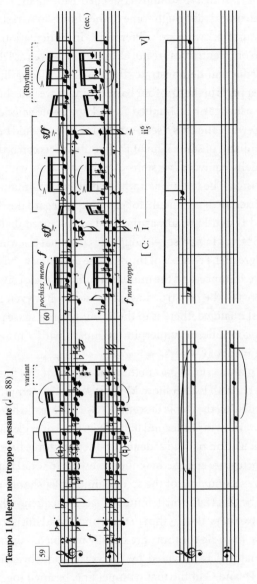

passage using music to which the composer applies the label 'Arrest' (alternating with a contrasting type of music, labelled 'Movement'). To look first at the harmonic context: although some of the chords in Arrest V are more prominent gesturally owing to differences in articulation, rhythmic emphasis and so on, hierarchies are not clear-cut. However, as Ex. 5.5 and its voice-leading reduction demonstrate, there is fairly strong linear movement in the outer parts in the first four bars, ending, if we take those parts by themselves, in a cadence on an implied C triad: the treble voice descends by step from A to E, while the bass rises from A to C. The C could be a tonic, or possibly the dominant of some kind of F: the outer parts can be interpreted as being in modally equivocal versions of either tonality, with fairly standard chromaticisms. The texture as a whole, however, maintains considerable harmonic friction. It is difficult, for example, to regard the third chord, with its overlaid D and E♭ triads, as the kind of enhanced diatonic chord Arnold Whittall[6] finds in Arrest I – though it is true that elsewhere the tensions are not so great: the conflict of thirds in the cadential C-based chord is a modal issue, for instance; and the minor seventh and major sixth from the bass here could easily be construed as added notes. But even if the tonal forces are at least qualified, there is in the ensuing bars a sense in which an F/C framework continues to underpin the music, with a move from the tonic to the dominant of C via ii$^6_5$.

Sequence plays a crucial part in the articulation of this framework, as the annotations beneath Ex. 5.5 show. Melodic sequence is employed first as a means of articulating the treble descent, A–G–F–E. Meanwhile the rhythmically pruned variant in the second half of Fig. 59$^{+3}$ provides a brake into (and strong articulation of) the cadence. In the next three bars, following Fig. 60, the entire texture engages in sequence, except for one change of note in the horns (the second note of the second quintuplet should be an A for the sequence to be exact). In spirit, if not in fact, the sequence then continues for another two bars: the rhythm in the trumpet and horns remains the same though the melodic contours are heavily modified. Further integration of pitch material is provided by the correspondence between the emphasised A♭, D♭ and G in the first trumpet line, beamed together below

6 Arnold Whittall, review of Ian Kemp, *Tippett: The Composer and his Music* (London: Eulenburg Books, 1984), in *Music Analysis* 4/3 (1985), 312–13.

Ex. 5.5, and the three upper voices of the initial chord of the passage – as David Clarke has shown.[7]

Much of the rest of Arrest V is also shaped by sequence and the non-sequential transposition of previously stated material. Ex. 5.6 is a paradigmatic précis of the section, showing on the left-hand side the various transpositions and variations of the opening four-bar phrase, and, on the right-hand side, the main points of harmonic focus in the intervening material. As comparison of systems (i) and (ii) shows, the second statement of the initial phrase is altered in the second bar to effect a transposition up a tone (in the treble, A♭ E♭ B♮ G E etc. instead of A♭ E♭ A♮ F D etc.). This opens up new harmonic territory pivoting around the pitch classes D and, especially, A: the *brillante* material for trumpets and horns between Figs. 65 and 67 (see system (ii)) revolves around chords rooted on A and B, the latter seeming like a neighbouring chord to the former largely because of the former's rhetorical strength at Fig. 65^{+2}. If, as I have already implied in discussing the first four bars of Arrest V, the bass notes have more structural weight than the others, then this represents an extension of the F/C–G fifths-structure outlined in relation to Ex. 5.5 (see also system (i) of Ex. 5.6). This does not, however, signal the unfolding of a uni-directional process: C returns as the pivotal bass note at Fig. 67^{+3} (the last event in system (ii) of Ex. 5.6), and as the dominant of F it ushers in a repetition between Figs. 68 and 71 of the F/C-based material of Figs. 59–62 (compare systems (i) and (iii)). (The C–G chord which this C supports and the transpositionally parallel D–A chord at Fig. 76^{+3} (see systems (ii) and (iv)) have the most unambiguously functional quality of all the chords in Arrest V, not only because of the absence of internal contradictions, but also because of the strong voice-leading motions towards them, particularly in the bass.) Furthermore, while D and A return as pivots, as indicated in system (iv), the *brillante* material at Fig. 74 now moves decisively away from A, and Arrest V ends on a G-based chord, shown as the last event in system (v). Such equivocation (using the term non-pejoratively) is entirely appropriate to the overall formal requirement that the section be non-concluding; while the lack of a single, all-embracing uni-directional process epitomises

7 See David Clarke, *Language, Form, and Structure in the Music of Michael Tippett*, 2 vols. (New York: Garland, 1989), vol. II, 71 (Ex.105 (a)).

Ex. 5.6 'Arrest V': paradigmatic précis

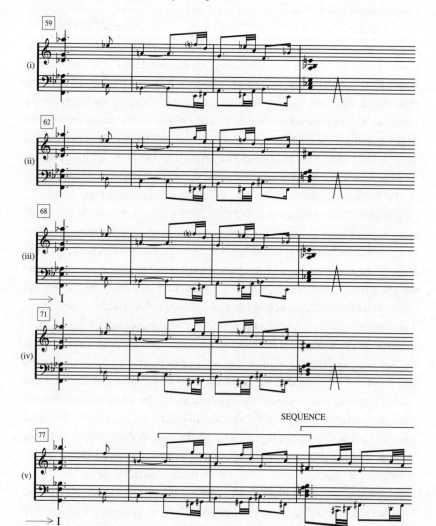

Ex. 5.6 (*cont.*)

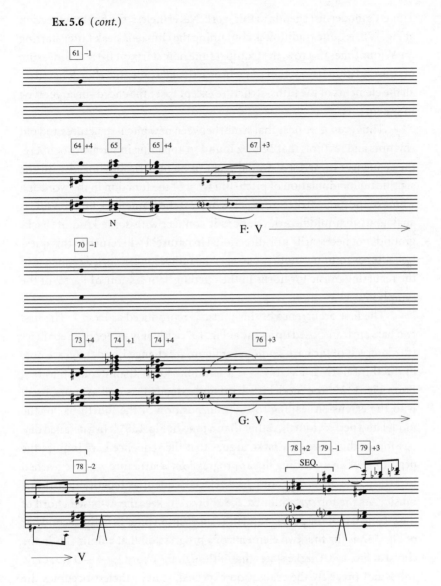

Tippett's modernist agenda in this work. Nevertheless, the final sub-section at Fig. 77ff. is quite traditional, containing the climactic peak (after starting on Ab four times in a row, the trumpet tune now starts on Bb) and a measure of consolidation (two sets of sequences articulate cadential chords based on all the elements of the fifths-structure except F: see the chords in larger type in system (v)).

Thus even if we hear that strain between new pitch-structures and old rhythms and textures that Boulez found so appalling in serial Schoenberg, the sequences in Arrest V would seem to be inextricably linked with the significant manipulation of pitch. But what of the function in the work as a whole of the pitch-structure isolated here? If the framework built on F/C is analogous to a middleground, does it connect with some kind of 'background', not necessarily uni-directional in nature? I will return to this question after examining another passage: the rather longer, varied sequence in the recurring music for horns in the opening 'jam session' of Part 2 of the symphony.

The first occurrence of this music is reproduced as Ex. 5.7. The first two bars are transposed up a tone at Fig. 137, with only minor discrepancies (the intervals of the harp semiquaver figure are changed, and the grace note in the third horn at Fig. 137^{+2} is a semitone lower than it 'ought' to be). From Fig. 137^{+3} the model is varied and extended, as well as transposed, with the extension leading to the transposition of the fourth bar of the model up a perfect fourth, rather than a tone, at Fig. 138^{-1}. In a detailed discussion of this passage, Clarke argues that the sequence here implies the beginning of an ascending linear progression, 'a structure we have learned to extrapolate from phenomena such as sequential repetition in tonal music'.[8] As the top system in Ex. 5.8 shows,[9] he sees the Ab-based chord of the second bar of the passage and its transposition onto Bb in the second bar of Fig. 137 as the first two elements of a progression that culminates in the chord at Fig. 138. Clarke states that 'although the chord Eb–Ab–D ... at Fig. 138 is not precisely the realisation expected, it nevertheless occupies the appropriate register for a linear connection to be made with the preceding structure. Furthermore, the link is reinforced by the lydian-coloured Ab tonality suggested by both parts of the structure.'[10]

8 Ibid., vol. I, 281. 9 Ibid., vol. II, 107 (Ex.150 (a)). 10 Ibid., vol. I, 282.

Ex. 5.7 Symphony No. 3, Part 2 (opening)

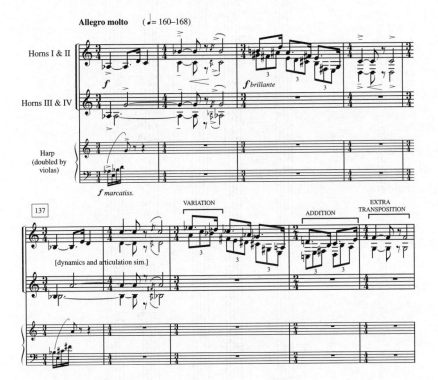

The A♭ tonality is in Clarke's view one of three intercutting tonal layers delineating 'flat-side', 'natural', and 'sharp-side' tonal fields (see Ex. 5.8). But this reading is not, on the face of it, without difficulties. The A♮ in the B♭-based chord and the non-A♭ pitches in the harp's flourishes would seem to weaken the case for an A♭ tonality, or even a Lydian-flavoured, A♭-based tonal field. It may also be felt that the criterion for the E♭–A♭–D chord's role as the realisation of the ascending linear progression (occupying 'the appropriate register for a linear connection to be made with the preceding structure') is rather too accommodating. In an important sense, however, these points do not detract from Clarke's main argument. For, as the quotations above imply, he views the ascending linear progression and the tonal binding, not just as *intra*textually signifying structures, but as cues for *inter*textual relationships: the music derives its coherence to a large

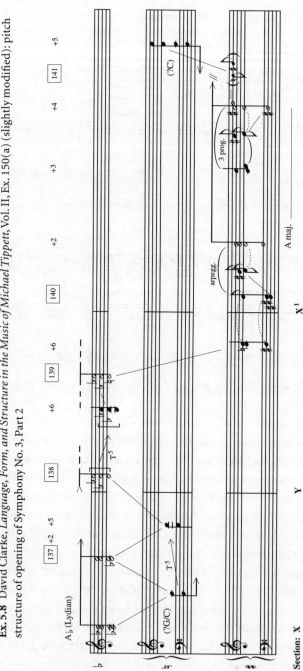

Ex. 5.8 David Clarke, *Language, Form, and Structure in the Music of Michael Tippett*, Vol. II, Ex. 150(a) (slightly modified): pitch structure of opening of Symphony No. 3, Part 2

extent by drawing on the listener's knowledge of common-practice conventions, whose coherence Tippett's own music borrows.[11] This is not the whole story, for, as Clarke maintains and demonstrates in detail, there are intratextual forces at work too. But the slightly defensive tone he adopts in this part of his commentary suggests greater confidence in the intertextual perspective.[12] Simplifying to an extent that Clarke might find unacceptable, I would say that what is important in the passage under discussion is the *fact* of sequence, rather than what this particular sequence delineates: it is the general sense of moving away or opening out lent by transposition that counts. The variations to the sequence seem to be simply rhetorical, too, projecting the music forward by increasing the degree of emphasis.

As with Arrest V, the question arises: is there any intersection with larger-scale pitch processes here? I cannot find any evidence of this. For critics who believe that musical meaning comes about through the demonstrably significant manipulation of pitch, such an analytical cul-de-sac represents a major problem. However, another example of sequence from perhaps the most forthrightly modernist piece Tippett has written, the Concerto for Orchestra (1962–3), might suggest that, like it or not, we need to view the role of pitch in a rather different light in at least some instances.

Ex. 5.9 reproduces the opening bars of the trumpets' first entry in the first movement. The passage is divided into four sub-sections beginning at Figs. 31, 33, 34 and 35. Sequences abound. They are mostly rising, and the energy thus created is what sustains momentum across the breaks between sub-sections to the top A at Fig. 35. A more immediate sense of propulsion is created by rhythm (particularly the syncopations), by the quasi-suspensions from Fig. 33 and by the canon from Fig. 34. As for the choice of pitches, it seems that these are the agents of the means of instilling momentum listed above, rather than these means (the sequences, suspensions and canons) being surface articulations of pitch processes. In other words the traditional situation is reversed. What is important in this mosaic-form movement is the delineation of musical character, and pitch is subordinate to this. Certain kinds of sonority and certain types of basic musical behav-

11 This is perhaps most obvious in the realm of phraseology: Clarke cites the opening eight bars of Mozart's 'Jupiter' Symphony, K.551 as a possible intertext for Tippett's phraseology here; see ibid., 281.

12 See in particular ibid., 284.

Ex. 5.9 Concerto for Orchestra, I

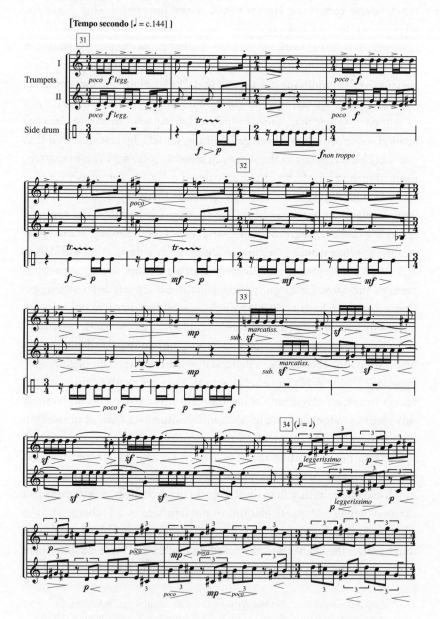

Ex. 5.9 (*cont.*)

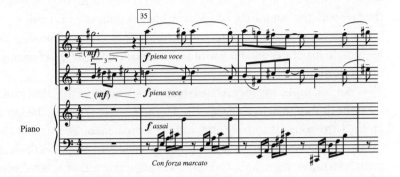

iour are required, but beyond delivering these pitch has no part to play. I would argue that this is even the case with the apparent emergence of an explicit tonal centre at Fig. 35. The D/A fifth may sound like a point of arrival because of the steady rise towards A in the first trumpet, but the almost pure D major does not have a wider, tonal function: rather, it is simply the expression of a kind of lyricism peculiar to the trumpet.

What I have been describing is a metaphorical approach to composition: the sequences, suspensions and canons 'stand for' their traditional effects, rather than creating them in the traditional way through relationships between the actual pitches. This view is perhaps inevitably reached, given Tippett's own statements about his concern with metaphor – though the kind of metaphor to which the composer and commentators on his music normally refer is not this intra-musical type, but the iconic (of which two examples among many might be the 'sound' and 'space' music from the beginning of *The Mask of Time*). Both kinds are worth considering a little, since, I suggest, they lie behind some of the main critical problems regarding post-*Priam* Tippett.

An iconic-metaphorical approach to composition relies heavily on the composer's ability to create highly graphic symbols: hence material is of the essence rather than its elaboration or extension. It is true that development can itself be a graphic symbol (of, for example, Beethovenian 'struggle'), but in a metaphor-based work the potential for development is likely to be curtailed by those requirements of the material just mentioned. The material is, in other words, likely to be fairly self-contained: the self-absorption it

111

requires to enable it successfully to function metaphorically does not readily admit extension – though decoration is easily enough achieved (as, again, is the case with the 'sound' chord). Meanwhile the difficulty of creating convincing development has an effect on form, leading to Tippett's predilection for mosaic structures and his use of superimposition as the chief means of intensification.

An example of the mosaic-form consequences of the iconic-metaphorical approach can be seen in 'The beleaguered friends', the second of the 'Three songs' that make up the ninth movement of *The Mask of Time* (1980–2). The mosaic structure, outlined in Table 5.1, comprises the statement, extension, repetition, transposition and variation of seven distinct and essentially self-contained blocks of material. This creates a pattern arranged around a central block, labelled C – the only block occurring once.[13] At a highly abstract level the mosaic pattern is symmetrical: the music both before and after C involves the repetition of a succession of blocks in which one block (B before C, and G after) is varied[14] on each appearance; the main difference is that the repetition before C involves transposition. The material of the pre- and post-C music is utterly different, however, so that the paradoxical overall impression is of through-composition.

Strikingly for late Tippett, the song contains two long stretches of pure diatonicism: B♭ major from the opening to Fig. 454 (the beginning of which passage is quoted in Ex. 5.10(a)), and A♭ major as the same music appears a tone lower between Figs. 457 and 461. Other shorter or not quite so pure passages of tonality/modality can be found at Fig. 464ff. (an extended B♭ Dorian/Aeolian: see Ex. 5.10(b)); at Fig. 467$^{+3}$ ff. (E♭ major-minor, repeated at Fig. 471$^{+3}$ ff.); and at Fig. 469 (E major brass fanfares: Ex. 5.10(c), repeated at Figs. 470, 473 and 475). Again, while it may be possible to coax functional connections between these passages, this seems to be beside the point: the reappearance of the opening B♭ centre at Fig. 464 (cf. Exx. 5.10(a) and 5.10(b)) does not sound like a return, and the music from

13 While C appears less than central in the table, the blocks following it tend to be much shorter than those which precede: D and F last only two bars and one bar respectively, for example.

14 Stricly speaking, 'reinvented' might be a more adequate description for the relationship between the G blocks, since their invariant features amount primarily to texture and a predilection for the minor ninth.

Table 5.1. Formal
scheme of 'The
beleaguered friends'

Fig.	Block
450^{-1}	A1
453^{-1}	A2
454	B1
457^{-1}	A3
460^{-1}	A4
461	B2
464^{-1}	C
467	D
467^{+2}	E
469	F
469^{+2}	G1
470	F
470^{+2}	G2
471	D
471^{+2}	E
473	F
473^{+2}	G3
475	F
475^{+2}	G4

Fig. 457 sounds like a re-take of the opening at the A♭ level rather than the continuation of a process already set in motion.

In short, it makes better sense to speak here of a number of tonal musics whose non-relatedness is an aspect of the mosaic form. These musics have a metaphorical function: they relate not to each other, but to external referents. The music for A (Ex. 5.10(a)) has in fact already appeared in *The Mask of Time* in a slightly different version. It forms part of 'Jungle', the third movement in Part 1 (see Fig. 69), where it already functions metaphorically as a setting of the solo baritone's text, 'Allah asks; "The heaven and the Earth and all between; thinkest thou I made them in jest?"' The orchestration (including the playing instructions 'harsh, rough tone'), the modality (at least, the *fact* of it, rather than the particular mode employed) and the ornate heterophony invoke an Islamic scene – which, it has to be said, is embarrassingly stereotypical. This scene is inevitably

Ex. 5.10 *The Mask of Time,* No. 9: 'Three songs': (2) 'The beleaguered friends'

(a)

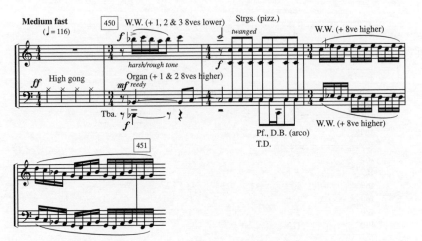

(b)

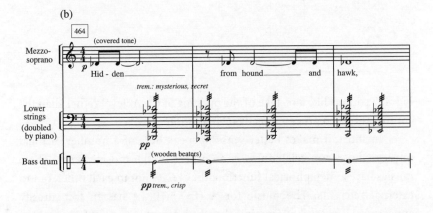

(c)

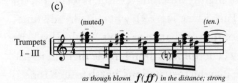

recalled in 'The beleaguered friends.' Most of the other tonal blocks allude to earlier, tonally based Tippett: the major-minor basis of *E* recalls the wordless penultimate section of *A Child of our Time* (Fig. 136$^{+4}$ff.), which is also initiated by the soprano soloist; the gravity and vocal timbre of the central block, *C*, recalls Madame Sosostris's aria in *The Midsummer Marriage* (1946–52); and the hieratic brass fanfares recall the ceremonial aspects of that opera.

If it is relatively easy to recognise that this song has a metaphorical basis, precise understanding of what the metaphors signify is dependent upon acquaintanceship with the source of Tippett's symbology, the *I-Ching*, and upon an awareness of the real-life situation to which the text itself only cryptically alludes. As Tippett tells us, 'The beleaguered friends' refers to a scene in which 'a group of anti-Nazis in Peking in 1944 awaits the end of the Second World War. While waiting, they listen to a series of lectures on the *I-Ching* by Helmut Wilhelm.'[15] In common with other artists with modernist leanings – T. S. Eliot, Tippett's self-confessed 'spiritual father', is a parallel case in poetry – the composer takes risks (here and in numerous other contexts) by assuming his listeners share the details of his own cultural knowledge. Those 'in the know' may find such allusions expressive; those who are not may feel confused or alienated (notwithstanding the partial help provided by Tippett's accompanying notes in the libretto). The epigrammatic nature of the allusions within the work itself to this historical incident and to the *I-Ching* limits what can be interpretatively 'fixed', beyond a general sense of mysterious divination ('he asks the book: What number is the now?') and optimism (the isolated word, 'Deliverance'; the related phrases 'return brings good fortune', 'hurrying brings good fortune').

Not all of Tippett's iconic metaphors are quite so slippery: the 'sound' and 'space' metaphors already mentioned are much more incisive, for instance. Certainly the potential for obscurity cannot in itself be a valid criticism of the method. However, as with the intra-musical metaphors of the Concerto for Orchestra discussed above, it is debatable to what extent the details of such music are important. Quite substantial changes could be

15 *'The Mask of Time'*, in *Tippett on Music*, ed. Meirion Bowen (Oxford: Clarendon Press, 1995), 254; this essay is based on the composer's notes to the libretto of *The Mask of Time*.

made to iconic-metaphorical music with no detriment to the overall result, because the pitches, rhythms and timbres are not required to function as part of a musical design in which integration is of signal importance: a general effect often suffices. Clearly, as the analyses of Symphony No. 3 show, the degree of significance of the details varies. The challenge for criticism – particularly the brand that continues to honour the work itself as the principal site of meanings – is to develop methods which can accommodate these variations, and, perhaps above all, to find ways of assessing the cogency of music which through a fundamental metaphoricity tends to defer meaning to external referents.

In describing the search for ways of expressing that which seems inexpressible, Dennis Potter (perhaps the greatest writer for television, one of Tippett's favourite media) once talked of 'bumping up against the rim of language'. The sense of strain and the shortcomings of technique that some commentators have found in Tippett may be said to reflect this kind of difficulty in musical terms, as the composer seeks ways of communicating his urgent visions. Critics, too, face the problem of finding or developing adequate means to refine their understanding of this music – or to focus their confusion about it. While analysis can clarify problems and aid critical assessment, it cannot determine the worth of a composition: a good piece, let alone a masterpiece, is always more than the sum of its rationalisable parts, and when, for example, the analyst has not found what I have called significant manipulation of pitch, who is to say that this is not simply a lack of observation, or a failure of imagination on his or her part? But concentration on pitch as the overarching unifying factor may not be the most efficacious way of understanding Tippett's post-*Priam* output, or indeed parts of earlier works. As we have seen, even in those instances where pitch does seem to count there are gaps, and often no apparent syntheses at the level of the work. A method that recognises the role of metaphor might be a more productive way forward.

6 Tonal elements and their significance in Tippett's Sonata No. 3 for Piano

ALASTAIR BORTHWICK

I

Enthusiasts of Tippett's piano sonatas might be surprised to read the words 'tonal' and 'significance' in connection with his Third Piano Sonata (1972–3). If the analytically palliative term 'elements' is interposed between these two words then their inclusion in the same sentence might at least enter the realms of plausibility. However, to effect the passage from plausibility to validity will necessitate the surmounting of serious, though by no means conclusive, aesthetic and historical objections.

Paul Crossley, who commissioned the sonata and gave its first performance, has commented that in its last movement, or section, 'the actual pitches of the notes do not matter',[1] a remark that is more than a little reminiscent of Harrison Birtwistle's self-assessment, though one that arguably befits his more unambiguously modernist approach to composition.[2] Drawing inspiration from the 130-bar palindrome in the sonata's final movement, Crossley pursues his point further by claiming that 'it would hardly matter if one turned the score upside down and played it that way'.[3] If there is any validity whatsoever to these judgements then the tonal elements uncovered in the sonata, particularly in the last movement, will have the unusual property of invariance not under the logical operation of inversion, but under the graphical operation of being turned upside down!

Consideration of the sonata's chronological context suggests a more ambivalent attitude to the study of tonal elements. The sonata belongs to

1 Paul Crossley, 'Tippett's Third Piano Sonata', *Composer* No. 70 (Summer 1980), 16.
2 Michael Nyman, 'Birtwistle's *Verses for Ensembles*', *Tempo* No. 88 (Spring 1969), 50. 3 Crossley, 'Tippett's Third Piano Sonata', 16.

the group of five works identified by Ian Kemp as concluding Tippett's post-*King Priam* period,[4] a period characterised by non-teleological tonal and atonal structures. The other four works in this group – *The Knot Garden* (1966–9), *Songs for Dov* (1969–70), Symphony No. 3 (1970–2) and *The Ice Break* (1973–6) – all contain clear tonal elements, but in all four cases these elements are justified on extra-musical grounds. No such justification is possible with the Third Piano Sonata, Tippett's first significant purely instrumental work since the Concerto for Orchestra (1962–3).[5] However, it is because of Tippett's devotion to music with a dramatic content, which justified such stylistic forays, that the expectation of tonal elements in the Third Piano Sonata seems reasonable: the habits of a decade cannot easily be set aside. Indeed, even in the period leading up to *King Priam* (composed between 1958 and 1961), Tippett's musical style demonstrated a penchant for what David Clarke has described as a transplant of 'elements from a system of pitch organisation endemic to earlier times into a period which has seen its demise'.[6] If all this conjecture risks becoming a music analyst's self-fulfilling prophecy then a brief survey of Tippett's writings in the years leading up to the composition of the sonata should help to affirm the importance of these issues to Tippett himself.

II

As a number of commentators have reported,[7] the problem confronting Tippett in his post-*Priam* music was how he might reconcile a style based on the juxtaposing of contrasted material with his long-standing faith in the Beethovenian sonata-allegro as a form capable of supporting

4 Ian Kemp, *Tippett: The Composer and his Music,* revised edn (Oxford: Oxford University Press, 1987), 401.
5 The only other instrumental works in the intervening period are minor pieces: 'Braint' (1966), Tippett's contribution to the composite *Severn Bridge Variations,* and the one-minute *In Memoriam Magistri* (1971), written in memory of Stravinsky.
6 David Clarke, *Language, Form, and Structure in the Music of Michael Tippett,* 2 vols. (New York and London: Garland Publishing, 1989), vol. I, 29.
7 See, especially, Kemp, *Tippett,* 351; and Arnold Whittall, *The Music of Britten and Tippett: Studies in Themes and Techniques,* 2nd edn (Cambridge: Cambridge University Press, 1990), 264.

large-scale works. At a theoretical level, Tippett's response to this problem was characteristically general. In an essay dating from 1970 he argues that many of the traditional titles for instrumental forms need to be re-examined and redefined if they are to be free from confusion.[8] Beyond this concern for critical clarity lies the more important question of the relevance of such a review to the composition of large-scale works. Tippett's solution to the problem of stylistic conciliation involves the division of instrumental forms into those that imply a 'historical archetype' and those that must be understood as 'notional archetypes'.[9] By 'historical archetype' Tippett is referring to the established norms of composition, such as those represented by Beethoven's middle-period symphonies, whereas 'notional archetype' is understood as an individual composer's subjective response to, and employment of, those established norms – Mahler's symphonies are presented as an example of the latter. Tippett's example of a notional archetype requires further clarification, since it reveals both the strengths and the weaknesses of his conceptual framework. In a later addition to the 1970 essay concerning his post-1970 concert pieces, Tippett makes the important observation that 'Beethoven's notional archetype in his Ninth Symphony could become a historical archetype', an observation that receives additional support when Tippett suggests both Beethoven's 'Pastoral' Symphony and Debussy's La Mer as two possible historical archetypes for The Rose Lake (1991–3), even though La Mer, in relation to the 'Pastoral' Symphony, was clearly a notional archetype at the time of its composition.[10] Hence, in general, Tippett's archetypes are not simply concerned with ontological descriptions of musical works, but also with the representation of musical knowledge. Tippett presents us with a crucial, if unrefined, insight into the nature of music's creation and evolution, one that foreshadows the more critically and analytically refined developments

8 This essay was Tippett's contribution to *The Orchestral Composer's Point of View: Essays on Twentieth-Century Music by Those Who Wrote It*, ed. Robert Hines (Norman, Oklahoma: University of Oklahoma Press, 1970); adapted as the first part of the chapter 'Archetypes of concert music', in *Tippett on Music*, ed. Meirion Bowen (Oxford: Clarendon Press, 1995), 89–108.
9 Tippett, 'Archetypes of concert music', 89. (See also Kenneth Gloag's discussion of these terms in his chapter in the present volume, pp. 78–9.)
10 Tippett, 'Archetypes of concert music', 100, 108.

in genre studies such as those by Jeffrey Kallberg and Robert Pascall.[11] Essentially, Tippett's archetypes can be said to embrace the regenerative aspect of genres, a regeneration that Pascall has described as 'a weighty focus of change which draws the past and future into the present'.[12]

The temporal dimension of Tippett's archetypes suggests the further possibility that they can be accommodated within the semiological tripartition applied to music discourse by Jean-Jacques Nattiez.[13] Indeed, further inspection of Tippett's essay appears to confirm this possibility. Considering Leonard Bernstein's inclusion of Stravinsky's *Le Sacre du printemps* in a BBC television programme entitled *The Twilight of the Symphony*, Tippett expresses his doubts over the reference to *Le Sacre* as a 'symphony'. These doubts arise, he says, 'not because I have a true (for me) historical archetype to which I refer it and dismiss it, but because I dismiss it with reference to my notional archetype, which is probably not the same as Bernstein's. My notion is no more valid, finally, than his.'[14] Drawing Tippett's various examples together and relating them to Nattiez's semiological tripartition of symbolic forms, it is clear that historical archetypes should be situated on the side of the poietic, and notional archetypes on the side of (or mediated through) the esthesic. In other words, historical archetypes are an aspect of the creative contexts of compositions, whereas notional archetypes depend on perceptual contexts – in the first instance on the perception of the composer.

According to Nattiez's model (albeit a self-consciously simplistic one),[15] the re-interpretation of historical archetypes as notional archetypes

11 Jeffrey Kallberg, 'The rhetoric of genre: Chopin's Nocturne in G minor', *19th Century Music* 11/3 (1988), 238–61 (also containing references to Carl Dahlhaus's extensive writings on genre); Robert Pascall, 'Genre and the finale of Brahms's Fourth Symphony', *Music Analysis* 8/3 (1989), 233–45.

12 Pascall, 'Genre', 236.

13 The semiological tripartition consists of poietic, neutral and esthesic levels. The poietic level is concerned with the process of a work's creation and the influences on it; whereas the esthesic level has to do with the reception and perception of a work. The neutral level can be understood either as the physical and material embodiment of the work or as a systematic analysis of the work that proceeds by 'neutralising' the poietic and esthesic dimensions. See Jean-Jacques Nattiez, *Music and Discourse: Toward a Semiology of Music*, trans. Carolyn Abbate (Princeton: Princeton University Press, 1990), 10–16.

14 Tippett, 'Archetypes of concert music', 90.

15 Nattiez, *Music and Discourse*, 180, n. 22.

takes place within a linear arrangement of separate, chronologically ordered tripartitions (see Ex. 6.1). The first of Nattiez's diagrams 'shows how Webern's poietics integrates a perceptive stance toward Bach and Renaissance composers, how Boulez in turn is the heir of Webern and a certain Webernesque understanding of Bach, and so forth'.[16] The second diagram is directed towards those who write about music (or, in fact, any subject), but the framework is equally applicable to the work of a composer, especially one such as Tippett who has also theorised about music. It shows the way in which '[a] writer, in a poietic position in relation to his or her own work, is at the same time in an esthesic position to the work of his or her predecessors'.[17] Hence, to return to Tippett's example, Beethoven's Ninth Symphony, although a notional archetype in relation to his middle-period symphonies, becomes a historical archetype in relation to Tippett's Third Symphony since it enters the domain of the work on the side of the poietic.

The importance of expressing Tippett's ideas of the archetype in terms of the semiological tripartition, beyond the obvious conceptual advantage of being able to represent the historical development of arche-types, lies in the analytical potential of the neutral level, as represented by the 'metatheory' described in my *Music Theory and Analysis: The Limitations of Logic*.[18] Briefly, this metatheory sets out a range of potential analytical interpretations of a work according to a collection of logically expressed axioms. Each element of a potential analysis can be classified as true, false or quantifiably ambiguous in a particular context (this last classification relates to the idea of 'many-valued logic' as distinct from the Aristotelian principle of bivalence); but the final analysis involves the sub-jective response of the analyst to these potential interpretations (an aspect of the esthesic dimension) with regard to other esthesic and poietic criteria, such as the historical significance (poietic) or acoustic properties (esthesic) of the various elements isolated by the metatheory. In esthesic matters such as the one concerning Bernstein and Tippett, which involves a difference of notional archetypes for the symphony, the analytical techniques that are derived from the metatheory can, in principle, elicit the myriad elements that, historically, constitute a symphony. However, for the purposes of

16 Ibid., 146. 17 Ibid., 180.
18 (New York and London: Garland Publishing, 1995).

Ex. 6.1 Nattiez's chronological arrangements of the semiological tripartition

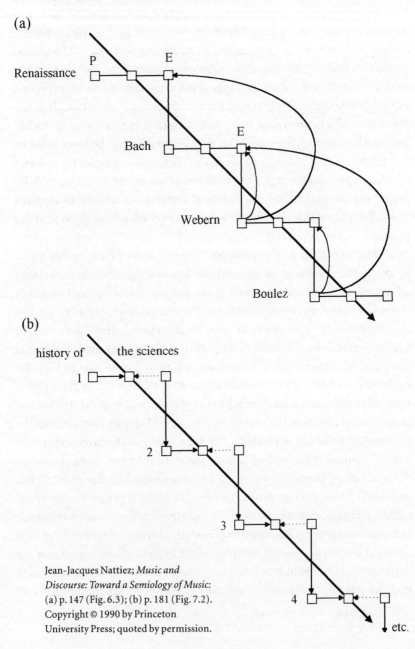

Jean-Jacques Nattiez; *Music and Discourse: Toward a Semiology of Music:* (a) p. 147 (Fig. 6.3); (b) p. 181 (Fig. 7.2). Copyright © 1990 by Princeton University Press; quoted by permission.

demonstrating the validity of a notional archetype in terms of the metatheory, such an arduous task is unnecessary: it is sufficient to be able to identify one or more common elements between a composer's or writer's notional archetype and *any* historical archetype, although clearly some notional archetypes will be judged more significant than others.[19] The alternative, in which there are no common elements, leaves the notional archetypes free to drift in a sea of relativism and, as our grandfathers taught us, 'worse things happen at sea'.

III

It will be apparent that references to the term 'elements' have re-emerged as an important part of the current discussion. These far from coincidental occurrences provide a link between Tippett's archetypes at the level of instrumental forms, and their unfolding as musical scores. For if it is possible, as Tippett has demonstrated, to apply the concept of the archetype to the symphony, the concerto and the orchestra, then logically the term can be applied to any aspect of a composition. In particular, it is possible to speak of archetypal tonal harmony, i.e. common-practice harmony; and, to a lesser extent, archetypal counterpoint – the music of Palestrina and J. S. Bach representing two overlapping but ultimately irreconcilable contrapuntal styles. By dividing tonal harmony and counterpoint into their constituent elements it becomes possible to relate these elements to essentially non-tonal works, such as Tippett's Third Piano Sonata. In order to explain the isolation of these elements it is necessary to mention just two basic ideas from the metatheory, ideas that receive additional emphasis from Tippett's brief analysis of his sonata.

These two features can be described in terms of proximity and identity relations. Proximity relations are concerned with the spatial separation of musical components, such as pitch and onset of note attack; whereas identity relations are concerned with quantifying the degree of similarity between musical components. Tippett's support for these ideas can be

19 Pascall sets out the kind of criteria that might be applied for the purposes of 'identifying and characterising specific musical genres', all of which can be applied to the study of notional and historical archetypes. See Pascall, 'Genre', 233.

gleaned from his sleeve notes to the original Paul Crossley recording of the sonata. The significance of proximity relations is revealed in the former's discussion of the duality of the hands:

> In Sonata No. 3, with its overall shape fast–slow–fast, the independence of the hands is explored chiefly in the outer fast movements and the unity in the slow middle. The sonata begins with the hands at the farthest possible distance apart, and this physical divergence of the hands to the extreme ends of the keyboard and their return jointly towards the middle became a feature many times repeated.[20]

The means by which proximity considerations lead to the isolation of tonal elements, specifically harmonic ones, will be considered later in this chapter. At a more general level the idea of two converging melodic lines – the separateness of which is determined by proximity relations – can be understood as a substitute for tonally directed motion, since convergence carries with it the possibility of continuation. Of course, the potential of such a Schoenbergian *Grundgestalt* to act in this way is extremely limited, since it is too closely associated with the musical surface. Nevertheless, in Tippett's sonata the convergence idea does exhibit some of the properties that are a feature of tonal teleology. Most notable of these is the spanning of silences to counteract the conventional formal divisions of the sonata which are given in Table 6.1 (these are considered in greater detail below). Instances of this procedure can be heard between bars 21 and 23 (Ex. 6.2). At bar 23 the b/a dyad is a continuation of the melodic convergence to c^1 and g♯ at the end of bar 21.[21] In terms of the proximity relations which are consistent with those that separated the two melodic lines in the first 21 bars, b is a continuation of c^1 because the separation of b and c^1 (an intervallic distance of a single semitone) is less than the separation of b and g♯ (a distance of three semitones). An equivalent argument pertains to the connection of g♯ with a in the left hand. Consequently, the silence at bar 22, which would otherwise have completely separated the first and second thematic groups, is bridged by logic – surely one of the shortest transitions in

20 Michael Tippett, record sleeve notes, Philips 6500 534 (1974); see also CD liner notes, CRD34301 (1985).
21 The registral designations here adopt the Helmholtz notation, where c=one octave below middle C, c^1=middle C, c^2=one octave above middle C, and so on.

Ex. 6.2 Spanning silence by pitch proximities (first movement)

(a)

(b)

Table 6.1. Formal divisions in Sonata No. 3 for Piano

Movement/Section	Bars	*Thematic elements and transpositional levels (T)* *relative to exposition (I and III) or theme (II)*
I / Exposition		
A	1–5	$a1 = a_1^1 + a_1^2 + a_1^3$
	6–10	$a2 = a_2^1 + a_2^2 + a_2^3$
	11–22	$a3 = a_3^1 + a_3^2 + a_3^3 + a_3^4$
B	23–30	b1
	31–8	b2
C	39–44	c1
	45–50	c2
	51–5	c3
D	56–62	codetta theme and retransition
I / Elaboration		
	63–71	$[a^1 + a^2]_{elab.}$ T variable
	72–9	$C_{elab.}$ "
	80–6	$D_{elab.}$ "
	87–94	$[a^3 + a^4]_{elab.}$ "
	95–111	episode —
I / Recapitulation		
A′	112–16	$a1_{recap.}$ T=0
	117–21	$a2_{recap.}$ T=0
	122–33	$[a_3^1 + a_3^2 + a_3^3]_{recap.}$ at T=0; $a_{3recap.}^4$ at T=2
B′	134–41	$b1_{recap.}$ T=2
	142–9	$b2_{recap.}$ T=2
C′	150–5	$c1_{recap.}$ T=2
	156–61	$c2_{recap.}$ T=2
	162–6	$c3_{recap.}$ T=2
D′	167–73	codetta theme and retransition T=2
	174–82	$[a^1 + a^2]_{elab.}$ T=2
	183–91	$a_3^3 + a_3^3(T=4) + a_3^3(T=8) + a_3^4(T=8)$
II		
Theme	192–210	
Variation 1	211–29	T=3
Variation 2	230–48	T=6
Variation 3	249–67	T=9
Variation 4	268–85	T=12 (i.e. T=0)
III		
A	287–352	
B	352–417	B is retrograde of A (i.e. A+B is a palindrome)
A′	418–74	A′ is a shortened form of A
Coda	475–89	

the history of the sonata allegro.[22] A similar spanning of silence links the first and second movements of the sonata, a link that supports the view that the movements are in fact sections (Tippett uses the term 'movements', but states that they are 'designed to be played as a single unbroken piece'[23]). For this second occurrence the note to which the left-hand melody converges is displaced by an octave, and so the convergence is only valid in an abstract space defined by pitch classes. The undermining of silence as a device of formal demarcation is particularly significant for Tippett since it was the use of silence in the earlier pieces of the post-*Priam* period, such as the Piano Sonata No. 2 (1962), that helped to frame the sharp contrasts between short sections, sections that were often only distantly related in terms of their musical content. In this sense, the unfolding of divergence/convergence patterns in Sonata No. 3 represents a move away from Tippett's style of the 1960s.

If the way in which the proximity relations manifest themselves in Tippett's Third Piano Sonata is relatively innovative, his application of the identity relations is decidedly conventional. The most obvious realisation of identity in this work takes the form of repetition. In common with many stylistically remote works, Tippett uses repetition as one of two principal means of establishing the relationships between form and content in the sonata, the second being that of contrast. However, before we turn to details of form, a few remarks relating to the neutral status of the proximity and identity relations are necessary.

It should be noted that the study of this sonata (or any other piece) in terms of proximity and identity, if pursued purely at the level of logic as represented by the metatheory, would produce a wide range of elements, only some of which could be related to the archetypes of tonality. Many of the non-tonal elements that could also be isolated might have some overall significance, but in most analyses a number of elements will be derived that are of little significance whatsoever. This inability of logical operations to attach value to the configurations they determine serves to emphasise the

22 For a more technical demonstration of this convergence see Borthwick, *Music Theory and Analysis*, 94–6, from which Ex. 6.2(b) has been taken.

23 Tippett, sleeve notes, Philips 6500 534. At a more general level, the independence or unity of hand positions mentioned by the composer also suggests three interdependent sections rather than three movements, i.e. a single argument spanning the whole sonata.

importance of the poietic and esthesic dimensions to the final analysis: only Tippett's belief in the necessity of historical and notional archetypes, combined with the sensitivity of most listeners to tonal elements, enable a distinction to be made between the logically potential configurations of the neutral level and those that finally have some discernible meaning.

IV

And so to the form of Piano Sonata No. 3 (Table 6.1).[24] Although the first movement is, more or less, a conventional sonata allegro, in that the divisions into what Tippett telegraphically describes as 'statement of contrasted materials – argument – restatement (decorated)'[25] are generally clear, a certain amount of ambiguity does surround the beginning of the 'argument'. Ian Kemp appears to place this juncture at bar 72, and in terms of the perception of a new section this judgement seems plausible.[26] But analysed in terms of thematic elaboration (to use Schoenberg's term)[27] and transposition, which functions as a substitute for modulation in this movement,[28] a clearer beginning to the middle section would be bar 63. In this case the codetta theme of bars 56–8 would be followed by a retransition to an elaborated, but incomplete, first subject. To ensure consistency in the interpretation of this movement, it would be necessary to understand the addition of bars 174–90 after the codetta theme and its retransition in the recapitulation as an attempt to complete the first subject that was previously truncated at bar 71. Fortunately, these problems only arise if an attempt is made to square Tippett's notional archetype of the sonata allegro with the historical archetype of Beethoven's middle-period sonatas. Since Tippett described the Third Piano Sonata as his 'late Beethoven' sonata – although suggested Beethovenian parallels have

24 Parts of this formal description concur with those of Kemp and Whittall. See Kemp, *Tippett*, 456–61, and Whittall, *The Music of Britten and Tippett*, 268–72.

25 Tippett, sleeve notes, Philips 6500 534.

26 Kemp does not give an explicit bar reference: see Kemp, *Tippett*, 459.

27 Arnold Schoenberg, *Fundamentals of Musical Composition*, ed. Gerald Strang with Leonard Stein (London: Faber & Faber, 1967), 206.

28 For a fuller discussion of this and related devices in Tippett's music see the chapter by Christopher Mark in the present volume, pp. 95–116.

included both the middle-period 'Appassionata'[29] as well as the late-period 'Hammerklavier'[30] sonatas – these difficulties should not be over-emphasised: it is enough to map out the thematic content of the work and use the results to orientate the ensuing analysis. Subsequent movements are less problematic. The second movement clearly divides into the theme and four variations described by Tippett, and the third movement is a ternary form built out of toccata ideas which necessarily resist further formal subdivisions.

V

A remarkable feature of the tonal elements that can be isolated in the first movement of the sonata is that they appear to serve a syntactical function in relation to the formal divisions of the movement. These tonal elements can be divided into the basic categories of melodic and harmonic entities. The melodic entities are based on the linear aspects of various tonal voice-leading figures – such as those derived from the neighbour note, the appoggiatura, the échappée (or escaped note), the cambiata (or changed note) and the passing note – but without reference to the harmonic consonances that support these figures in their historical-archetype forms. Melodic patterns of this kind can be referred to as poietic entities because their significance within a score depends on comparisons with historical precedents. It may not be too far-fetched to suggest that for a composer who returned to the study of counterpoint with R. O. Morris in his mid-twenties such comparisons are of special import. The harmonic entities are all drawn from the repertory of common tonal chords: principally major and minor triads, augmented and diminished triads, and triads with added sevenths.[31] Once again, the isolation of such elements in the sonata is only significant because of the poietic standing of these chords.

It is the absence of even an implied harmonic component to the voice-leading figures of Tippett's sonata that complicates the task of identifying the

29 Kemp, *Tippett*, 457. 30 Crossley, 'Tippett's Third Piano Sonata', 16.
31 A related point is also developed in connection with Tippett's *Fantasia Concertante on a Theme of Corelli* in Anthony Pople's chapter above, pp. 27–54.

precise types of linear elements present.[32] No passage in the sonata demon-
strates the kinds of ambiguities that can arise in this context better than the
first thematic group. The stems and slurs in Ex. 6.3(a) tend to conceal the
possibility that there might be other equally valid analyses, that notes defined
as structurally subordinate might in fact be the more stable ones. For reasons
I will explain later, the description of voice-leading figures in Ex. 6.3(a) is the
most valid, inasmuch as any voice-leading analysis of this sonata is justified
at all. But even at this early stage it is worth stressing that the syntactical func-
tion of these tonal elements is by stylistic allusion; they are certainly not inte-
grated into the syntax of the whole piece. Indeed, in common with the
majority of Tippett's post-*Priam* pieces, the likelihood of identifying a con-
sistent and ubiquitous syntax is extremely remote because Tippett shuns the
use of compositional systems. It is claimed that bars 1–6 of the sonata contain
four different voice-leading figures: an appoggiatura – whose rhythmic
stress is by accent rather than metrical placing (the normal tonal explanation
of this anacrusis as an incomplete passing note does not seem admissible in
this non-tonal context); an échappée; a cambiata; and a passing note. The
échappée and cambiata figures differ from their historical archetypes in that
the final note of each figure has been displaced by an octave.

Let us consider each of these four figures in turn. An alternative
reading of the appoggiatura figure has e^3 as the structural note and $f\sharp^3$ as the
subordinate one, leading to the formation of an échappée figure. No har-
monic component is available to adjudicate between these two analytical
readings, but Ian Kemp's interpretation of this first thematic group as being
in B major tends to give prominence to the F♯.[33] However, this argument
does not extend to the échappée figure that bridges bars 2 and 3. Inspection
of the recapitulation in Ex. 6.3(c) reveals a return to e^3 at the end of bar 112,
which completes the formerly incomplete neighbour note, making $f\sharp^3$ sub-
ordinate to e^3. A comparison of the échappée figure in bar 4 with its
recapitulation version in bar 115 leads to a similar conclusion. The row of

32 Some theorists have argued that the attempt to establish voice-leading analyses
in non-tonal music is fundamentally flawed: see, for instance, Joseph Straus,
'The problem of prolongation in post-tonal music', *Journal of Music Theory* 31/2
(1987), 1–21. For a counter-argument related to Tippett's Piano Sonata No. 3 see
Borthwick, *Music Theory and Analysis*, 139–42

33 Kemp, *Tippett*, 459. Note that B minor is equally possible according to a note
count of the opening bars.

Ex. 6.3: Voice-leading figures (first movement)

(a)

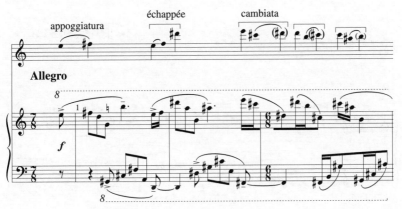

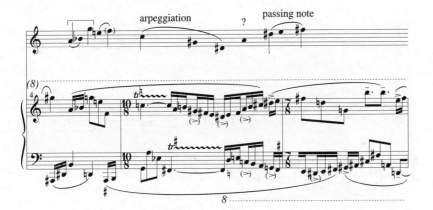

(b)

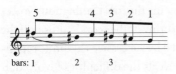

131

Ex. 6.3: (*cont.*)

(c)

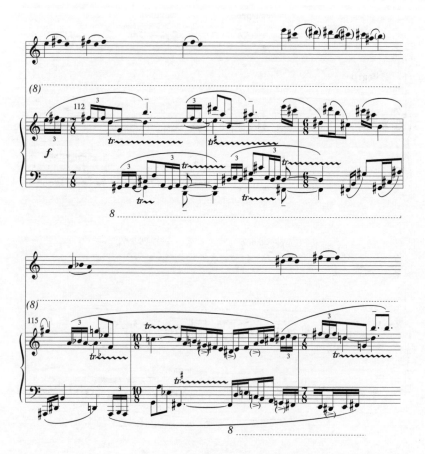

cambiata figures between bars 2 and 3 remains the most ambiguous voice-leading passage of all, even after careful scrutiny of the score – although the integrity of the figures is strongly supported by successive rhythmic repetitions. An examination of the first figure reveals the difficulties involved. If we imagine the presence of a harmonic component, purely for the sake of argument, the motion from e^4 through $c\#^4$ to $d\#^3$ could be understood as a consonant skip from e^4 to $c\#^4$ followed by an arbitrary note that happens to be $d\#^3$, acting as an anticipation at the octave of the following $d\#^4$. But this

reading fails to include all three notes as part of the same notional archetype – even the interpretation of d\sharp^3 as an anticipation breaks down at the equivalent point in the third thematic group (Ex. 6.4(a)), between the second and third appearances of the figure (bar 39). Nevertheless, the integrity of these cambiata figures receives compensatory support from their successive rhythmic repetitions, as well as from the resulting localised middleground descent from the fifth of B major (Ex. 6.3(b)).[34] The final voice-leading figure is derived from the passing note at the end of bar 5. The analytical ambiguities of this note are similar to those of the échappée figure in bar 1 since the alternative interpretation makes d\sharp^3 an appoggiatura to e$^3$. Once again, comparison with the recapitulation (Ex. 6.3(c), bar 116) reveals that d\sharp^3 is the structurally more stable note.

No equivalent analysis has been given for the left-hand melodic line since it contains few of the above voice-leading archetypes. In fact, its unfolding is permeated with the interval of a fourth – a common thread in Tippett's bass lines that reaches back as far as the Concerto for Double String Orchestra (1938–9). Towards the end of the sonata it is even possible to identify a submerged triadic progression based on rising fourths, or falling fifths (Ex. 6.7(g), bars 323–6).

The derivation of the remaining examples is uncomplicated, even if the final interpretation of the tonal elements is surprising. Briefly, in these examples the harmonic entities are isolated by considering note successions, such as the arpeggiation of tonal chords (Ex. 6.4(a), bar 38, left hand); and the spatial separation of tonal chords from their immediate contexts by proximity relations (see Ex. 6.4(a), bar 41, right hand). Certain middleground voice-leading figures are derived on the basis of identity by accentual salience (Ex. 6.3(a), bar 5) or metrical placement (Ex. 6.5). The inclusion of the middleground arpeggiation in bar 5 should not be taken as an indication of its significance in comparison with the preceding foreground figures (see below).

34 This middleground is 'localised' in the sense that it represents a passing stylistic allusion: it is not possible to derive a consistent middleground for the whole of the sonata. David Clarke has also suggested to me that these cambiata figures might be related to a descending arpeggiation of a Z' chord – an interpretation which provides a useful link with later harmonic developments in the sonata (see below), although the particular figures present in bars 2–4 still require a linear interpretation.

Ex. 6.4: Syntactical functions of voice-leading figures and tonal triads (first movement)

(a)

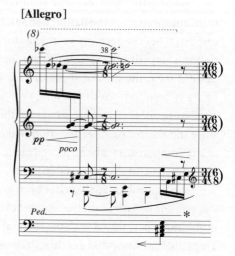

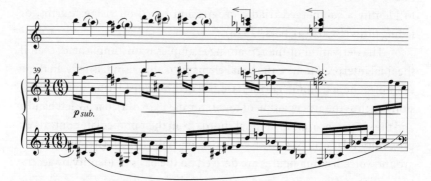

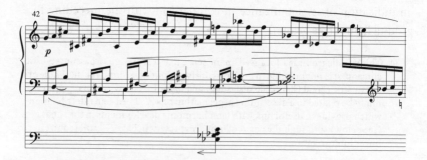

Ex. 6.4: (*cont.*)

(b)

VI

If the distribution of tonal elements in Piano Sonata No. 3 had been random then the study of them would have been futile. But each of the three movements of Tippett's sonata appears to use these elements in quite distinctive ways.

In the first movement Tippett establishes an exclusive association between voice-leading figures and phrase beginnings. This can be seen clearly in Exx. 6.3 and 6.4, although the pattern is already well established by the end of the first thematic group. (It should be recalled that the sectional repetitions in this sonata mean that these associations will be very wide-

135

Ex. 6.5: Middleground voice-leading figures (second movement)

spread.) In contrast, isolated tonal chords are associated with phrase or section endings; that is, they perform a retrospective function (indicated by the backward-pointing arrows) in which a connection is made with the preceding part of the phrase and/or the beginning of a section (marked with voice-leading figures). This association first becomes apparent at bar 38 (Ex. 6.4(a)) with the appearance of what Crossley calls 'an unexpected dominant seventh',[35] or, to use an analytically more neutral designation, an arpeggiated but sustained A[7] chord. If this chord is unexpected at first, with

35 Crossley, 'Tippett's Third Piano Sonata', 15.

hindsight its appearance is at least logically consistent: major triads with added sevenths also end phrases at bars 44 and 54 of the third thematic group (Ex. 6.4(b)). This group epitomises the use of tonal associations: phrases begin with elements of tonal voice-leading figures and end with isolated tonal chords. It could be argued that the association between tonal chords and phrase endings is foreshadowed in the first thematic group by the middleground arpeggiation through the enharmonic equivalent of an A♭ major chord (Ex. 6.3(a), bar 5), but this arpeggiation – being paired with voice-leading figures in an F major pitch space – only serves to demonstrate that such tonal elements are divorced from any sense of tonal function: they are no more than stylistic allusions that help to articulate the relationship between form and content.

The particular associations in this first movement point towards Tippett's later works: his String Quartet No. 4 (1977–8), which, as Arnold Whittall has observed, contains textural and formal similarities with Piano Sonata No. 3,[36] is framed by clearly discernible elements of voice-leading in the opening seventeen bars (up to Fig. 5) and a series of 'higher consonances' based on an A^7 chord in the very closing passage (Fig. 127ff.), as well as many similar intervening melodic/harmonic pairs.[37] At Fig. 4 the linear voice-leading elements even have the support of a tonal-harmonic component, and the connection between beginning and end is further strengthened by timbral and dynamic similarities (the alternation of tremolo *sul ponticello* with *naturale* played *piano* or *pianissimo*). Based on the evidence of the first movement of the Piano Sonata No. 3, it could be argued that the purview of Whittall's 'higher consonance' should be extended to include the domain of melody, leading to the classification of 'higher melodic consonances' derived from the historical archetypes of voice-leading. Such an extension would help to justify the distortion of historical archetypes such as the cambiata figure's octave displacement of its final note in bars 2–3 of the sonata, since higher consonances do not depend on literal tonal entities. Further support for this proposal can be found in Whittall's analysis of the theme from the last movement of Tippett's Fourth Piano Sonata (1984), which reveals that it is similarly permeated by tonal voice-leading elements and concludes with a higher consonance built on a major triad: arguably the whole theme, characterised as it is by an obvious lyricism, stands as a

36 See Whittall, *The Music of Britten and Tippett*, 270, 295.
37 The term 'higher consonance' is Whittall's: see, for example, ibid., 5.

higher consonance in relation to the variations that follow it before ending with a return to the higher consonance of the theme.[38] In this way, lyricism itself could be understood as an extended form of higher melodic consonance, an understanding that would also embrace the lyricism that delineates the five song-centred sections of *The Rose Lake*: 'The lake begins to sing', 'The lake song is echoed from the sky', 'The lake is in full song', 'The lake song leaves the sky', 'The lake sings itself to sleep.'[39] However, only substantial further study of Tippett's late works – for it is my impression that the higher melodic consonance is a feature of Tippett's late period – will confirm the value of this extension to the higher consonance idea.

The second movement of Piano Sonata No. 3 exhibits a more restrained use of the kind of tonal elements described above, although, ironically, the permeation of this movement by higher consonances produces a more immediate sense of tonal legacy. The middleground neighbour-note and arpeggiation figures shown in Ex. 6.5 (a similar instance can be found in bars 248–54), might even suggest a degree of tonal functionality, especially in the case of the neighbour-note figure which, as a linear figure, is analogously consistent with either $I–V^7–I$ or $I–IV–I$. In terms of the kind of function performed by similar tonal elements in the first movement, these figures could be said to superimpose a ternary form onto the theme and four variations, leading to a grouping of theme-plus-variation 1; variation 2; and variations 3–4. The tripartite division of this movement is coincident with the only mid-movement tempo change in the whole piece, as well as being consistent with the ternary forms of the outer movements. A second significant use of tonal elements here is the superimposition of a C triad onto a B♭ augmented triad in bar 202 (Ex. 6.6). The association of isolated tonal chords with phrase or section endings might prompt an interpretation of this bar as an endpoint, an interpretation that would be at odds with the clear endpoint of the theme at bar 210. However, the sense of a section ending at bar 202 is

38 The final movement is described as a variations set by Paul Crossley in his essay 'The Fourth Piano Sonata', in *Michael Tippett O.M.: A Celebration*, ed. Geraint Lewis (Tunbridge Wells: Baton Press, 1985), 232. See also Arnold Whittall, 'Resisting tonality: Tippett, Beethoven and the sarabande', *Music Analysis* 9/3 (1990), 274–81.

39 The use of 'song' as a means of delineating the sections of *The Rose Lake* is corroborated by Meirion Bowen in 'Songlines', chapter 4 of his *Michael Tippett*, 2nd edn (London: Robson Books, 1997), 82. Tippett's fascination with a style of lyrical heterophony might also be studied as a form of higher melodic consonance.

Ex. 6.6: Pivotal function of superimposed C and B♭ augmented triads (second movement)

[Lento]

counteracted by the increased separation of chord onsets: the duration between chord endings and chord beginnings up until this point has been a minim, but the separation of chords (by last and first onsets of attacks) in bars 200 and 201 is a dotted minim. Hence, bar 202 can be understood as a pivot at the centre of the theme (this is the tenth of 17 ± 1 chords).[40]

40 Tippett claims there are seventeen chords (see Tippett, sleeve notes, Philips 6500 534), while Kemp suggests sixteen or seventeen (see Kemp, *Tippett*, 459–60). I would argue that there are either sixteen or eighteen chords, the sixteen being the ones set out by Kemp, and the extra two in bars 207 and 208. Since Tippett claims there are seventeen chords, the logic underlying his claim, in which a harmonic entity is related to the duration of a simultaneity, forces the conclusion that there are in fact eighteen chords. In this case bar 202 is the exact mid-point.

The final movement does not use tonal elements as a means of articulating musical form, but instead invokes them as a pervasive link between seven of the movement's eight toccata ideas (see Ex. 6.7). Only idea (e) in bar 311 omits triads as an otherwise ubiquitous underlying similarity. If these triads are combined with other adjacent notes to create, for example, the $g\#^2$–b^1–e^2–a^2 group from the first four notes of the right hand in bar 287 (Ex. 6.7(a)), the presence of many of these triads can be explained by their similarity to or identity with the chord designated Z′ by David Clarke,[41] a sonority with a long lineage in Tippett's *œuvre*. This chord makes its first appearance as a simultaneity in bar 338 (Ex. 6.7(h)), but the example from bar 287, for instance, can be rearranged to give A–E–G♯–B, which is also a representative of Z′. A final manifestation occurs in the last bar of the sonata (Ex. 6.8). At this point the Z′ chord D–A–C♯–E is superimposed on an inversion of another, modified Z′ chord. Devotees and critics alike of Deryck Cooke's *The Language of Music*,[42] with its associations between words and music, might be amused to learn that two other ordered vertical segments of the Z′ chord are used in the setting of the protagonists' 'Goodbye' at the end of *The Knot Garden* (Fig. 500). So the final chord of Piano Sonata No. 3 is a fitting ending not only to the piece but also to this chapter. It only remains (continuing *The Knot Garden* connection) to raise the curtain on not-so-distant vistas of research into Tippett's music.

In his Third Piano Sonata (notably the outer sections) Tippett remembers the musical past and reconstructs it, creating a studied collage out of tonal elements, but within a conventional formal framework. This is the legacy of the techniques first employed in *King Priam*: but in the sonata it is music, rather than drama, that provides the external influences on the unfolding of the work. Subsequent pieces might be studied in order to determine the role ascribed to tonal elements (if any) as well as the way in which these elements are made to cohere rather than fragment the musical work. Does the existence of these elements in the Third Piano Sonata (and the *end* of *The Knot Garden* – the exact placing of the Z′ chord might be significant) signal a return to a diffracted form of Tippett's earlier neoclassicism (just as that neoclassicism was a diffracted form of an even earlier classical order)? Preliminary probing of Tippett's String Quartet No. 4 (see

41 See Clarke, *Language, Form, and Structure*, vol. I, 8, 81–2. Z′ refers to a favourite Tippett sonority, or higher consonance: the major triad with an added fifth below the root. 42 (Oxford: Oxford University Press, 1959).

Ex. 6.7: Permeation of toccata ideas by tonal triads (third movement)

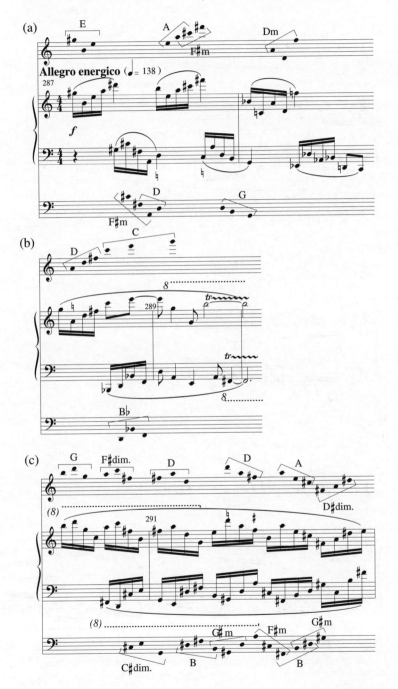

Ex. 6.7: (*cont.*)

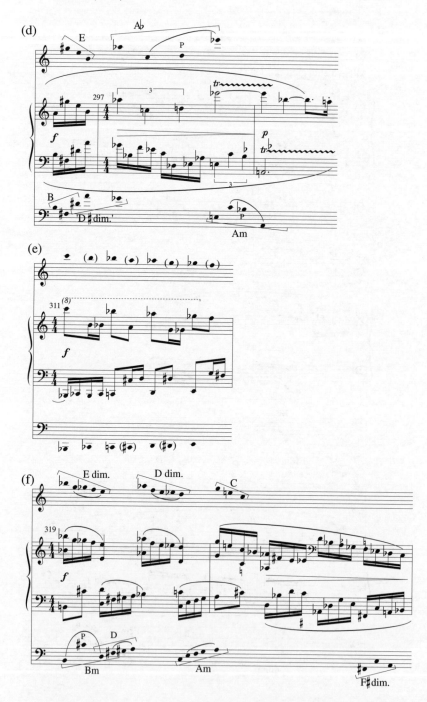

Ex. 6.7: (*cont.*)

(g)

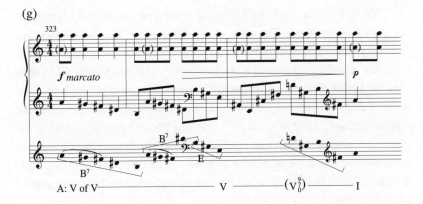

(h)

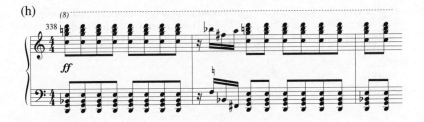

Ex. 6.8: Final chord

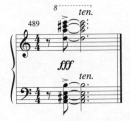

143

above) and Sonata No. 4 for Piano suggest that this might indeed be the case.[43]

My impression that the historical archetypes of voice-leading have continued to permeate Tippett's music throughout the last twenty-five years raises the further question of how important the perception of these elements is to the understanding of this music. In Piano Sonata No. 3 they have negligible esthesic significance – appearing to be little more than an ordered collection of private reminiscences. But in subsequent pieces this private, almost purely notational, world has become public: the elements can be perceived through performance alone. Precisely how this change has come about can only be decided with reference to Tippett's last works, for it is in these works that the historical and notional archetypes are most apparent to the listener.

43 For a specific discussion of Tippett's neoclassical practice see Kenneth Gloag's contribution to this volume, pp. 78–94. The chapters by Stephen Collisson (pp. 145–65) and Peter Wright (pp. 200–22) also provide oblique evidence of Tippett's return to a more classical order.

7 'Significant gestures to the past': formal processes and visionary moments in Tippett's Triple Concerto

STEPHEN COLLISSON

'Significant gestures to the past' is a phrase that has been used in summarising the retrospective qualities of the three large-scale works Tippett completed in the late 1970s: the Fourth Symphony (1976–7), Fourth String Quartet (1977–8) and Triple Concerto (1978–9).[1] These works are related not only by virtue of their chronological proximity, but also by a number of shared features, not the least of which is their adoption of cyclic formal principles. The Triple Concerto for violin, viola, cello and orchestra, being the last to be composed, assumes a uniquely retrospective position which incorporates both the immediate past (namely the other works in this trilogy) and the more remote past. Its range of retrospection is captured across various commentaries. For example, the composer himself states that in the second interlude of the concerto he 'felt impelled to quote some of the dawn music from the concluding scene of *The Midsummer Marriage*';[2] and Arnold Whittall suggests that the concerto's adoption 'of extended lyric melody ... permit[s] the clearer use of focused harmonies ... which hint at the old style of extended tonality';[3] while Meirion Bowen reminds us that after their initial cadenzas 'the three soloists ... join together to play music that is explicitly based upon the coda of the [Fourth String] [Q]uartet'.[4] The

1 The phrase comes from Arnold Whittall's *The Music of Britten and Tippett: Studies in Themes and Techniques,* 2nd edn (Cambridge: Cambridge University Press, 1990), 298.
2 Michael Tippett, 'Archetypes of concert music', in *Tippett on Music*, ed. Meirion Bowen (Oxford: Clarendon Press, 1995), 104.
3 Whittall, *The Music of Britten and Tippett*, 297.
4 Meirion Bowen, *Michael Tippett,* 1st edn (London: Robson Books, 1982 (paperback edn, 1985)), 130; see also 2nd edn (London: Robson Books, 1997), 191,198.

act of self-quotation to which Bowen alludes – an aspect of the Triple Concerto's intertextuality – involves music from the Fourth Quartet which the composer regarded as evoking the numinous, or transcendental. This concept was a recurring concern for Tippett, and just how he brings it to realisation in the concerto, and how this relates to its expression in other works, will be examined in the following account, which in an attempt to understand the significance of the concerto's 'significant gestures' will subject their formal, intertextual and transcendental aspects, as outlined above, to analytical, aesthetic and critical inquiry.

I

It was shortly after returning from a visit to Bali in 1978 that Tippett began work on the Triple Concerto. The sound of the Balinese gamelan was to have a direct influence on the work's melodies and timbral effects. In his autobiography Tippett speaks of 'the serenely flowing music of a gamelan (with singer) in the hotel lobby at Jogjakarta [which] suggested at once the kind of melodic line I wanted all three instruments to play in the slow movement. I noted its general pattern on a piece of card . . .'[5] Among his published works this was only the second of Tippett's ventures into fullblown concerto writing (the first being the Piano Concerto of 1953–5),[6] partly because he 'was not terribly in sympathy with the late Romantic confrontation of soloist and orchestra'.[7] Rather than writing in an alternative concerto style (as he had with the *Fantasia Concertante on a Theme of Corelli* in 1953) he decided that he would write for three *soloists,* thereby emphasising the contrast between the instruments instead of exploiting their potential for blend. The historical precedents for the Triple Concerto indicate, therefore, an affinity more with Brahms's Double Concerto and Mozart's Sinfonia Concertante for violin and viola, than with the most obvious choice of Beethoven's Triple Concerto, in which the soloists tend to be treated as a piano trio ensemble.

5 Michael Tippett, *Those Twentieth Century Blues: An Autobiography* (London: Hutchinson, 1991), 258.
6 The early *Fantasia on a Theme of Handel* for piano and orchestra (1939–41) is disregarded here, given that it is more a set of variations than a *bona fide* concerto. 7 Tippett, 'Archetypes of concert music', 101.

The connection Tippett makes between the Triple Concerto and its precedents raises the question of the formal consequences of using three soloists and not two. Mozart's procedure in his first movement, for example, is to employ the two soloists in an antecedent–consequent manner virtually throughout the exposition. Though Brahms follows suit to a certain extent once the exposition is under way, the manner in which he introduces and uses the soloists varies considerably from Mozart's, since the cellist and violinist interrupt the orchestral exposition with cadenza material which is later developed in the soloists' exposition proper. Brahms also often treats the two solo instruments as one, the passing of a musical idea from one to the other usually being dictated by constraints of range. Tippett, like Brahms, exposes the soloists by means of a brief cadenza for each instrument. Their starkly contrasting material, however, asserts the individuality of the three, with the result that the moment at which they first play as an ensemble (Fig. 6) is given a particularly elevated status. The profusion of ideas in these cadenzas usurps any traditional notion of principal subject or theme (unless this is (mis)understood as appearing at Fig. 6, the first point of ensemble). Tippett neither allows an extended orchestral exposition nor uses the soloists in an antecedent–consequent fashion. Their textural treatment includes a mixture of timbral exploitation in an ensemble presentation of a single idea (e.g. Fig. 16), external conflict through juxtaposition of several conflicting ideas (e.g. Fig. 28), and individualistic extended solo passages (e.g. Fig. 32).

The single-movement design of the entire work subdivides into five sections, the first, third and fifth being articulations of the historical fast–slow–fast concerto archetype, while the second and fourth sections are interludes, serving both as links and breaks in the chain of events. The role of the interludes is to transmute the image of day into night (the first interlude) and of night into dawn (the second), as well as to provide contrasts with the preceding music. Although the first, fast section is essentially a sonata-allegro movement its development section is also an extended and varied recapitulation of the exposition. With the exception of the two extended solo passages for cello and violin respectively, Tippett recapitulates much of the exposition material (Fig. 27ff.) a tone higher. The conflation of recapitulation and development – that is, the varied recapitulation of ideas in a 'foreign' tonality – introduces a degree of

instability which remains unresolved and thereby creates justification for later resolution in the finale (discussed below). The Balinese-influenced melody of the slow section acts formally as a rondo-like theme, whose texturally varied repetitions are interspersed with episodes from the soloists; its central significance to the work as a whole is reflected in this essay. The finale is regarded by many as the least successful section – indeed, Tippett made several revisions before settling on the published ending.[8] The bipartite construction of this section culminates in a recapitulation of the concerto's opening scenario, complete with the soloists' cadenza material; after which the fragmentation of the gamelan refrain from the first section (see Ex. 7.2, below) to a point near to disintegration brings the work to a close.

II

The Fourth Symphony, Fourth String Quartet and Triple Concerto are similarly conceived in that they share what Ian Kemp calls the 'cyclic archetype' as a structural basis. Tippett had previously avoided this archetype because of its associations with Romanticism – a tradition he had hitherto considered irrelevant. Kemp remarks, however, that this preoccupation with cyclicism has to do less with the composer reconciling himself to a bygone aesthetic and more with the metaphorical image that the cyclic archetype is capable of generating, that is, an image of comprehensiveness.[9] Each work is concerned with a different metaphorical cycle: Tippett himself refers to the birth-to-death cycle in the Fourth Symphony, which opens and closes with breathing, the ultimate metaphor of life. Kemp applies this concept to the Fourth String Quartet, which he

8 After the concerto's premiere the composer, in consultation with Colin Davis, revised the textural density at Fig. 138; and in the last three bars of the finale there are reductions to the textural density, which was originally similar to that immediately preceding at Fig.161. Revisions were also made to other parts of the work. The oboe and cor anglais entries in bars 2–4 were added at a later stage by the composer (following consultation with Davis and Meirion Bowen) because there was originally not enough support for the orchestral violas once the horn doubling in the first bar ends. For similar reasons the harp doubling at Fig. 22 was added after the first performance, on the recommendation of Bowen and Andrew Davis. I am grateful to Michael Tillett and Meirion Bowen for providing this information.

9 Ian Kemp, *Tippett: The Composer and his Music* (London: Eulenburg Books, 1984), 478.

Table 7.1. Formal schemes of Fourth Symphony, Fourth String Quartet and Triple Concerto

Symphony No. 4	String Quartet No. 4	Triple Concerto
EXPOSITION	FIRST MOVEMENT (slow)	FIRST MOVEMENT
Episode 1 (Fig. 21)		Interlude 1 (Fig. 67)
SLOW MOVEMENT (Fig. 62)	SECOND MOVEMENT (Fig. 15) (fast)	SLOW MOVEMENT
Episode 2 (Fig. 58)		
SCHERZO (Fig. 100)	THIRD MOVEMENT (Fig. 56) (moderately slow)	
Episode 3 (Fig. 139)		Interlude 2 (Fig. 114)
RECAPITULATION (Fig. 160)	FOURTH MOVEMENT (Fig. 81)	FINALE (Fig. 125)
+ CODA (Fig. 178)	+ RECAP. of opening material of movement 4 (Fig. 122=82) CODA=new material (Fig. 124)	+ CODA =RECAP. of opening of first movement (Fig.148)

suggests is a metaphor 'of an individual life, ending, after passion has receded, in a vision of transcendence', and to the Triple Concerto, regarded as 'a natural cycle from one day to the next'.[10] The similarity of formal and metaphorical concepts between these three works prompts the investigation of other shared features and intertextual relationships. More detailed scrutiny of the formal schemes of these works, shown in Table 7.1, reveals Tippett's experimentation with both continuity and resolution. In the Fourth Symphony each movement is linked by episodic material that is both new and yet integrated with the whole. Arnold Whittall suggests this results in an 'uneasy balance between contrast and continuity' due to the lack of 'dramatic confrontation between distinct ideas and . . . between the successive stages of the structure'.[11] None the less, the recapitulation, replacing a finale which would otherwise introduce more new material, 'demonstrates in a very simple and effective manner how the expansive the-

10 Ibid. 11 Whittall, *The Music of Britten and Tippett*, 293.

matic prodigality of the work is gradually brought under control, and the final, mediating presentation of the opening material prepared'.[12]

It is the word 'mediating' that is of particular interest here. For it suggests the notion of confrontations remaining unresolved, a lack of resolution – which is indeed Whittall's conclusion regarding the symphony's coda.[13] This passage comprises two ideas contrasting in tempo, texture, timbre and dynamics, the quieter of which gradually expands in length, while the louder contracts (Fig. 178ff.). A similar scenario can be found in the Fourth String Quartet. Here the four movements succeed one another without transitional or episodic passages; and the finale's recapitulation of its own material occurs in a position that denies it any real power to resolve in the traditional sense. The most forceful element in the last movement is the reference to Beethoven's *Grosse Fuge*, which, rather than generating a struggle that eventually resolves (as in Beethoven's case), gives way abruptly to a new theme of high harmonics leading in a different direction (compare Figs. 84 and 95). This new idea eventually transforms into the coda material, a 'vision of transcendence', as Kemp puts it, at Fig. 124. There is again in this mediating coda no sense of resolution or conciliation, only a feeling of sudden ascent to a 'higher' plane. This thread of the transcendental, together with more concrete musical associations, creates an even closer relationship between the quartet and its successor the Triple Concerto, to be discussed later in this chapter. The Triple Concerto experiments further with the cyclic archetype – seeming actively to seek resolution rather than mediation. This shift of emphasis can be attributed to a number of causes, not least of which is the control Tippett exerts over motivic material. The coherence of the motivic development creates a network of relationships which not only promotes a circumscribed recapitulation, but also reinforces the music's drive towards a conclusion.

The central motivic kernel – central both in location and in importance – is a three-note intervallic cell labelled x in Ex. 7.1(a). Pitch classes here are derived from the cell's initial utterance in the opening solo viola cadenza (Ex. 7.1(c)). It is my contention, however, that the gamelan melody,

12 Ibid.
13 See also Whittall's '*Byzantium*: Tippett, Yeats and the limitations of affinity', *Music & Letters* 74/3 (1993), 395–8; and his 'Resisting tonality: Tippett, Beethoven and the sarabande', *Music Analysis* 9/3 (1990), 283–4.

Ex. 7.1 Triple Concerto: initial presentation, and derivation of motivic kernel *x* (dynamics and expression marks omitted)

(a) Motive *x* and variant, abstracted from initial cadenzas

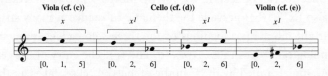

(b) Central gamelan melody as source of *x*

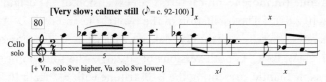

(c) Opening solo viola cadenza

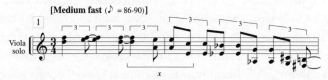

(d) Solo cello cadenza

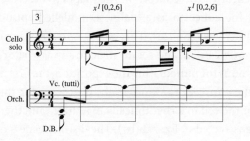

(e) Solo violin cadenza

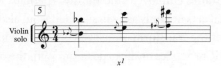

which informed the work's genesis, is both the source of this three-note cell and the focal point and fulfilment of the potential for transformation latent in its first appearances. This melody, which forms the central slow section of the concerto, can be seen in Ex. 7.1(b). Motive x and its derivatives x^1–x^5 (see also Ex. 7.3(b)) pervade the thematic substance at many structurally important moments. Openings of the three solo cadenzas are shown in chronological order in Ex. 7.1(c), (d) and (e). The entry of the cello on D and Ab, underpinned by the C in the orchestral cellos, takes up the three-note figure, the perfect fourth having expanded to a tritone, and the semitone to a tone (in more technical terms, an expansion of the original set [0,1,5] to [0,2,6]).[14] The oscillation of the two tritone intervals D–Ab and E–Bb generates two cells over the C pedal, one a transposed inversion of the other (D–C–Ab, Bb–C–E: both versions of [0,2,6]). The solo violin entry dons the same mantle, presenting the E–Bb tritone with F# (again [0,2,6]). This process of transformation is further developed in the 'second theme' (Fig. 16ff.), whose three successive appearances (Fig. 16, solo violin and cello; Fig. 18, solo viola and cello; Fig. 20, solo violin and viola) are centred around the tonalities of Bb, F and A, respectively. This large-scale reflection of the three-note cell x demonstrates a remarkable sense of motivic coherence and stability, while linear transformation of the cell occurs at a more local level in the melody itself.

In his essay 'Archetypes of concert music' Tippett describes the material of Fig. 22 of the concerto as a 'Balinese-modelled episode' or 'refrain'[15] (transcribed here as Ex. 7.2a). This passage presents a concentrated version of the motivic cell x, and serves structurally as a 'ritornello' (to use Tippett's expression) for punctuating the exposition, the first movement and eventually the entire work. Motivically, it exposes for the first time the purest form of the cell in a rhythmically repetitive (and therefore memorable) pattern (abstracted in Ex. 7.2 (b)). The distinctiveness of this material is articulated in several further ways: first, by its repetitive nature; secondly, by the orchestral timbres employed; and thirdly – perhaps most importantly – by the fact that it acts not only as a *quasi*-codetta, but also as a kind of motivic restoration of the transformations which the motivic cell has undergone in the thematic processes of the exposition. With the onset

14 For a glossary of set-theoretic terms see the Appendix to the present volume, pp. 223–4. 15 P.104.

Ex. 7.2 (a) Gamelan refrain from first movement (all instruments notated in C); (b) 'pure' form of motivic cell x and variant x^4 embedded within refrain; (c) re-emergence of x^4 in introduction to central slow section

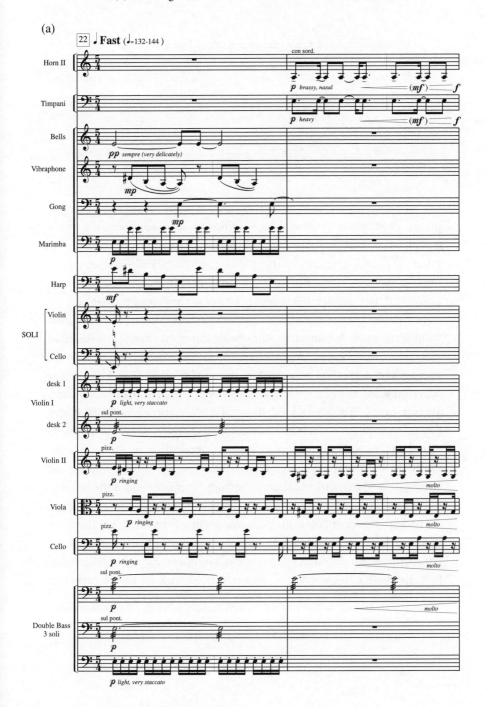

Ex. 7.2 (*cont.*)

of the development/recapitulation section there begins another meta-morphosis of this pervasive motivic element. The return of the gamelan refrain at Fig. 61 serves as a further point of structural stability and restoration for the preceding motivic transformations. By its very static nature, however, it may 'absolve' but it does not 'resolve' the preceding material.

Meirion Bowen has termed the two interludes that separate the three main sections of the concerto 'non-music', after the manner of the cine-matic 'dissolves' Tippett employed in *The Knot Garden* (1966–9).[16] In the opera, the 'dissolves' are periods of music with (as Whittall puts it) 'shifting superimpositions . . . representative of the polyphonic priorities of later Tippett in all save its lack of distinctive thematic elements'.[17] If this definition implies an athematic condition – a characterisation with which I would concur – this would make Bowen's application of the term 'non-music' to the interlude material somewhat questionable. For there are clearly defined thematic statements in both interludes and quite conven-tional ones in the case of the first. Ex. 7.3(a) shows the alto flute melody in the first interlude, with its quite clear relationship to motive *x* and therefore its integration with the work as a whole. Significantly, while the second phrase presents a different pitch content and intervallic contour from the first, its motivic/set content is closely related, and indeed is expressed

16 Bowen, *Michael Tippett*, 1st edn, 131. Interestingly, this characterisation of the interludes is withdrawn in the second edition of Bowen's monograph (cf. 2nd edn, 199). 17 Whittall, *The Music of Britten and Tippett*, 244.

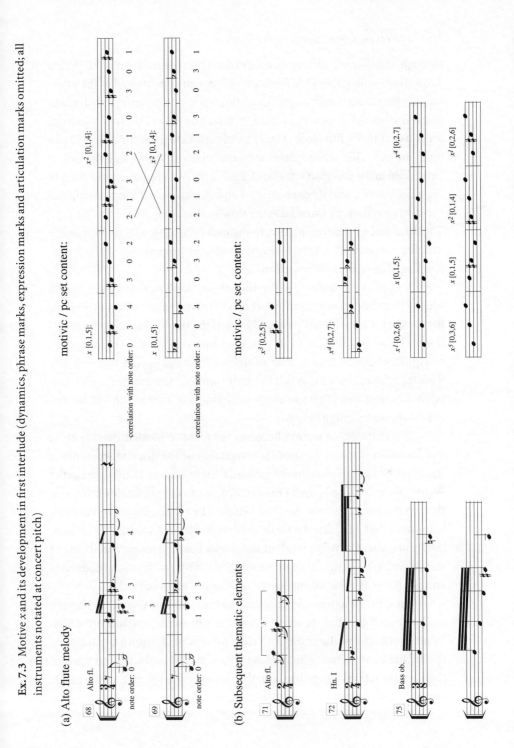

Ex. 7.3 Motive *x* and its development in first interlude (dynamics, phrase marks, expression marks and articulation marks omitted; all instruments notated at concert pitch)

(a) Alto flute melody

(b) Subsequent thematic elements

through a similar correlation of note order to the generative melody. In Ex. 7.3(b) three salient thematic elements subsequently employed in the interlude are paradigmatically aligned, and their motivic/set content analysed to reveal further development of the x motive. The first of these comes from the coda to the alto flute solo (Fig. 71), which links to the second (Fig. 72) – a horn motive. This second developmental element draws out the cell x^4 embedded in the gamelan refrain (cf. Ex. 7.2 (b)) – a kind of interlocking of the 'pure' motive and its derivatives – and in transposed form anticipates the motivic cell which introduces the slow section at Fig. 79 (cf. Ex. 7.2.(c)). The third and final development, in the bass oboe (Fig. 75), re-focuses the melodic material in a saturation of x-cells, in preparation for the outpouring of the central slow section.

A conclusion based on the immanent, analytical evidence would suggest that the dynamic motivic process in this interlude serves to form, in part at least, a transitional passage between the first and second main sections. The transformation to an 'other-worldliness' (which is more a result of Tippett's textural devices than of any attempt to dissociate the interlude from the whole) amounts in fact to a more immediate metamorphosis than might be construed from the above analysis – a feature which will be discussed at greater length below.

The central slow section becomes the focus of motivic development and its fulfilment; and the motivic integration of the discrete segments of the Triple Concerto offers greater potential for resolution than occurs in the Fourth Symphony or Fourth Quartet. The success of the finale of the concerto in this respect would seem to be elliptically acknowledged by Whittall, who states that 'initially, the finale may seem the least substantial section, but its progress towards a recall of the work's opening music and its use of that material shows that Tippett has lost none of his zest for jaundiced references to the goal-directed endings of the Great Tradition.'[18]

It is difficult to provide a convincing tonal scheme that reinforces the kind of 'goal-directed' procedure mentioned above – a fact to which Whittall attests. But the strong and clear presence of E – both as a basis for the 'higher consonance' which opens the work, and as the central pitch of the gamelan refrain – together with the almost blatantly expressed F major

18 Ibid., 297.

Ex. 7.4 Large-scale tonal connections

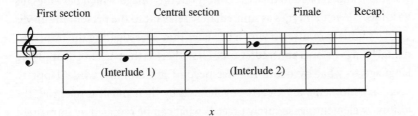

of the slow central section suggests a relationship, if not a conflict, borne out by the presence of the *x* motive. The move from the E of the initial fast section to F of the central slow section (by way of D, prominent in the first interlude) is counterbalanced by a descent from B♭ in the second interlude to the opening A-based sonority of the finale before the reprise of the E-based exposition material. These large-scale shifts, summarised in Ex. 7.4, reflect the desire for a coherence of tonal thought even if it is expressed purely in motivic terms and not by the relationships of a tonic to its subdominant and their respective Neapolitan relatives.

The process of more local motivic development thus far explained demonstrates fluctuations from stability to instability and back in a cumulative pattern (further enhanced by the abrupt change in mood in the first interlude). These can be seen to parallel events in the music whose significance is not fully revealed by the immanent analysis of formal structure and motivic processes, but instead lies in an aesthetic domain concerned with the transcendent – which in this work is also intimately bound up with the notion of intertextuality.

III

The concept of the visionary or transcendent is recurrent in Tippett's music, and is traced in Ian Kemp's life-and-works study of the composer.[19]

19 Kemp, *Tippett*. See in particular Kemp's discussion of *The Vision of Saint Augustine* (1963–5; pp. 386–401); *A Child of our Time* (pp. 87–8, 122–3, 174–9); String Quartet No. 3 (1945–6; pp. 193–7); *The Midsummer Marriage* (pp. 210–17, 236–40, 251–5, 257–8, 271); Symphony No. 4, String Quartet No. 4 and Triple Concerto (pp. 475–81).

More recently, David Clarke has investigated both Tippett's concern for the visionary, and, related to this, the concept of the 'image' which pervades his writings.[20] What emerges as immediately relevant to the present inquiry is Clarke's initial premise, in which he states that 'investigating the transcendental brings its own contradictions. First, there is the paradox of applying language to what by definition lies beyond it. Secondly, while Tippett's visionary moments are clearly engendered by their musical material, the visionary element *per se* surely exceeds what can be revealed by immanent musical analysis.'[21] Part of what Clarke seeks is a clearer understanding of the relationship between the apprehension of the 'numinous' or 'ineffable' in a musical statement and 'the technical business of what is going on between the notes'.[22] In his discussion of the opening of Sosostris's aria from Act III of *The Midsummer Marriage* (1946–52) he concludes that 'the ... attempt to bridge the gap through a metaphorical interpretation of the meaning of musical structures is a rationalisation made *a posteriori* of what appears empirically as an immediate relationship between form and feeling'. He posits alternative interpretations of this gap, settling for one in which the physical body is understood as 'a source of mediation of information and sensation'.[23] In the second of his studies, Clarke investigates the significance of the concept 'image', its relationship to Tippett's experience of Jungian psychology and its potential as an analytico-aesthetic concept for a deeper, more fruitful, understanding of Tippett's music. Among the musical instances Clarke gives is the opening figure of *The Ice Break* (1973–6), which the composer describes as a metaphor for the 'archetypal ... exhilarating sound of the ice breaking on the great northern rivers in the spring'.[24] Clarke discusses this figure, and how a subject might perceive its musical content, as follows:

> The material's harmonic and motivic profile – determinant features of its
> consciously cognized identity – are subsumed within a gesture whose
> powerful brass inception and subsequent iterated contractions seem to be
> apprehended directly in the viscera. Lower-register doublings at several

20 See David Clarke, 'Visionary images', *The Musical Times* 136, No. 1823 (January 1995), 16–21; and 'The significance of the concept "image" in Tippett's musical thought: a perspective from Jung', *Journal of the Royal Musical Association* 121/1 (1996), 82–104. 21 Clarke, 'Visionary images', 16. 22 Ibid., 17.
23 Ibid. 24 Composer's note to the vocal score.

octaves amplified by the elemental timbre of untuned percussion evoke a sublime, abysmal space – apprehended phenomenally as an inner space whose immensity is a translation of the scale of the sound, and the physical resources which generate it, in relation to the perceiving subject's body.[25]

In an earlier example, Clarke refers to Helen's aria from Tippett's second opera, *King Priam* (1958–61), outlining the musical conditions whereby the sensuous essence of the dramatic moment is manifested. He cites extremes of (melodic) range, the gradual integration of a musical idea and its timbral configuration, and individual harmonic events as becoming 'the source of a subliminal level of apprehension beyond that of their syntactic signification'.[26] In all three of the above examples, corroborating evidence for their appropriateness is furnished by the composer, either by virtue of the dramatic situations he presents (in the cases of *The Midsummer Marriage* and *King Priam*) or by a more direct written indication of his intentions (in the case of *The Ice Break*). These examples have ramifications for the present discussion of transcendence and intertextuality in the Triple Concerto.

What brings the concerto into a closer relationship with the Fourth String Quartet, is its quotation of material from the latter's coda at the point where the three soloists play together for the first time. The two excerpts are shown in Ex. 7.5. Tippett's reference to the quartet extract (Ex. 7.5(a)) as 'an overwhelming vision of lyricism and radiance'[27] clearly demonstrates his intention as to the meaning of the musical content of the passage. On an immanent level, parallels can be drawn between the quartet passage and the *Priam* example discussed by Clarke: first, there is the extreme use of register (high first violin, unusually high cello, unusually low viola); secondly, this sustained textural configuration shifts the emphasis from the musical idea itself to a more equal relationship between the idea and its timbral projection, whereby the projecting timbre becomes as significant as the idea it projects. These two features remain salient in the passage's transplantation into the Triple Concerto (Ex. 7.5(b)). The pitch content of the initial viola and cello sonorities is preserved, while the two violin parts of the quartet are adapted to form a vertical sonority more closely related to the E-based

25 Clarke, 'The significance of the concept "image"', 99. 26 Ibid., 96.
27 Tippett, 'Archetypes of concert music', 101.

Ex. 7.5 Transplantation of coda of String Quartet No. 4 into Triple Concerto

(a) String Quartet No. 4 (coda)

(b) Triple Concerto (first section): first convergence of soloists

Ex. 7.5 (*cont.*)

(c) Triple Concerto: adaptation of harmonic content to conform to new context

higher consonance that opens the concerto (see Ex. 7.5(c)). The two-bar phrase structure is maintained, as is the all-important registral spacing between viola, cello and violin. Aspects of register and timbre, then, are congruent with the quartet passage and, by implication, with the aesthetic properties found in the *Priam* example.

One question that remains, however, is how Tippett fits what was originally a final 'vision of radiance' (or transcendence, as Kemp refers to it) into the scheme envisaged for the concerto, which if anything is directed towards an apotheosis in the central slow section, and not twenty bars into the work. Part of the answer is to do with the material's location within the chronology of events. After the violent outbursts of the *Grosse Fuge* material in the final stages of the quartet the transcendent passage is as stark a recession (or even procession) to another world as the violence is a reminder of the present one. In the concerto, the three soloists have made their individual personalities known in the opening cadenzas and, although there is a sense in which common purpose might be said to supersede the individual, the tension between the three contrapuntal lines at Fig. 6 does not remain controlled for very long and begins to disperse by the fifth bar. For a further possibility that may in part account for the different sense of the visionary passage in the quartet, one can again turn to Clarke. In positing an alternative view of the concept 'image', adapting ideas from Thomas Weiskel,[28] Clarke suggests that the term might be understood 'not as the bearer of an immanent, ineffable meaning, but rather as a rhetorical device for dis-

28 See Thomas Weiskel, *The Romantic Sublime: Studies in the Structure and Psychology of Transcendence* (Baltimore and London: Johns Hopkins University Press, 1976).

rupting conventional modes of signification, for dislodging signifiers from signifieds, sending the perceiving mind into a state of disorientation in relation to its object'.[29] This approach, which construes contrast as the disruption of linear structures, is germane to the passages from the Fourth Quartet and the Triple Concerto. In the former, the contrast of violence and 'radiance' constitutes an abrupt shift which forces the listening subject to adjust his or her relative perception of the diachronic moments; in the latter, subliminal reaction to the appearance of the transplanted passage is less likely to involve the same kind of challenge to the relationship between object and mind. In the Triple Concerto, then, Tippett captures the essence of the quartet's apotheosis (its image, perhaps) but at the same time transmutes its significance, out of the necessity to allow within the large-scale structure for a later, more exalted, 'elevation' in the slow section.

The abrupt shift into the concerto's first interlude raises a similar question of subjective response. Here, again, Tippett's use of timbre casts associations which reach beyond that of the immediate context and, on another level, even beyond conscious perception – a contributory factor to the transcendental nature of the impending central section. The novel (in this work at least) timbral effect of the arching harp and marimba gesture coloured by nine solo violins, together with the use of other orchestral sonorities such as alto flute, celesta, bells and glockenspiel, generates associations with the earlier use of this sort of timbral device in *The Midsummer Marriage*, to evoke a magical, 'other' world (as at Fig. 14 of that work, for example).[30] The power to evoke the numinous in this way is not restricted to Tippett's own music – a point Ian Kemp has discussed – but speaks more of a code of shared musical understanding, the purveying of a received knowledge. The first interlude, therefore, instead of simply forming a transition between the first fast section and the slow central one, as the previous discussion of motivic process in isolation suggested, rather more immediately opens the door to a fantasy world and, through the agency of the motivic processes, sets about paving the way to its centre.

29 Clarke, 'The significance of the concept "image"', 101.
30 A similar scenario can be found at Fig. 88 of *The Mask of Time* (1980–2). Here Tippett quotes the marimba-and-violins gesture from the Triple Concerto at a point where its function would seem to suggest – as it does in the concerto – transportation, or transmutation of circumstances.

The zenith of the motivic succession towards the central slow section of the concerto is coincident with the sublime moment of Fig. 80ff.: the utterance of the gamelan melody. The immanent characteristics that mark this theme out as an expression of the transcendental can again be identified as associations of timbre and register, as well as tempo. Tippett himself linked the registral placement of the three soloists with the passage at Fig. 6 and, by implication, with the 'vision of radiance' of the Fourth Quartet.[31] Possibly the concerto's most overt manifestation of the visionary, this central passage could prompt an interplay between Clarke's corporeal and Weiskel's psychological models of investigation. Certainly subjective visceral experience that can only be rationalised *a posteriori* would seem to hold the key to an objective apprehension of this music as 'transcendent' – an experience, that is, of the shift from the extended tonality (or tonal ambiguity) of the first fast section and first interlude to the unequivocal F major of this central section. The sense of tonal release here serves a higher aspiration than resolving or absorbing tonal conflict (or indeed, presenting the culmination of a motivic process): it not only absorbs the conflict between the soloists as individuals (and diffuses their collective struggle against the orchestral forces), but also transmutes this conflict into a unification of purpose – enhanced by the soloists' unison statement (given octave transpositions) of the gamelan melody.

The subjective apprehension of such unambiguous tonal gestures asserted against a surrounding context of extended tonality will inevitably invoke historical notions of consonance and dissonance, and with these their visceral associations of tension and relaxation. An *a posteriori* rationalisation of such responses, however, involves considering the re-orientation within the perceiving subject's mind to the object in question. This amounts to a readjustment in the listener's understanding of what he or she perceives – in particular, of how this tonal statement, which constitutes a disruption of prior (extended tonal) modes of signification, might relate both to what has gone before in the music of the Triple Concerto and (perhaps more importantly) to previous tonal experiences. This is a different kind of re-orientation from that demanded by the 'radiant' music of Tippett's Fourth String Quartet. In the one case (that of the concerto) we

31 See Tippett, 'Archetypes of concert music', 102.

have a response to an unequivocal assertion of tonality which may carry connotations of the sublime; in the other case (that of the quartet) we have an experience which might be said, following Weiskel, to '[exceed] comprehension . . . to contain a residue of signifier which finds no reflected signified in our minds'.[32] An element of recognition through historical association is present in the first case, absent in the second. The presence of tonality in the former serves to enhance the listener's potential recognition of the moment as sublime: first, by being 'different' from the context within which it appears, and secondly, by forming associations with the past.

This overt manifestation of tonality in the Triple Concerto suggests an association with similar scenarios in Tippett's earlier works – for example the closing spiritual (Fig. 139$^{+4}$ff.) of *A Child of our Time* (1939–41), and the *alla pastorale* section (Fig. 78$^{+2}$ff.) following the fugue in the *Fantasia Concertante on a Theme by Corelli* (1953). Such passages can be apprehended as presenting visionary moments beyond the expression of their respective contexts. In truth, the tonal stability of the episodic passages of the fugue in the *Fantasia Concertante*, which is quite literally removed by Tippett's decorative procedures, is restored with the final entries of the fugue subject (Fig. 73ff.), albeit in a different key from that of the outset; but in the absence of closure the harmonic momentum is carried forward to the *alla pastorale* section. Further to this, the eclipse of the implied harmonic goal of D (at Figs. 77 and 78) with an eventual shift to V then I of F (following Fig. 79$^{-1}$) marks an abrupt step into another realm, as it were: the tonal stability of F major at this point is as unequivocal as it is in the Triple Concerto. Another dimension to the relationship between these two pieces emerges from the comparison of the introduction to, and treatment of, the solo (or concertino) group. The 'transcendent' moments in both works are preceded by brief orchestral introductions, lasting three bars in the case of the Triple Concerto and one bar in the *Fantasia Concertante*. Each comprises repetitive figuration echoing, if not entirely comparable with, the kind of cyclic treatment of musical elements accompanying the visionary moment in Sosostris's aria at Fig. 387ff. of *The Midsummer Marriage*. Texturally, the two introductions are also similar: a decorated motivic fragment occurring against a harmonically static back-

32 Weiskel, *The Romantic Sublime*, 23–4; quoted in Clarke, 'The significance of the concept "image"', 101.

drop. This backdrop overlaps with the entry of the soloists: imitative, in the case of the *Corelli Fantasia*, and unison in the Triple Concerto. Finally, the solo groups themselves share a common purpose in the articulation of melodic content over the surrounding harmonic stasis. The existence, then, of such distinctive common elements reveals (or at least suggests) significant gestures to a past more distant than that created by the formal and intertextual relationships between the three works of the late 1970s.

The Triple Concerto occupies a peculiar, if not singular, position in Tippett's *œuvre*. On an immanent level, formal features and processes suggest a preoccupation with the cyclic archetype linking the concerto to its immediate predecessors, the Fourth String Quartet and Fourth Symphony – a link further enhanced by the quotation from the Fourth Quartet; while a similarly intertextual gesture invokes the much earlier *Midsummer Marriage*. On another, less tangible, level – that of the transcendent – the network of relationships broadens to include other works from Tippett's earlier and later periods, namely, *A Child of Our Time*, the *Fantasia Concertante on a Theme of Corelli*, and *The Mask of Time*. The common structural and aesthetic traits manifested here suggest that these were in some way 'absorbed' by Tippett into a particular vocabulary, a set of personal *topoi* for the revelation of specifically visionary moments. Such a vocabulary, while presenting itself only in part to the listener to the Triple Concerto, can be more fully understood within the broader context of Tippett's *œuvre*, to which his significant gestures to the past (both overtly stated and covertly implied) do undoubtedly attest.

8 Tippett's *King Priam* and 'the tragic vision'

ROWENA POLLARD AND DAVID CLARKE

I

King Priam represents the culmination of a project which, like many of Tippett's artistic ventures, had a long genesis. As early as 1953, in the immediate wake of *The Midsummer Marriage* (1946–52), the composer can be seen ruminating in his essay 'Drum, flute and zither' on the twin themes of tragedy and transcendence.[1] *King Priam* (1958–61) was eventually born from a conviction that these notions could once again be made into an authentic experience in the modern-day theatre. The realisation of such an ambitious proposition, however, would depend on two factors in particular: an aesthetic conception which would underwrite the contemporary legitimacy of the tragic principles employed, and the practical ability to execute that conception in operatic, that is, musico-dramatic terms. It is the intention of the present study to investigate Tippett's strategies on both these fronts, and that investigation will need to reflect the different kinds of thought processes represented by each. Accordingly, what follows will involve both an examination of key textual sources which informed the opera's dramatic conception, and an investigation of technical procedures applied in the music. While the discursive tenor of each of these inquiries must necessarily be different, these should be seen as complementary perspectives on the same set of issues, which ought ultimately to add up to more than the sum of the separate parts.

'Drum, flute and zither' and various other writings by Tippett provide important evidence that the compositional process of *King Priam* was informed by a significant level of intellectual reflection. Especially pertinent in these texts is the fact that while Tippett was clearly attracted by the

1 In *Moving into Aquarius,* 2nd edn (St Albans: Paladin Books, 1974), 67–84; '*The Midsummer Marriage*', in *Tippett on Music,* ed. Meirion Bowen (Oxford: Clarendon Press, 1995), 185–98.

putatively universal features of tragedy, he was also sensitive to the issues thrown up by the different cultural contexts at each stage of the genre's history. Among the tragedies he mentions are representatives of three different dramatic traditions: ancient Greek (such as *Oedipus* and *Hippolytus*), classical French (such as *Phèdre*) and English (*King Lear*). While *King Priam* bears traits of all three of these types, two features in particular, one deriving from Greek tragedy and one from French, make their mark. The first is the emotional effect which Greek tragedy sought to work upon its audience, and which Tippett believed could be recreated in a modern context: his 'positive conviction that the pity and the terror, and the exaltation strangely intermixed with these, which we feel in the theatre before the great tragic spectacles of the past, are both possible and appropriate as a spectacle of the present'.[2] The second feature is an attribute of Racinian tragedy, or at least a reading of it advanced by the theorist Lucien Goldmann, paraphrased by Ian Kemp as the process whereby 'a tragic figure, gripped by and accepting the consequences of some supreme passion or commitment and entirely withdrawn from the normal standards of life, would eventually enter a state of mind which was god-like, absolute'.[3] Together these two notions determine much of *King Priam*: the selection and structure of incidents, the emphasis on certain themes (such as that of human choice), characterisation and, not least, the music.

The exact texts in which these key ideas have their roots are respectively the *Poetics* of Aristotle, and Goldmann's *Le dieu caché*.[4] For example, when in the final act of *King Priam* Hermes addresses the audience with the line 'Oh but feel the pity and terror as Priam dies', this is a direct reference to the *Poetics*, in which Aristotle cites pity and fear as the emotions which are special to tragedy – its 'proper pleasure'. These emotions, Aristotle tells us,

2 Michael Tippett, 'The resonance of Troy: essays and commentaries on *King Priam*', in *Music of the Angels: Essays and Sketchbooks*, ed. Meirion Bowen (London: Eulenburg Books, 1980), 226; *Tippett on Music*, 212.

3 Ian Kemp, *Tippett: The Composer and his Music* (London: Eulenburg Books, 1984), 355.

4 Lucien Goldmann, *Le dieu caché: Étude sur la vision tragique dans les* Pensées *de Pascal et dans le théâtre de Racine* (Paris: Gallimard, 1955). Quotations below are from the English version of the text, *The Hidden God: A Study of Tragic Vision in the* Pensées *of Pascal and the Tragedies of Racine*, trans. Philip Thody (London: Routledge and Kegan Paul, 1964). Tippett would have read the volume in the original French.

should be the result of a complex plot-structure and certain tendencies in characterisation. He asserts, 'it is not every pleasure, but the appropriate one, which should be sought from tragedy. And since the poet ought to provide the pleasure which derives from pity and fear by means of mimesis, it is evident that this ought to be embodied in the events of the plot.'[5] Tippett evidently believed that the tragic emotions should not only be engendered but also function in an Aristotelian manner; that is, they should generate *katharsis*. This standpoint is implicit in a letter he wrote in 1958 to Colin Franklin (one of several parties with whom he discussed his ideas for *King Priam*) in which he states: 'Achilles makes ½ the right choice; but Patroclus is killed. From that comes Hector's death & Priam's going to ground. From going to ground in the fundamental sense that Lear or Oedipus goes to ground, there comes the *purgative* tragedy.'[6] While purgation is a somewhat old-fashioned notion of the way in which *katharsis* works or the effect it is meant to have, Tippett demonstrates an understanding of the term closer to that of current scholarship when he states in his essay 'The resonance of Troy': 'I am unrepentantly certain . . . that when audiences will see Priam's death at the altar as Troy burns, they will feel the old pity and terror and be *uplifted* by it.'[7]

If the emotional response (and the rationale behind it) that Tippett courts in *King Priam* is overtly Aristotelian, the image through which he releases it, that of tragic man cut off from the rest of the world, owes much to Goldmann's interpretation of Racine. In other words, these two principal tragic conceptions exist in a means/end relationship. That said, however, the subtleties of the overall matrix of relationships between the four figures concerned – Tippett, Aristotle, Racine and Goldmann – should not be over-

5 Stephen Halliwell (trans.), *The Poetics of Aristotle: Translation and Commentary* (Chapel Hill: University of North Carolina Press, 1987), 45–6.

6 British Library, Add. MS 69422B, fols. 15v–16r (original emphasis). This is one of a series of letters enclosed with manuscript and other material used for the first edition of *Moving into Aquarius* (1959); Franklin was Tippett's main contact at Routledge and Kegan Paul, who published the volume.

7 In *Music of the Angels*, 223 (emphasis added); *Tippett on Music*, 210 (text slightly modified). *Katharsis* is the subject which has provoked more debate than any other in Aristotle's output. In more recent scholarship the notions of purgation and purification as explanations for *katharsis* have been replaced by a trend of thought which holds that emotions are not expunged but are simply restored to a harmonious equilibrium. See, for example, Stephen Halliwell, *Aristotle's Poetics* (London: Gerald Duckworth, 1986), especially pp. 198–201 and appendix 5.

looked. For example, Tippett's source of information about Aristotle seems to have been the prefaces to Racine's tragedies (he admitted to not having read the *Poetics* at first hand[8]). But, as already stated, his reading of Racine is in turn mediated – at least in part – by Goldmann's *Le dieu caché*. Goldmann's significant position in relation to *King Priam* is accordingly brought to the fore in what follows, in order to demonstrate his crystallising role in the work's chemistry of influences.

II

Tippett read *Le dieu caché* in 1956, a year after its publication. Its importance for *King Priam* is evident from the composer's own remarks: 'Goldmann, through his acute analysis of tragedy in Racine's work, determined the tragic nature of my new opera *King Priam*', he writes, going on to claim 'Goldmann . . . brought me to Racine.'[9] Kemp, however, suggests that while Goldmann may have determined the tragic nature of *King Priam*, he 'was not responsible for the philosophy behind it'.[10] As Kemp sees it, the opera is not based on Goldmann's (Marxian) beliefs, but, rather, refutes them: while Goldmann believed tragedy no longer to be possible in a world that was either Christian or Marxist – both optimistic philosophies – for Tippett tragedy was still viable and rewarding.

That tragedy is no longer viable may have been Goldmann's central thesis, but he never states this explicitly in *Le dieu caché*.[11] As far as one par-

8 In a public interview held at the Newcastle Tippett Festival, 30 July 1995. For further discussion of Racine as a secondary source for the *Poetics* see Rowena Pollard, 'From ancient epic to twentieth-century opera: the reinvention of Greek tragedy in Tippett's *King Priam*', M.Litt. thesis (University of Newcastle upon Tyne, 1995), 67–9.

9 Tippett, 'The resonance of Troy', in *Music of the Angels*, 223; *Tippett on Music*, 209, 210 (text modified). Tippett, however, was no stranger to Racine, as is evidenced by 'Drum, flute and zither', written three years before he read Goldmann. 10 Kemp, *Tippett*, 355.

11 He does, however, frequently highlight the differences between tragic vision and both Marxism and Christianity; for example: 'Each of these three doctrines – rationalism, hedonism, the tragic vision – is basically individualistic, the third even more so than the others, since it defines man in terms of his absolute but impossible demand for transcendence . . . Other doctrines, whether that of Augustinian Christianity or that of dialectical materialism, change the very position of the problem by replacing the question What ought I to do? by the essentially different one of How ought I to live?' (Goldmann, *The Hidden God*, 263–4).

ticular aspect of *King Priam*'s aesthetic is concerned, namely the *absolute* nature of tragedy, one can go further and say that this at least was clearly determined by him. Although Kemp claims that this idea was one (among several) that Goldmann simply clarified,[12] there are two reasons why this is unlikely to be the case: first, mention of the idea does not appear in Tippett's writings until after his reading of Goldmann; secondly, it corresponds so accurately to the conception of tragedy described in *Le dieu caché* that it can hardly have come first. Tippett writes:

> Important for *King Priam* is the Racinian concept of tragedy as being absolute. In each of the Racine tragedies there is always some point when the tragic protagonist accepts, willingly or unwillingly, his or her tragic destiny, and with it the absolute necessity of a certain conduct, which because of its uncompromising *absolute* quality, must finally end in death. And, following from this, since the *absolute* qualities of the tragic destiny and ensuing conduct are refused by the rest of us, who make up the ordinary matter-of-fact world, the tragic protagonist acting out his destiny from this absolute source, is incomprehensible to those around him. No real understanding or communication is possible because *a fortiori* the sense of the tragic destiny is by its nature inexpressible.[13]

In this single paragraph Tippett sums up the essential points of what Goldmann terms 'the tragic vision', a world-view which prevailed in mid seventeenth-century France and which is equated with Jansenist movement.[14] The first point of contact between Tippett and Goldmann, then, is the absolute nature of the tragic protagonist's acceptance of destiny, about which the latter writes:

> There are two essential characteristics of tragic man which should be noted if we are to see him as a coherent human reality: the first is that he makes this

12 Kemp, *Tippett*, 355.
13 Tippett, 'The resonance of Troy', 226; *Tippett on Music*, 212 (punctuation slightly modified).
14 In chapter 6 of *The Hidden God* (pp. 103–41) Goldmann describes the social and political upheavals during the reigns of Louis XIII and XIV against which the legal professions, deprived of their status and influence, reacted – either actively or by withdrawing from society, thereby following an important Jansenist ideal. Another significant feature of Jansenism is an indifference towards the mysticism which can lead to a 'total identification with God' (ibid., 148). The isolation of the individual in the wake of his refusal of the world is in Goldmann's view definitive for 'the tragic vision'.

absolute and exclusive demand for impossible values; and the second is that, as a result of this, his demand is for 'all or nothing', and he is totally indifferent to degrees and approximations, and to any concept containing the idea of relativity.[15]

Goldmann states that man enters the tragic universe when he 'suddenly becomes aware, by a movement which, strictly speaking, is outside time, of the contradiction between the imperfect values of man and the world and the perfection of those to be found in God'.[16] Other ways out, such as trying to achieve perfect values in the world (the rationalist approach) or taking refuge from the world (the romantic approach), have to be rejected, 'for tragedy believes neither that the world can be changed and authentic values realised within the framework it provides nor that it can simply be left behind while man seeks refuge in the city of God'.[17] Tragic man has to live in the world in order to refuse acknowledgement of it:

> For if we refuse the world absolutely and unilaterally, then we deprive it of any possible meaning, and reduce it to the level of an abstract anonymous obstacle, without form or qualities. Only an attitude which places itself within the world in order to refuse the world can, without abandoning anything of the absolute character of this refusal, still allow tragic man to know the world on which he passes judgement and thus justify his refusal of it by keeping his reasons for doing so constantly in mind.[18]

Having entered the tragic universe, man is alone. He cannot communicate with ordinary men because his values separate him from the community. In Goldmann's words: 'if there were a single human being in the world who could understand the words of tragic man and reply to them, then there would be a possible human community in the world, tragedy would be transcended'.[19] Instead tragic man has to express himself through monologues, or 'solitary dialogues', that is, speaking to a God who does not reply.[20] The God of the tragic vision is always both absent and present – in other words, hidden. As a result he 'bring[s] man no help from outside...he offers man no guarantee of the validity of his own strength and powers of reasoning'.[21] God is hidden because 'at the very moment that [he] appears

15 Goldmann, *The Hidden God*, 63. 16 Ibid., 64. 17 Ibid., 50.
18 Ibid., 52. 19 Ibid., 69.
20 Ibid., 68. Goldmann borrows the term from Georg Lukács. 21 Ibid., 38.

to man, then man ceases to be tragic. To see and hear God is to go beyond tragedy.'[22]

It should be clear that this framework corresponds closely to the situation in which King Priam is depicted in Tippett's opera. In the final stages of the work Priam's alienation from the world is all but complete – an alienation which arises from the contradiction between an unmitigated apprehension of the world's imperfections, and the simultaneous realisation of some higher order of values (which one might equate with a God-term) which can neither be manifested in nor communicated to the world. Tippett also follows the tragic precept described by Goldmann[23] that this absolute schism arises at a particular moment of conversion: in the opera this comes when Priam sings, 'I do not want these deaths. I want my own' (Act III scene 2), and issues from his 'solitary dialogue' ('a final confrontation of himself'[24]) after the news of Hector's death. From here onwards, Tippett tells us, Priam has only one concern: 'his own death as the tragic hero'.[25] And from this moment Priam enters what Goldmann terms 'the tragic universe', from which he is no longer able to communicate with the world; as Hermes tells us, 'He will speak only to Helen in the end.'

Goldmann's investigation of the historical context of the tragic vision offers a further interpretative insight into the characterisation of Priam. Goldmann describes two positions within the framework of the tragic vision, which he terms 'dramatic centralism' and 'tragic extremism'.[26] The former position, held by Antoine Arnauld (1612–94), the leading theologian of moderate Jansenism, is less relevant here: Arnauld believed that there was no necessary contradiction between life and society, that reason was still valid and that man's task could still be in the world. The latter position, held by Arnauld's nephew, Martin de Barcos (1600–78), who believed that man had no task in the world, that active opposition was pointless, and that no trust could be placed in reason, has more significant parallels with the portrayal of Priam – notwithstanding the translation from the original Christian context.[27] As Tippett says of his character, 'the father and King has

22 Ibid., 37. 23 See ibid., 64–6.
24 Tippett, 'The resonance of Troy', 229; *Tippett on Music*, 215.
25 Ibid. 26 See Goldmann, *The Hidden God*, 148.
27 For example, Goldmann writes: 'both Arnauld and Nicole (1625–95) neither recommend the Christian to refuse the exercises of political authority nor try to stand apart from it themselves, but ... they do genuinely argue in favour of the application of moral principles to social and political life' (ibid., 153–4). By

already passed into a world of values in which the parity concerns of vengeance . . . are meaningless'.[28]

III

These various factors point to the final scene of *King Priam* (Act III scene 4) as a focus for an inquiry into how Tippett translates tragedy into an operatic conception. For it is here that Goldmann's formulation of the tragic vision is most fully in evidence: Tippett concentrates on the idea of the tragic hero withdrawn from the normal realm of existence, and grants his protagonist an experience before his death that is indeed visionary. It is self-evident that if Tippett has successfully negotiated the passage from a purely theatrical conception of tragedy to a musico-dramatic one, the workings of the musical material itself require close investigation. This entails not only a shift to a different kind of discursive language, but also careful interpretative framing of music's role, or roles, in the proceedings. For example, while Kemp's assertion that the music 'becomes the means by which the tragedy can, in some sense, become uplifting' is undeniable, his claim that Tippett's tactic in the final scene is to 'trade on the audience's impending sense of absolute and uncontrollable tragedy by quietly shifting the focus from the character, about whom nothing can be done, to the music' calls for qualification.[29] It is true that as the scene approaches its climax the depiction of Priam must increasingly contend against other accumulating musical forces, but if anything this serves to reinforce his

contrast Barcos is 'reluctant to deal in a general manner with the problem of the State, because he is afraid of slipping into an attitude which is foreign to him, that of active opposition. In his view the true Christian, withdrawn into solitude, knows nothing of the State and of the world, and speaks of them only when compelled to do so' (ibid., 156).

Goldmann likewise compares the attitude of the two parties towards reason. On the one hand Arnauld's position is described as 'quite close to that of Descartes' (ibid., 158), since the latter (in his own words) makes 'rules which we should bear in mind while seeking the truth' (ibid.). On the other hand, Barcos is quoted writing in 1652 to Mother Angélique (who began the reforms in 1608 which led to Port-Royal becoming the centre of the movement): 'I like both the matter and the style of your letter, for the ease with which you allow your mind to wander from the laws of human reason, placing no other limits upon it but those of charity, which has no limits when it is perfect and yet too many when it is weak' (ibid., 159).

28 Michael Tippett, 'At work on *King Priam*', *The Score* No. 28 (January 1961), 67.
29 Kemp, *Tippett*, 370, 369–70.

presence as a character – as tragic hero – rather than shift attention away from it. In fact it will be argued that the musical situation here delineates tragic man's radical separation from his surrounding world in a way that is remarkably consistent with Goldmann.

Two essential musical forces are at work in the last scene. The first is dynamic, and has to do with the accumulating dramatic momentum as the events of the plot lead to their final *telos*: Priam's death and the fall of Troy. Interpreted according to Goldmann's scheme, these events belong to the world; they are the outcome of decisions made by individuals in the struggle with life's contingencies, in particular the fatal choices made by Priam and Paris in the opera's first two scenes. Uppermost within this teleological musical tendency is a staged process of recapitulation. This could be understood to begin in Act III scene 2 (Fig. 446ff.), where Priam re-lives his earlier choices as he approaches the moment of absolute decision at which he wishes his own death. The process takes a firmer hold in the last scene with the appearance of all the still-living characters (Paris, Hecuba, Andromache and Helen) that brings with it their associated music (Fig. 554ff.); in part this is an act of remembering, a compression of key musical and dramatic gestures into the opera's closing minutes. The ultimate stage in the process is the recapitulation of the work's opening fanfares at Fig. 592ff., signalling closure and the imminent fulfilment of the prophecy made in the very first scene.

The second musical force has to do with temporal stasis: moments which suspend or resist the dramatic action impelled by the teleological musical material described above. As Tippett tells us in 'Drum, flute and zither', such suspensions are a necessary condition for portraying the transcendental.[30] He uses them in *King Priam* as a means to convey the world into which the eponymous hero has entered – in Goldmann's parlance, the tragic universe. Apposite in this respect is the music which accompanies Priam as he prays at the altar, first heard at Fig. 568. The king is preparing to die: 'He already breathes an air as from another planet', as Hermes (paraphrasing Stefan George's *Entrückung*) puts it in the preceding interlude. Hecuba, Andromache and Helen come to speak with him in turn, but only Helen is admitted. His reply to Hecuba and Andromache, 'I cannot see her', and his valediction to Paris elicit an eerie music for tuba, contrabassoon

30 See, for example, *Moving into Aquarius*, 82–4; *Tippett on Music*, 197–8.

and bass clarinet (Ex. 8.2) which reflects his altered state. Except for a possible resemblance to the melody of his earlier monologue, 'A father and a King', this music differs in every way from material we have come to associate with Priam. The uncanny sound of an ensemble of low wind instruments whose more conventional role would be to double lines played by their family relatives is one such difference; their timbre aligns Priam with the visionary figure of the Old Man who prophesies his death.[31]

A comparison with Priam's earlier music is called for in order to convey the full measure of its difference from that of the final scene. Ex. 8.1(a) quotes the beginning of the music that marks the king's first entrance at Fig. 17. Tippett calls this theme 'Priam's strength', a description vindicated by the firm, march-like crotchet pulse and percussive and clear instrumentation for horns and piano. On each appearance this music characteristically begins by asserting the diatonic major, usually D major, as here. Despite the chordal nature of the accompanying texture, the harmonic vocabulary is not based on the triad. Instead Tippett draws from the complete diatonic spectrum of the prevailing tonal centre – a kind of pandiatonicism. Even so, the vertical configurations are subject to constraints, as the analysis beneath Ex. 8.1(a) indicates. Using Allen Forte's nomenclature,[32] the analysis interprets the verticals as unordered pitch class sets, certain of which can be seen to be recurrent. Among these are sets 3-4, 4-10, 4-14 and 4-23 – of which 4-14 joins 4-22 as the preponderant sets of the remaining, unquoted portion of the passage. Particularly significant is the fact that most of the sets in this example are contained within the larger set 6-32, and their complements contain that of 6-32. Stated more technically, these sets form a complex around the nexus set 6-32; in Forte's terminological shorthand they are Kh-related.

Ex. 8.1(b) cites 6-32 in the transposition most frequently invoked by the passage under consideration. The set is essentially the diatonic major hexachord, and the few sets in Ex. 8.1(a) not Kh-related to it, indicated in

31 In fact the Old Man's version of this material, for bass clarinet, bassoon and contrabassoon (see Fig. 26ff.), reappears momentarily and ominously in Priam's monologue in Act I scene 2 (see Figs. 108$^{+4}$, and 110$^{+4}$), but at this stage its connection with Priam is as an 'external' omen of the prophecy working its fatal course.

32 Allen Forte, *The Structure of Atonal Music* (New Haven and London: Yale University Press, 1973). For a glossary of terms used in Forte's pitch-class set theory see the Appendix to the present volume, pp. 223–4.

Ex. 8.1 'Priam's strength' (Act I scene 1)

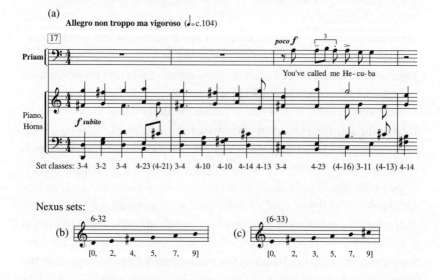

Nexus sets:

parenthesis, instead belong to a subcomplex about its close relative, 6-33, the Dorian minor hexachord, quoted in Ex. 8.1(c).[33] The salient difference between the two hexachords is the presence of a tritone within 6-33, which has a destabilising potential. As the opera proceeds this difference becomes amplified and extended in musical ideas associated with Priam. Although it would be overly simplistic to claim a precise symbolic homology between sets and dramatic situations, there does seem to be a broad correlation between set complexes and the soundworlds representing Priam's changing psychological states. For example, much of the music accompanying his Act I monologues, conveying images of confidence and compassion, contains a preponderance of sets belonging to the diatonically stable subcomplex about 6-32.[34] Subsequently, with the onslaught of the war with the Greeks, Priam's soundworld begins to move away from this nexus towards one dominated by a subcomplex about the less stable nexus, 6-33, and then

33 Many sets in the extract in fact belong to both Kh complexes, but in order to maintain a manageable number of variables these additional connections have not been shown.

34 For a more detailed account see Pollard, 'From ancient epic to twentieth-century opera', 109–12.

beyond into a realm of increasingly amorphous chromaticism, as the king approaches mental breakdown in the final act.[35]

Returning to the final scene of the opera, it can now be seen just how far Priam's music is removed from what has preceded. If the music characterising Priam's assured engagement with the world ('Priam's strength') draws from the diatonic nexus set 6-32, that portraying his withdrawal into the tragic universe does so by repressing 6-32 in favour of an altogether more ambiguous nexus. Also starkly contrastive is the texture of these two musics. While the first is homophonic and purposeful, the second is linear and kaleidoscopic, with a corresponding shift in the distribution of salient sets from the vertical to the horizontal dimension. Ex. 8.2 illustrates the features of the latter music in detail. Not least important is the quasi-canonic imitation between the instruments in increasing rhythmic diminution. Equally pertinent is the quasi-symmetrical profile: the final eight pcs of the tuba line form an exact retrograde of the pitch series of its opening motif, x, the set 7-25; and a similar, though less exact retrograde is implemented at the close of the contrabassoon line.

While the series x in the tuba is exactly imitated by the bass clarinet two bars later, the intermediate contrabassoon entry takes a slightly different course, substituting E♭ for the tuba's B♭ at the end of the series (the two pitches in fact coincide vertically as a result of the imitation in rhythmic diminution). These two versions of the headmotif yield two closely related sets, 7-25 and 7-32 (their relationship may be formally designated R_p), which together with their aggregate 8-26 form a complex that assumes a primary status within the passage, influencing various of the succeeding pitch configurations. For example, the ensuing sets 4-6, 4-4, 7-27 and 5-29, shown in Ex. 8.2, are variously connected with the primary complex through some form of inclusion relationship – either Kh, or the less restrictive K – to form a secondary complex that prolongs the soundworld of the primary complex, as shown in Table 8.1.[36] (As this matrix also shows, this second crop of sets manifests a further, tertiary complex of its own.)

35 See ibid., 112–21.

36 The designation (s) in this table denotes that the inclusion or similarity relationships are strongly represented; that is, they obtain directly between invariant pcs of the sets in question, rather than necessitating any mediating principle of tranposition.

Ex. 8.2 Priam's 'tragic universe' music (*King Priam*, Act III scene 4)

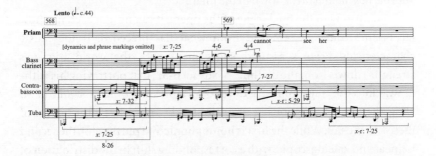

What characterises the members of the primary complex is their increased incidence of semitones and tritones in comparison with the earlier 6-32 nexus set. In particular the tritone A♭–D functions as a clear marker of Priam's transfigured state[37] (it will continue to do so in his later exchanges with Helen); and the fact that neither 7-25 nor 7-32 is Kh-related to 6-32 reinforces further the distinctiveness of the soundworld of Priam's tragic vision. That said, the new sets are not completely devoid of diatonic implications: 7-25 is Kh-related to 6-33, while the aggregate set 8-26 includes both 6-32 and 6-33 in its Kh subcomplex. But the point is not that such connections are completely expunged, rather that they occupy a position that is subservient to the primary complex. For instance, Ex. 8.3(a) reveals certain implicit diatonic collections in the centre of the passage, which are representatives of either 6-32 itself or sets Kh-related to it. However, when considered in the slightly larger vertical or linear context into which they are embedded, most of these sets can be shown to be governed, either directly or at one remove, by the primary subcomplex. This can be seen in Ex. 8.3(b) and Table 8.2, where 7-27, represented twice, is Kh-related to 8-26; 7-23 is R_p related to 7-25; and 7-23 is related at one remove to 8-26 by dint of its R_2R_p relation to 7-27. The primary complex can thus be seen to be a crucial determinant of the soundworld by which Priam's entry into the tragic universe is conveyed.

Further support for this argument is provided by the musical material

37 A similar point is made by Nicholas Morris in his article 'Simply the thing I am shall make me live', in *Michael Tippett O.M.: A Celebration*, ed. Geraint Lewis (Tunbridge Wells: Baton Press, 1985), 99.

Table 8.1. Relationship between sets of Priam's 'tragic universe' music (cf. Ex. 8.2)

	Primary complex		Secondary complex			
	7-25	7-32	4-6	4-4	7-27	5-29
8-26	Kh(s)	Kh(s)	K	K	Kh	K(s)
7-25		$R_p(s)$	K	–	–	K(s)
7-32			–	–	–	K(s)
4-6				R_p	K	K
4-4					K	–
7-27						K(s)
5-29						
			(Tertiary complex)			

when Priam eventually speaks with Helen, his last living act. While it may seem puzzling that it is only with Helen that he is able to communicate at the end, this is explained by the fact that she too is in a sense a tragic character. This interpretation is again prompted by Goldmann, who states that the tragic figure not only recognises the gulf between himself and the world, he also has a 'clear and unambiguous awareness of his own condition';[38] characters of the world, on the contrary, do not understand their own contradictions. While Priam only gradually learns the full nature of his condition, Helen is portrayed throughout as possessing an absolute acceptance of the circumstances of her being. In Tippett's words, 'she alone perhaps of all the characters in the opera has a true acceptance of herself. As she says, in answer to questions, with ultimate simplicity, "I am Helen".'[39]

It is perhaps unsurprising therefore that something of this situation is reflected in the musical construction of Priam and Helen's final exchange. Notably, the primary set complex of Priam's 'tragic universe' music impacts on their vocal lines. The sets of the complex, 8-26, 7-25 and 7-32, are quoted in part (a) of Ex. 8.4, while Ex. 8.4(b) sketches in the pitch contours of the relevant melodic material and indicates the sets which these represent. Only when there is no connection with the primary complex (that is, when neither a member of the primary complex itself nor any of its subsets are

38 Goldmann, *The Hidden God*, 325.
39 Tippett, 'The resonance of Troy', 228; *Tippett on Music*, 214 (punctuation slightly modified).

Ex. 8.3 Priam's 'tragic universe' music

(a) diatonic elements

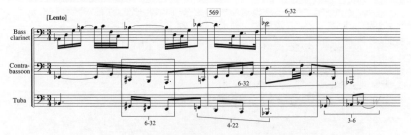

(b) subsumption of diatonic elements by primary complex

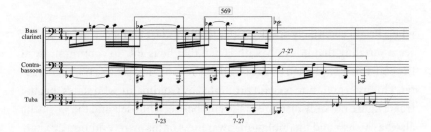

represented) are no pitches notated. As can be clearly seen, this amounts to very few instances: most of Priam's phrases present subsets of 7-25 and/or 8-26, as shown by the parenthetical indications after the set annotation for each melodic segment. Moreover, as the asterisk prefixes show, a preponderance of these sets draws from the actual pcs of the generative complex (in other words the relationship between the passages is clinched without any mediating transposition). Throughout the exchange the tritone D–A♭ is evident (shown with braces in Ex. 8.4(b)), a connection with the salient initial dyad of the instrumental parts of Priam's 'tragic universe' music. But what is also significant is the tendency for Helen to enter Priam's pitch domain. Her second utterance, 'Neither you nor Hector ever by word or deed reproached me', presents the superset 8-26 in its original transposition. And between Fig. 599$^{-1}$ and Fig. 601, her monosyllabic confirmations of Priam's statements prolong the pitch d, salient within his subsets of 7-25. The clear reference here to the pitch content of Priam's 'tragic universe' music aptly reinforces the detachment of both characters from the events

Table 8.2. Priam's 'tragic universe' music: relation of vertical sets to primary complex (cf. Ex. 8.3(b))

	Primary complex			
	7-25	7-32	7-23	7-27
8-26	Kh(s)	Kh(s)	–	Kh
7-25		R_p(s)	R_p	–
7-32			–	–
7-23				R_2R_p
7-27				

which the king reports: Paris's death, and Helen's impending restitution to the Greeks. Especially pertinent is the resistance of the two characters' lines to being assimilated into the recapitulation of the opera's prelude against which they are pitted. Although Priam's and Helen's phrases are partially drawn towards the oscillating tonal centres of E and E♭ of the brass fanfares, they none the less retain a strongly individual profile against them – an exact musical metaphor for the dramatic situation, whose significance barely needs repeating: music representing the tragic vision is upheld against that signalling the final catastrophe.

IV

For Goldmann, the tragic vision arises from the relationship between three mutually exclusive elements: the world, tragic man, and God. While the preceding discussion has shown how Tippett portrays tragic man and his separation from the world in musical terms, music's role in the delineation of any kind of God-term has yet to be accounted for. This last could be understood to be what Priam perceives when he enters the tragic universe, that is, some transcendent principle, or higher truth; though in a reading consistent with Goldmann's its significance would not be to indicate a divine presence, but precisely the opposite: an assertion of 'a set of values which transcend the individual'[40] made despite a God who remains hidden. This ambiguous situation has a further twist in the opera's relationship to

40 Goldmann, *The Hidden God*, 33.

Ex. 8.4 Priam and Helen's final exchange (Act III scene 4): relation of set classes to those of 'tragic universe' music (cf. Ex. 8.2)

(a) Source sets from Priam's 'tragic universe' music

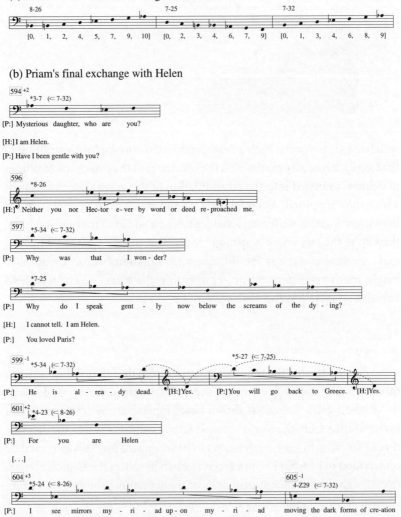

(b) Priam's final exchange with Helen

the audience. On the one hand, if the tragedy is to be uplifting, this must come from some communication to the audience of the vision and values (which are ultimately moral ones) finally apprehended by the tragic hero; on the other hand, the very essence of this vision is that it cannot be communicated. As Hermes puts it, 'The world where he is going, / Where he has gone, / cannot communicate itself through him, / . . . / But through the timeless music.' This brings with it a further paradox. While Hermes's ensuing 'Hymn to Music' might have delivered the implicit promise of a glimpse of what Priam apprehends, its effect is instead that of a serene interlude, positioning us outside the tragic proceedings and thus placing a (perhaps necessary) distance between us and Priam.

This scenario sketches something of the complex conditions of the final scene. Although Tippett through his messenger Hermes suggests that music alone has the capacity to convey the transcendent, the exact nature of the transcendent principle cannot be unambiguously defined, nor can its presentation be reduced to a single musical moment identified by a unique set of materials. In short, Tippett's strategy is not monological: instead there are several 'timeless' moments, or suspensions of dramatic action, which contend against the prevailing recapitulatory momentum, and offer different, not necessarily compatible perspectives on the transcendent. First, Hermes's Hymn to Music is sung to and for the audience, acknowledging our presence. A rare moment of light in the opera, it perhaps suggests a world that could be imputed to the divine, but because the God is always hidden – and hence outside the dramatic action – we can never know how this relates to Priam's equally incommunicable vision. Secondly, we hear the music accompanying Priam at prayer, discussed at length above (see Ex. 8.2). The musical soundworld issues from Priam, but – to borrow a conceit from Carolyn Abbate[41] – most parties are deaf to it: certainly Hecuba and Andromache seem to be, given their uncomprehending response to the king's altered state. We the audience, however, are again implicated, in being allowed to 'overhear' this music, and thus at least something of what Priam's world of apprehension is *like* (dark, mysterious, unfathomable), even if the sounds do not convey any unmediated or

41 Carolyn Abbate, *Unsung Voices: Opera and Musical Narrative in the Nineteenth Century* (Princeton, New Jersey: Princeton University Press, 1991); see especially chapter 4, 119–55.

unallegorical image of what that world actually *is*. Thirdly, the music which accompanies Priam's final words, 'I see mirrors myriad upon myriad moving the dark forms of creation', has been used previously in the opera to convey timelessness. However, its mercurial, and conceivably ironic, dancing ostinati would seem to add a disturbing ludic element to the already equivocal content of Priam's words. Fourthly, the very last music of the opera is again concerned to position the audience in relation to the action. Although Tippett describes these curious sounds as 'the momentary musical expression of our inward tears',[42] they more probably invite us to internalise the mysteriousness of the preceding 'timeless' materials, and to register that the tragic vision involves a profound assimilation of negative experience.

Individually considered, these musical figures seem less than likely to engender the galvanising emotional response in the audience that is, in Aristotle's language, the proper pleasure of tragedy. However, the potential for that response certainly exists, namely in the larger musico-dramatic scenario into which these individual musics fit. Although the audience is not, and cannot be, directly privy to the tragic vision of the protagonist (in this Tippett keeps faith with Goldmann), it is offered its own moment of transcendence through the dramaturgical portrayal of tragic man wresting something universal and timeless from the cataclysmic forces of a world and a fate indifferent to humanity. We are moved by the fact that after losing everything in the world itself there remains for Priam a residue in the experience of being human that renders him equal to the catastrophe about to engulf him. And the power of this vision is conveyed musically: by the totality of the processes described above, that is, by the countering of the recapitulatory tidal wave with musical materials that resist its teleological momentum. It is in the final exchange between Priam and the semi-divine Helen that the process is most acutely and movingly felt. On the one hand the recapitulated fanfares and choral ululations from the opera's prelude powerfully (and, in a perverse but entirely proper sense, thrillingly) project the terror of Troy Falling.[43] On the other hand the depiction

42 'The resonance of Troy', 225 (see also p. 230); *Tippett on Music*, 211 (see also p. 216).

43 Tippett's originally intended title for the opera, deleted on the ink manuscript of the score (British Library Egerton MS 3786).

of the individual human figure of Priam, transfigured, and devoid of malice towards the woman who was the catalyst for the war that will destroy him, transforms an otherwise irredeemably horrific picture. Whether what the audience feels in response to this are literally the specific emotions of pity and fear, the overall musico-dramatic presentation unquestionably implies an emotional response of the most powerful order.

Thus the composer engineers a kind of *katharsis*: in the end we are indeed uplifted. As Tippett himself puts it: 'the protagonist cannot express [the sense of tragic destiny], in communicative terms to his ambience. But it is expressed to *us*, in the theatre, by his or her actions. The pity and the terror and the exaltation are *ours*, not the hero's.'[44] The sources of the two tragic concepts described here should by now be plain – as should their fundamental importance to *King Priam* and the means by which Tippett ensured their musical realisation. It is nothing less than the convergence of notions from both Goldmann and Aristotle – notwithstanding the fact that these conceptions are (necessarily) not coterminous – that makes possible the composer's transformation of an ancient Greek theatrical genre into a modern-day operatic one.

44 'The resonance of Troy', 226 (original emphases); *Tippett on Music*, 212.

9 Tippett at the millennium: a personal memoir

WILFRID MELLERS

Born around a decade later than Sir Michael Tippett, I have attained an age which is seriously old, no longer qualifiable by some such euphemism as 'elderly'. That Michael was my senior in years allowed me to be a disciple to his guruship, and I can remember – 'as though it were yesterday' instead of sixty years ago – the sense of a new dawn that his music awoke in me. In those distant days the two young composers in Britain who were endowed with indubitable genius were, of course, Britten and Tippett. I goggled at Britten's native talents and hope I didn't betray envy in dismissing them, even to myself, as 'too clever by half' – as did many people, perhaps understandably. But I recognised that I couldn't identify with Britten's gifts, which were truly exceptional, though not superhuman. As the years have passed I've come to think that Britten was the supreme musical genius of this British time and place, and to believe that his uncanny instinct for – rather than thought about – what mattered for him at this moment and the next was the most telling evidence of this genius. *A Boy was Born* (1932–3), written in his late teens, was an apprentice piece that carried the seeds of a lifetime's creation; the *Variations on a Theme of Frank Bridge* for strings (1937) offered a review of the musical past and present that revealed the necessary future relationship between a British composer and continental Europe; while *Peter Grimes* (1944–5), the first major fruit of that marriage, was a 'grand' opera in a land reputedly without music (let alone the complexly hybrid musical-theatrical art) by a composer barely thirty, which triumphed not only with éclat, but also worldwide. The subject, being based on Crabbe's verse narrative and centred on East Anglia, Britten's own country, was as English as could be; while the musical and theatrical techniques, evolving from Britten's preludial exercises in instrumental music and in song-cycles with European affiliations,

186

were totally unprovincial. We were to discover that Britten's creation would evolve with the same inevitability; and over the years I've come to accept this flowering as surrogate for all of us, certainly for me.

That Michael Tippett didn't have this 'miraculous' instinct for what he had creatively to accomplish meant that I could empathise, even identify, with him as I couldn't with Britten. I discovered how close I was to identification when, while still a student at Cambridge (where I read first English Literature, then Music), I reviewed a privately issued recording of Tippett's First Piano Sonata (in its original version of 1936–8) for the January 1942 issue of the journal *Scrutiny*. This was when Britain and Europe were already racked with wars, yet Tippett's unportentous sonata glinted with light and sparkled with effervescence. He made a new sound with the piano: an extraordinary achievement after the production of so vast a body of music for the ubiquitous instrument. The first movement – not a teutonic sonata form but a variation set – discovered new ways of transcending duality; the slow movement combined a genuine folk song with rarefied Hindemithian counterpoint; the scherzo youthfully pranced and danced while embracing within its ebullience more than a hint of Beethovenian dynamism and daemonism; while the rondo finale, wide-eyed and open-eared in pentatonicism, had both the lyrical lilt and the rhythmic zest of jazz. That one wasn't tempted to think of it as a 'great' work was part of the point; what mattered was that, at a dark time of the year, it affirmed life.

It was through my review of the sonata that I came to know Michael Tippett. I think he must have written to me; certainly I was invited to meet him, and went to his bungalow at Oxted, Surrey. Talking to him, watching him work, I could have no doubt as to my deep affinity with what he was about, though his creative gift was so much stronger than mine. T. S. Eliot, Yeats, Jung, war and peace were topics bandied between us: themes in contact with the deepest springs of his being, touching mine peripherally though not vicariously. He had by this time already made his follow-through to the First Piano Sonata: a Concerto for Double String Orchestra that spontaneously fused the body's joy (in bounding, 'sprung' rhythms deriving alike from madrigalian polyphony and from jazz) with the spirit's ecstasy (in lines soaring and winging across the prison of the bars), creating, especially in the last movement, a fulfilled 'wholeness' that seemed near-

incredible when the piece was first performed in 1939, the very year of the war which seemed to mark the beginning of the end of Europe. Shortly afterwards Tippett set about composing a big work which, having a text, could be explicitly 'about' the cataclysmic events in the world out there. This was his oratorio, *A Child of our Time* (1939–41), based on a true story of oppression and persecution such as was (is) endemic to our time. The Child of our Time was, of course, the boy of the story, but also Tippett himself, and you and me.

Michael told me how, in making a text that should be an 'objective correlative' for a modern myth, he'd at first sought the help of T. S. Eliot, whose verse he deeply admired, as did most men of good will and sound percipience. Eliot persuaded him that he could more effectively make his own text, since he, as a composer, would be more intimately aware of what his music needed than any professional poet. The language Tippett invented owed something to Eliot, while being more conducive to music in being more neutral. Although the text was sometimes depreciated – there were already pleas that Tippett should engage a 'professional' literary man – it seemed to me that its bareness, and indeed its occasional naiveties, were the measure of its truth, which the music made aurally incarnate. Any momentary embarrassments occasioned by the text's abstractions were vindicated by its honesty: which was in turn conditioned by an extraordinary intelligence. It was this intelligence that enabled Tippett to arrive at so effective an artistic formulation for his adventures of the spirit. In particular, to substitute Negro spirituals for Bach's Lutheran hymns as a point of contact between artist and people was a brilliant *trouvaille*, especially since Tippett's versions of the spirituals were so acutely aware of the spirit and technique of the originals. There was, and still is, a genuine *rapprochement* between the plight of the oppressed Negro and our plight in 'a world I never made' – as Studs Lonigan, James Farrell's proletarian hero (exactly contemporary with Tippett's *Child*) put it. These were matters that Michael and I could mull over – as Britten, who didn't write his own texts but always knew precisely what they had to be, had no need to. Certainly in this case Tippett's forethought and canniness paid off. When *A Child of our Time* was performed, during the war and immediately after it, the final chorus's slowly unfurling paean to life reborn, followed by the emotional release of the epilogic spiritual, was validly comparable in effect with the end of Bach's *St*

Matthew Passion. This doesn't mean that 'Tippett equals Bach' in the hierarchy of Auden's 'composing mortals'; but it does mean that conscious thought had served unconscious intuition to make a miracle, comparable with those Britten accomplished unwittingly. In those crucial years I recognised that I'd been privileged to know as passionately human a man as Tippett, at a time when he was not only a man, but also a Pan, a Puck and the god Hermes: a divine messenger who, effecting on our behalf acts of psychological restitution, enabled us to survive horrors which, at the time, we couldn't adequately anticipate.

Not, of course that I articulated any such high or deep sentiments when in Michael's company. Young or fairly young, we chattered mostly about musical and literary practicalities that concerned us and in the process defined us: for broad and grand issues were inseparable from apparent trivialities. I remember Michael remarking on how he was trying to wean 'young Antony Hopkins' from his devotion to Rachmaninov, and persuade him to play – even on a 'wrong' instrument, the piano – the keyboard works of Orlando Gibbons as well. Hopkins was then known mainly as a talented and intelligent pianist who composed, not as the deservedly popular lecturer and media-man he became. What Hopkins played was not a triviality; one might even say that playing Gibbons was part of a crusade in which people like Tippett and myself were implicated; even that it had something to do with *A Child of our Time*, since playing Gibbons related madrigalian to jazz polymetres and linked us, as the war loomed, to the panoply of English life from Shakespeare to Purcell.

This was the more significant because in the 1940s Tippett was already involved in the all-embracing project of his first opera, *The Midsummer Marriage* (1946–52), which occupied most of his moments over a period of seven years. The opera, unlike the oratorio, was not specifically 'about' what was happening in the world, but it was a mythic testament to the 'condition of Britain', a Blakean Vision of Albion. Michael said it was a 'one-off': a summation of everything he'd so far discovered in his composing life. Although its book, of course by Tippett himself, occasioned much bewilderment and even a little demeaning facetiousness, I could never understand this, since, given a rudimentary acquaintance with Jung, its meanings are transparent, and are in any case manifest in the music. The ritual-opera mates the senses' joy with the spirit's mystery in a

way that would have been inconceivable had not Tippett recently completed an oratorio that was affirmatory in the teeth of the storm. Both works confront the totality of human experience, for he believed, like Blake in *The Marriage of Heaven and Hell*, that 'Without Contraries is no progression.' This is why Tippett, unlike Britten, has always embraced Beethovenian will and consciousness within his humanism; and it is probably why he remarked to me – understandably but I think erroneously – that he had 'much further to go than Ben'. However this may be, in his opera he found the imagery that, relating anthropological mythology to Jungian psychology, enabled him to strike deep, releasing any earlier technical inhibitions in the luxuriance of the opera's score, with its sprung rhythms and exuberant counterpoints. I had and have no doubt that *The Midsummer Marriage* is one of the supreme musical-theatrical creations of our bruised and battered century, not merely in this country but worldwide. It will, I hazard, resist the attritions of time, even though it is unlikely to be frequently performed, given the technical demands it makes on singers and instrumentalists alike. The 'difficulty' of the music is an aspect of its truth; and it must be significant that singers and orchestras – even talented students – are now able to negotiate it if not with ease, then certainly with aplomb. That the score still sings and dances boggles the mind and beggars description – appropriately to borrow metaphors from Shakespeare.

In *The Midsummer Marriage* thought is subservient to immediacy of feeling, though the opera, embracing the conflicting energies that went to make modern society, has strenuous intellectual content. I counted Michael as a friend, rather than a mere acquaintance, during those years, and I was around during the period when he was asking himself what could or must come next – after the paradise which, as a consequence of pain and strife, his opera had envisaged. We are told that Beethoven himself, when the devoted but dim-witted Schindler enquired why he hadn't appended a finale to the celestial Arietta of his last piano sonata, Opus 111, barked: 'What could come *after* Paradise?' But Tippett's answer to the question, again arrived at after long gestation, seemed to be Paradise's renunciation: for his second opera, *King Priam* (1958–61), written during the war's aftermath, in celebration of the new Coventry Cathedral, is explicitly about thought and choice. After the timeless and placeless Britons of the mythical *Midsummer*

Marriage, Tippett's libretto addresses the Greeks of classical antiquity, adapting the Homeric legend of the hero-king in the light of thought and of personal feeling. *King Priam* tackles the problem of how far human decisions may ever be responsible, since we are enmeshed in emotional traumas and social conditions which, being imperfectly understood, we can only partially control. Macho men (but not women) may kid themselves that they are in charge of their own and of other people's destinies; but though they may try their damnedest, if not their best, they may loose catastrophe, which King Priam's choice here precipitates and Tippett's music aurally enacts.

As compared with the life-enhancing sonorities of *The Midsummer Marriage*, this Greek king's music is hard, relentless, contrarious; the linear textures are thin, lucent, glinting, tense as steel. Energy furiously abounds, as it tends to in life when we're conscious of being conscious; the instruments whirl interdependently through four complementary bands, one of brass (associated with the male warriors), another of strings (associated with the female mourners), and two more of woodwind and percussion (which have volatile functions between the men and women). The brazen end to the bellicose second act makes the hair stand on end like quills upon the fretful porpentine; even in the few, brief quiet moments the sonorities are electrical – in the sense in which Beethoven applied this in his day new and dubiously understood term to his own music.

Yet this wouldn't be a Tippett opera if it presented only one side of the coin. The Greeks' rationality, for which they were esteemed, was complemented by their irrationality; and if *The Midsummer Marriage* absorbs will into magic, *King Priam* reverses the process, emotionally tempering destructively intellectual ego. *The Midsummer Marriage* is about private pilgrimages that may have public consequences; *King Priam* is a public, indeed political, opera that is triggered by the private life when its king-hero, choosing wrongly, brings ruin to his world. The god Hermes, messenger between flesh and spirit, calls on the power of music to effect contact, if not reconciliation, between Priam and dark-goddess Helen, whose own wrong choice was the immediate cause of the war. Since on every level Priam is himself the heart of the action, his charismatic presence irradiates every aspect of the work, including the savagely difficult orchestral parts. Few orchestral scores since Berlioz contain so high a proportion of music

191

that is extremely fast, not only in metrical tempo, but also in melodic-harmonic pulse. So much happens, in so brief a space; the orchestra sounds airborne, or as though on tight-ropes from which we might easily topple. What makes *King Priam* a great opera – although or because it stands at an opposite pole to the consummately consummated *Midsummer Marriage* – is that it unflinchingly faces the grim world we inhabit while also affirming, in an inconclusion that is uncompromisingly tragic, that life is worth the carrying.

Mankind learns little by experience, and the criminal imbecilities of the Greek wars pale in comparison with our own. In this context the moments of stillness in *King Priam* prove painfully pertinent to ourselves, being the more potent because they come but rarely. I recall Michael's near-ecstasy at his invention of Achilles' nocturnal meditation to a guitar, wherein he yearns for home, but overrides nostalgia in sublimating dream into vision. Still more moving is the explicitly visionary aria sung by the god Hermes in the final act, extolling the power of music to palliate death itself. Earlier I spoke of Tippett himself as a Hermes-figure; and it would seem that for many, perhaps most, modern composers (notably Britten and Janáček) opera tends to be not only mythical and historical, but also autobiographical. In *The Midsummer Marriage* and *King Priam* Tippett gets the balance between these elements exactly right: which is why the pieces function with unabated impact. He didn't always bring off this delicate task in his later operas, in which he was brave and intelligent enough to take on board, within the elitism of the conventional opera house, techniques derived from the crossover arts of later years, including rock and pop and science fiction. Such consciously formulated directions, unnecessary to Britten, were obligatory for Tippett if he were to fulfil his (and, he hoped, our) destiny. For the sequence of his initial oratorio and the operas that follow it charts stages in a pilgrimage that is reflected too in his instrumental music, the First Symphony (1944–5) being a precipitate from *A Child of our Time*, the Piano Concerto (1953–5) from *The Midsummer Marriage*, the Second Piano Sonata (1962) from *King Priam*: and so on, through the years and works to come.

My modest personal involvement in Tippett's music ceased with *King Priam*: partly because I lived for a while in America, but probably also

because by the time I returned in the 1960s Michael had risen to the international eminence he enjoyed in the latter part of his life. Perhaps it's only this slight personal involvement that encourages me to find the peaks of Tippett's work in the wondrous Concerto for Double String Orchestra, the magical *Midsummer Marriage*, and the starkly uncompromising *King Priam*. Greatly though I admire much of his later work, I find a distinction between the first flush of dawn in those initial masterpieces and the 'messages' he communicated, as it were from guru to acolytes, as the years passed. Comment on his third opera, *The Knot Garden* (1966–9), will indicate what I mean – though by this time I was an acquaintance rather than friend, and have no personal experience of the piece's genesis. When it was first produced at Covent Garden it seemed unhappy to be there, for this was before the proliferation of so-called 'performance art'. Certainly, it provoked bewilderment in its (presumably establishmentarian) public, and the now familiar regrets that Tippett didn't get his opera books written by a literary professional. Given the nature of Tippett's 'autobiographical' project, that wouldn't have been possible; and when the opera was revived a decade or so later it seemed – though still in the elitist Covent Garden which the piece obliquely repudiates – to sound less uneasy, being performed by the professional singers and instrumentalists with almost easy assurance, and being accepted by a (surprisingly young) clientele with a measure of comprehension. Although the music didn't sound insouciant, and shouldn't have done since it is about our emotional instabilities and intellectual contrarieties, the fecundity of Tippett's invention carried the day. Despite what was sometimes called the 'gimmickry' of the media-techniques, we were able, along with the opera's protagonists (and after D. H. Lawrence), painfully to say: 'Look, we have come through.'

Even so, there was something eerily discomforting about such a work in such a place. The notion was widely canvassed that the opera would date because it exploits contemporary slang and the varied musical genres – jazz, folk, pop, rock – that are the warp and woof of our pluralistic world. Tippett countered with the belief that such superficial modernities would affect his opera's future no more than the pop speech and in-jokes in Schikaneder's libretto for *The Magic Flute* have affected that 200-year old opera: which has much in common with *The Knot Garden* in its approach to themes of self-deception and of ambiguity between reality and illusion. Tippett had a

point, even though the libretto of *The Magic Flute* is, for complex historical reasons, a farrago of non-sequiturs that only a Mozart could have salvaged. One might argue that such inchoate confusion mirrors our own predicament; and one may more legitimately claim that *The Knot Garden* is 'difficult' in much the same way as are mid-seventeenth-century operas like Monteverdi's *L'incoronazione di Poppea* and Cavalli's *La Calisto*. Those pieces teeter bewilderedly and bewilderingly between musical-theatrical conventions, reacting to the chaos let loose by the First Scientific Revolution among once-proud post-Renaissance people. Their confusions of gender and identity seem very like ours, as we move, approaching the new millennium, from that first scientific age into the electronic Second Scientific Revolution and the Age of Aquarius.

Faber, the central character – hardly the hero – of Tippett's libretto is a 'maker' in the guise of a modern engineer, dicily married to a frustrated wife, Thea. Their ward, Flora, isn't a 'real' daughter presumably because the couple's liaison is too emotionally aborted to foster offspring. Another dicily 'married' but homosexual and therefore childless couple – the black poet Mel and the white pop musician Dov – impinge on the household, along with Thea's sister, a militant freedom-fighter (wearing a quasi-uniform that desexes her), who is at odds not so much with real people as with her preordained polity in a corrupted society. Whatever line one takes, the outlook is bleak – even though the outsider-psychiatrist Mangus strives to steer the action from socially biased tragi-comedy to an exploration of traumas within the psyche, and so to a healing of breaches between appearance and reality through the catalyst of Art. Supreme art like that of Shakespeare may sometimes do for us what religion did for earlier epochs: so the psychiatrist turns into Prospero from Shakespeare's epilogic play *The Tempest*, itself about identity and self-knowledge; and a masque is enacted, masked within a play within an opera. These multi-layered theatrical meanings involve different kinds of music, ranging between a Schubert song (which belongs to the past and is about love lost, not found) and the blues of Dov's electric guitar that, agitatedly trying to hymn the present, proves to be itself an illusion. All this time-travelling and 'secondary' reliance on art rather than life, though fashionable then and perhaps still valid now, can't help being a cop-out – though one sees the point of the

technique's being, like that of Monteverdi's *Poppea* and of Cavalli's *La Calisto*, theatrically cinematic, flickering through a sequence of disconnected clips, one damn thing after another, like life (especially seventeenth- and twentieth-century life) itself. Musically the piece is comparably volatile, not merely because it shifts through so many disparate styles of so many different dates, but also because of the pace of its invention; the melodic-harmonic, as well as rhythmic tempo, is even dizzier in alacrity than that of *King Priam*.

Whereas Tippett's first opera, composed almost immediately after the Second World War, owed its celebratory affirmation to its startling luxuriance, *The Knot Garden* stumbles towards a jittery assent out of its frenzy. Thirty years on, the piece still sounds and looks knotty indeed, exhausting alike to participants and audience. Intermittently, Tippett's ear remains wonderfully acute: the luminous flutes, in the third act's unwonted but much-wanted stillness, again transcend technique into miracle; and the vocal pandemonium pays off in lines that are, even for Tippett, extravagantly acrobatic. Thea's final aria as (potential) mother and Laingian Undivided Self wouldn't be so moving in a blander context; and we admire – in both the normal and the literal senses – Tippett's courage in making an opera that doesn't evade the fact that we modern folk lock ourselves in mirror-prisons and ride on raucous unmerry-go-rounds, kidding ourselves in our illusions. Even the psychiatrist confesses that he, like Prospero, is a charlatan and has no answer to Pilate's eternally Unanswered Question: What is Truth? We pay tribute to Tippett's admission that we're still tied in these knots, and are grateful for his hint that we might, with pain, extricate ourselves from them. Shakespeare's final message of reconciliation in *The Tempest* resonates with Tippett's Blakean plea: 'I would know my shadow and my light, So shall I at last be whole' – words from his exploratory oratorio that have re-echoed throughout his life's work.

Even so, the intrusion of Prospero-Shakespeare still seems to me an abnegation of responsibility; and I suspect that the reason why Tippett's fourth opera, *The Ice Break* (1973–6), hasn't begun to establish itself in the repertory is that it is still less successful in identifying musical meaning with theatrical message. It is even more tortuous in its teeterings between 'unconscious' musicality and the 'conscious' exploitation of the pluralism

of modern culture, and of the theatrical techniques associated with it. Art music, rock ritual and performance art fail to gel.

But Tippett doesn't end on this note of frustration. He went on to compose a fifth opera, which has the appropriately millennial title of *New Year* (1986–8), and was first produced in the New World, at the famously forward-looking Houston Grand Opera, in 1989. Although its British premiere a year later at Glyndebourne was undeniably in an establishmentarian set-up, the enterprise of Peter Hall's direction, abetted by Paul Pyant's lighting, Alison Chitty's designs and Bill Jones's choreography, was such that dubieties about the work's status, let alone its stature, were effaced. Perhaps the fact that Glyndebourne, though one of the world's most highly professional opera houses, has always preserved elements of a country-house cultural party aided our acceptance of the venue as appropriate – certainly more so than Covent Garden would have been.

In any case, *New Year* is Tippett's most experimental opera, both spiritually and technically: wherein the disparate, even contradictory, techniques that pertain to our polyglot society work because the music recaptures the pristine quality of *The Midsummer Marriage*. If the tone of renewal is not as exuberant as in the earlier work, it is more economical in fostering the same marriage of body and spirit, as traditional seasonal rites for the dying year merge into the new year resurgent. Again, creative and destructive forces are, in Jungian and Blakean terms, interdependent; and the *agon* of the protagonists functions, as in *The Midsummer Marriage*, simultaneously in terms of music and of human drama and ritual dance. The central protagonists (again in the Greek sense) are two orphans – Jo Ann, a white girl and Donny, a black boy – whose parentless state reflects on D. H. Lawrence's (First War) cry that 'humanity today is like a great uprooted tree'. She, to put it crudely, is upwardly mobile soul or spirit, with love for putative individuals and with compassion for suffering mankind, yet unable to fulfil her dreams because, enclosed in her books and study, she cannot face the world 'out there'. He is instinctive animal libido, alive in corporeal sufficiency, yet deficient intellectually and spiritually, and therefore delinquently abortive as a social creature. The 'polymorphous perversity' of the everyday world is manifest in entangling groups of dancers who represent the various strata of our global village, from lager louts to hippies to

196

yuppies, all with their typical musical idiom from 'classical' to blues, to rock, to rap, each with its appropriate instrumentation. *New Year* thus becomes a choreographed masque and a rock musical, as well as an elitist opera. Its festive rites are more complex than those of *The Midsummer Marriage* because they embrace, or at least hint at, the future as well as the present and the past.

The earthly Calibanism of the multi-ethnic modern scene is balanced by Ariel-like, upward-aspiring propensities represented by visitors in a space-ship, clinically garbed as today's magician-scientist-priests presiding over an array of flickering computers. The composer tells us that this is not science fiction; significantly, the computers fail to project visions of the future, getting no further than garbled images of a vaguely modified past. For Tippett, despite his adventurous enterprise, remains basically a prag-matist; the visitors from space are not 'real', but manifestations of new forms of consciousness and of human potentiality that may, or may not, become operative. This is explicit when the dreamy intellectual Jo Ann falls in love with the pilot of the space-ship, Pelegrin, who is a pilgrim no less than she. But since he has as yet no physical existence no love affair can occur. He leads her into a garden where she fulfils her nature in belatedly dancing as well as singing; but this presumably means merely that she is his dream, as he is hers. That the dreams are what matters is signified by the fact that Pelegrin manipulates the computers to obliterate the Nowhere he is in, while Jo Ann bravely but tremulously totters into the Terror Town. There, both their human potentials may one day be realised in flesh and spirit, and the final words of the Presenter – Nelson Mandela's universal dream of 'one humanity, one justice' – may come true not merely for whitely aspirational Jo Ann and darkly libidinous Donny but also for Tom, Dick and Harry, Jane and Joan, you and me.

If this farrago of social and ethnic states and of musical styles sounds confusing, that is because our world is itself confused. The ripe immediacy of the music disguises this: for although it cannot quite live up to the invoked parallels with *The Midsummer Marriage*, it is hardly less lyrically compelling, and perhaps slightly more luminous in harmonic and orches-tral texture. The vocal lines, if demanding, are made for – not against – the voice, the problems they present being not musical, but inherent in the exploratory nature of the project. The central tenor role of the Presenter

calls for a singer-actor who can convince both within and without the action. Jo Ann, though a human being, is hardly an ordinary one, but has to be accepted by the audience as simultaneously a nervous wreck and a heroine. Her black counter-orphan must be an acrobatically prodigious dancer who can sustain a wide-ranging baritone line with precision; while Pelegrin, being a space-man, offers few precedents for a live actor-singer to start from. Of course, Tippett is not alone among late twentieth-century opera composers in requiring enhanced vocal, choreographic and dramatic abilities from singers, and by now there is some evidence that a new-old type of musical-theatrical artist is embryonic.

How important this is emerges if we concentrate precisely on this new element in Tippett's last opera – the intrusion, among real human beings on this earth, of space creatures who affect both our identities and the nature of the world we live in. With 'real' Jo Ann and Donny we don't think of their respective whiteness and blackness in terms of good and evil, but as a Blakean *conjunctio oppositorum*, which we accept because we've met people like them. I'm not sure this works with the space-beings, the white pilot Pelegrin and his complement of a black earth-goddess who has the sinister name of Regan yet who, in understandable deference to a feminist credo, seems to be boss of the operation. One can take the point not that science is 'bad', but that new forms of consciousness are bound to be dangerous, and that the danger must be confronted, not evaded. One can see too that there's a relation between Pelegrin's 'post-conscious' computerised mechanisation and Regan's 'pre-conscious' libido – a relationship that may, perhaps, bear on the current vogue for so-called minimalist music which works simultaneously in mechanistic terms and on principles derived from what were once termed 'primitive' musics. Tippett is far too complex and self-conscious a composer to come within the category of minimalism, but in his late work, and especially in *New Year*, he called on magical patterns and processes that resemble the quasi-minimalist music-machines of Harrison Birtwistle. Indeed, the basic burden of this opera is that superhuman majesty and subhuman mechanisation must be fused if Jo Ann, A Child of our Time, is to flower into our potential future. That she perhaps loves both earthly black Donny and whitely spaced-out Pelegrin, and that she certainly yearns to emulate black-goddess Regan, is suggested by her androgynous double name as well as, occasionally, by her music. This is a bit too much to

be 'realised' in Tippett's orchestral sonorities, wherein light shines through in aural simulation of stained glass; or in the visual and choreographic dimensions that effect magical metamorphoses, turning cities into magic gardens, and vice versa. Even so, the piece does make us more aware of the violent unpredictability of the world we nervily inhabit, while instilling into us the hope, or even belief, that this New Year may be more richly potent than the old. That is worth saying, in view of the cataclysmic events of the last decade, and the jittery promise of the next millennium.

It isn't easy to think of an artist who confronted this unknown future as boldly as Tippett, and for his courage we must honour him. Yet, although *New Year* is the most intelligent, honest and deeply committed of the late operas, it remains a commentary on the human condition, rather than an affirmation of life in the making, as is *The Midsummer Marriage*. I suspect this is true also of Tippett's last, largest and consummatory oratorio, *The Mask of Time* (1980–2): a mind-boggling cosmic history of the universe, fraught with moments of aural illumination yet in total effect more a tract than a living organism. At this critical phase in humankind's story we need such a compassionate awareness of where we stand and where we may be going. But still more desperately we need the living organisms of that modest Double Concerto, and of those first two indubitably great operas – along with the mature operas of Benjamin Britten. This still leaves Michael Tippett as one of the greatest composers of our time, however suspect the tag may be in our postmodernist, deconstructive context. The words of W. H. Auden – the finest English poet of Tippett and Britten's generation – apply to both artists impartially, having been written, in New York, on that crucial day, *September 1, 1939*:

> Defenceless under the night
> Our world in stupor lies;
> Yet, dotted everywhere,
> Ironic points of light
> Flash out wherever the Just
> Exchange their messages:
> May I, composed like them
> Of Eros and of dust,
> Beleaguered by the same
> Negation and despair,
> Show an affirming flame.

10 Decline or renewal in late Tippett? The Fifth String Quartet in perspective

PETER WRIGHT

I

Tippett had to endure much adverse criticism during his long career. Yet when the reception history of his music comes to be written it will be surprising if, among the more negative critiques of his work, there is any that quite matches Derrick Puffett's extraordinary article 'Tippett and the retreat from mythology' in terms of the sustained and forthright nature of its attack.[1] Published in the month of the composer's ninetieth birthday, this highly personal polemic describes, against the background of the composer's own writings, some of the changes which Tippett's music and its reception have undergone over the years. Puffett, while strongly sympathetic to the earlier work (despite claims of technical miscalculation and misjudgement in questions of formal proportion), finds evidence of a 'sad decline' in the composer's musical and literary output that began some time after the composition of *King Priam* (1958–61).[2] Tippett's abandonment of myth, the original inclusion of which is seen as key to the success of such works as *The Midsummer Marriage* (1946–52) and *King Priam*, and his subsequent failure – in Eliot's words – 'to transmute his personal and private agonies into something rich and strange, something universal and impersonal', are held to be at the root of this decline.[3] The composer's heavy

This essay is dedicated to the memory of Derrick Puffett, in gratitude for his inspired teaching and the stimulus of his writings on Tippett. Particular thanks are due to David Clarke, who made a number of helpful suggestions about the chapter's content.

1 *The Musical Times* 136, No. 1823 (January 1995), 6–14.
2 Puffett, 'Retreat', 9.
3 Ibid., 10. Puffett quotes a slightly inaccurate version of Eliot's text which has been amended here; see T. S. Eliot, 'Shakespeare and the stoicism of Seneca', in *Selected Essays*, 3rd edn (London: Faber & Faber, 1951), 137.

reliance on allusion and metaphor is seen as having led to a division in the late works 'between style and subject, a splitting of gesture from meaning', and to the increased usage of his music for purposes with which it is unable to deal adequately. 'Why', Puffett asks, 'can Tippett not be content with making beautiful objects, the "artefacts" he praises in his autobiography and elsewhere? It was good enough for Stravinsky.'[4] While primarily concerned with the relationship between music, words and ideas, Puffett also questions the very integrity of Tippett's musical language, which he sees as having become increasingly 'limited' and 'mannered', complaining of 'torrents of notes' in the late works, 'none of which seem to mean anything' – 'a lifetime's experience', as he bluntly puts it, 'reduced to two stale "archetypes" ['arrest' and 'movement']'.[5] Although Puffett does find occasional things to admire in the late works, there are not enough of them to prevent him from consigning Tippett to 'the ranks of those noble but tragic composers . . . who have lived beyond their time'.[6]

A harsh verdict indeed on one of the proclaimed giants of twentieth-century music, delivered in a manner clearly intended to shake the composer's devotees out of their supposed complacency. Yet however strongly one may disagree with Puffett on matters of judgement or taste, there can be no denying the importance of many of the issues he raises, or the force of certain of his arguments: Tippett did, for instance, occasionally miscalculate or misjudge (as he himself acknowledged); his heavy reliance on allusion and metaphor, and the ambitious demands he made of his music, are well recognised; and there is perhaps some substance in the charge of mannerism in the later music. Puffett commands our attention not just because of the evident authority with which he writes but because of the admiration he has for much of Tippett's earlier work; his disappointment lies, after all, in what he perceives as the composer's failure in the later stages of his career to match his previous accomplishments. And in that perception Puffett has not been alone. Paul Driver, for instance, normally a champion of Tippett's work, concluded in a review of the Triple Concerto written

4 Ibid., 11. 5 Ibid.
6 Ibid., 14. For a consideration of some of the issues raised by Puffett, see Arnold Whittall's review of Michael Tippett, *Tippett on Music*, ed. Meirion Bowen (Oxford: Clarendon Press, 1995), in *The Musical Times* 136, No. 1827 (May 1995), 238–40.

in 1980 that 'not since *The Knot Garden* . . . has [he] produced anything worthy of his early masterpieces'.[7] Two years later, in the first edition of his book on Britten and Tippett, Arnold Whittall wrote that 'it would be difficult to claim that any of the works [Tippett] has begun in his seventies are the equal of earlier compositions'.[8] Ian Kemp, while not venturing as far as this in his monograph of 1984, nevertheless adopts a distinctly guarded tone when it comes to the works of the late 1970s, which he considers in a postscript to his book. In this context it becomes difficult not to construe a remark such as '[Tippett's] late music in no way represents a weakening of creative ambition'[9] as possibly implying some doubt as to his success in realising that ambition. Other writers have been similarly reserved or guarded.[10] The main point is that Puffett has given particularly robust expression to doubts which others have voiced less forthrightly or merely hinted at.

But is there any justification for the view that there is a decline in the quality of Tippett's work? Or is it that the later compositions are harder to come to terms with, either because of the more challenging nature of their musical language or because of the different aesthetic demands they make of us? Such questions need to be asked, and Puffett's critique at the very least highlights the relative paucity of substantive critical commentary on the later part of Tippett's output compared with that which exists for the earlier part. The possibility that the composer's creative powers declined in old age, if difficult to contemplate, cannot be ignored.

It is against the background of these issues that the language, structure and meaning of one of Tippett's last compositions, the String Quartet No. 5 (1990–1), are considered here. This has not proved an especially controversial work, nor is it one with which Puffett takes particular issue (his sole reference is to its final chord, which he cites as one of the 'marvellous' things in late Tippett – seeming to imply that he has little time for the

7 Paul Driver, 'Tippett's Triple Concerto', *Tempo* No. 135 (December 1980), 51.
8 Arnold Whittall, *The Music of Britten and Tippett: Studies in Themes and Techniques*, 1st edn (Cambridge: Cambridge University Press, 1982), 292.
9 Ian Kemp, *Tippett: The Composer and his Music* (London: Eulenburg Books, 1984), 477.
10 See, for example, Peter Hill, 'Tippett's Fifth String Quartet', *Tempo* No. 182 (September 1992), 28–9.

rest of the piece[11]). But in belonging to a genre to which Tippett made some of his most acclaimed contributions (the first three quartets are widely seen as embodying the highest compositional ideals), the Fifth Quartet has a context within which the notion of decline may be usefully addressed.

II

Although Tippett composed only two string quartets during the past half-century, there can be no doubting the importance of the genre for him. He wrote more quartets than any other kind of instrumental music, and they include both his first published opus and his last major score but one, as well as two apprentice works. Each of the last four quartets, moreover, was composed directly after a large-scale choral or orchestral work (*A Child of our Time* (1939–41), the First Symphony (1944–5), the Fourth Symphony (1976–7) and *Byzantium* (1989–90) respectively), suggesting that at various points in his life the intimacy of the medium may have afforded Tippett a kind of creative refuge.

The first three quartets, written between 1934 and 1946, tend to be seen loosely as a group, since they belong to the composer's so-called 'first period' and share many of the same concerns. Furthermore, any affinities between them are inevitably reinforced by the sheer gulf in musical language that separates them from the Fourth and Fifth Quartets, which at times sound as remote from the earlier works as they do in turn from, say, Brahms or Schumann. This is especially true of the Fourth Quartet (1977–8), an astringent, at times almost rebarbative work which explores extremes of range, dynamics and sonority in a manner virtually unparalleled in the rest of Tippett's output. The Fifth Quartet, on the other hand, is closer in sound and spirit to the first three, sharing with them characteristics that seem to transcend stylistic boundaries – notably an intense lyricism, and an emphasis on continuity of line and the sustaining power of stringed instruments (few modern quartet composers have so eschewed timbral effect).

Common to all five string quartets is an indebtedness to Beethoven,

11 Puffett, 'Retreat', 13.

which manifests itself in many ways, nowhere more clearly than in matters of form. As Tippett himself explained, the number and nature of movements, and the relationship between them, were questions of overriding concern to him in his works from the period leading up to *The Midsummer Marriage*,[12] and this helps to account for the diversity of formal schemes adopted in the early quartets: the first in three movements with an opening sonata-allegro, the second in four movements with the main sonata movement placed last, the third a five-movement arch-structure in which fugue takes precedence over sonata principles. There is no sign, moreover, of this preoccupation having abated. The Fourth Quartet, like its companion works the Fourth Symphony and Triple Concerto (1978–9), is organised as a single movement with well defined sections, thus marking a conscious break with the past; while the Fifth Quartet is cast in two movements, a decision presumably also conditioned by earlier choices. This is an unusual scheme, unique in Tippett's published output and rare in the quartet repertoire as a whole. Among the few twentieth-century examples the most notable is Berg's Op. 3, although there are precedents among the Beethoven piano sonatas, including Op. 111 which has the same pattern of movements (fast–slow) as Tippett's quartet.[13]

Like Berg and Beethoven, Tippett set himself the challenge of building a balanced whole from two components, needing to avoid any sense of having created a body with a limb or two missing. With Beethoven there is a tendency for the movements to be less strongly differentiated than they might be in the context of a three- or four-movement work, and this is even more the case with the Berg quartet, where the two components are thematically integrated. The movements of Tippett's quartet, on the other hand, are widely divergent and show little evidence of specific musical linkage: the second, predominantly slow and inward-looking, contrasts sharply with the brisk, outgoing character of the first, and is more than half as long again in performance. Yet despite these emphatic differences there is no sense of imbalance. In order to see how Tippett achieves this, the internal balance of each movement – the relationship between form and content – needs to be considered.

12 Michael Tippett, sleeve note to the Lindsay String Quartet's recording of String Quartets Nos. 1–3, L'oiseau-lyre DSLO 10 (1975); see also CD liner notes to the Lindsays' recording of the complete Tippett string quartets, ASV CD DCS 231 (1996). 13 As noted in Hill, 'Tippett's Fifth String Quartet', 28.

Ex. 10.1 String Quartet No. 5, I: first subject

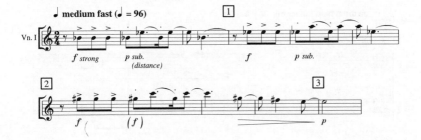

III

The Fifth Quartet's opening movement, like its counterpart in the revised Quartet No. 1 (1934–5, rev. 1943), is a sonata-allegro, although, in the absence of the strong tonal underpinning found in the earlier work, the sonata archetype adopted here is – to borrow the composer's own terminology – more 'notional' than 'historical'.[14] The three main sections are clearly defined, a bar's silence marking the end of the exposition (Fig. 35$^{-1}$), a cello solo the opening of the development, while a varied reprise of the first subject signals the start of the recapitulation (Fig. 55). Nowhere in Tippett's music, except perhaps when he quotes directly, is Beethoven's presence more keenly felt than in the drama and intensity of this movement's first subject (Ex. 10.1), in its restless forward drive, its strongly motivic character and its immediate development through sinewy counterpoint. A climax is reached at Fig. 7, with the most dissonant chord of the movement, initiating a transition section in which the mood of intensity continues and subsides, the instruments maintaining strict rhythmic unison throughout.

After such highly charged music there is every need for the kind of expansive lyricism that follows. The second subject (Ex. 10.2), set in a slightly slower tempo, unfolds at a leisurely pace, mainly through falling figures in two- and three-voice combinations which contrast effectively with the sharply rising contours and densely packed textures of the first subject. The main melody is concentrated in the first violin, which is joined

14 See Tippett's contribution to *The Orchestral Composer's Point of View: Essays on Twentieth-Century Music by Those Who Wrote It*, ed. Robert Hines (Norman, Oklahoma: University of Oklahoma Press, 1970), 203–19; adapted as the first section of 'Archetypes of concert music', in *Tippett on Music*, 89–108.

Ex. 10.2 String Quartet No. 5, I: second subject

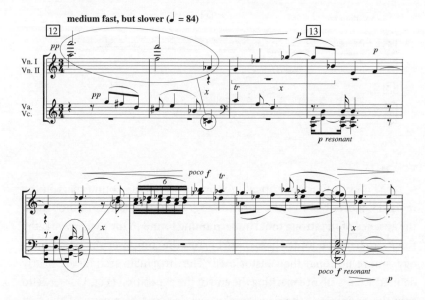

by the second in listless, quasi-rococo figuration. Brief echoes of the first subject are heard in the cello, and just before the climax of this section the violins, accompanied by the cello in its uppermost register, make passing reference to the same idea (Fig. 17$^{+3}$). The music sounds relaxed by comparison with what has gone before, yet there is an air of suppressed tension in the harmonies.

Two further, equally distinct ideas follow. The first (Ex. 10.3(a)) is linear, dynamic, even frenetic: a single figure – a series of triplet semi-quavers rising angularly to a point of attack – developed through a succession of increasingly extended statements, with the instruments again in rhythmic unison. The second idea (Ex. 10.3(b)), by contrast, is chordal – static rather than dynamic in effect: a series of 'ringing' chords, rhythmically animated by the cello, serving as a kind of codetta to the exposition, its final sounding bar (see Ex. 10.6(e), below) a distant echo of the movement's opening (Ex. 10.6(a)). Thus whereas the first and second subjects are motivically or thematically based, the closing sections of the exposition are essentially athematic explorations of texture and sonority.

The ebullient chord on which the codetta is centred typifies Tippett's

206

Ex. 10.3 String Quartet No. 5, I: end of exposition

(a)

(b)

late harmonic language in its combination of a major triad with additional notes – an example of what Whittall terms 'higher consonance'.[15] Similar formations, presented both melodically and harmonically, occur in almost every bar of the score, the choice and number of additional notes serving as a means of regulating tension. The combined major–minor triad features especially prominently, generating a significant quantity of melodic and harmonic material and thereby helping to unify the music's linear and vertical aspects (see figure *x* in Ex. 10.2).

In his exposition, then, Tippett presents us with a succession of sharply contrasted ideas which convey an overriding impression, despite an almost languorous second subject, of urgency and momentum. If the result is a somewhat episodic feel, the essence of the exposition nevertheless remains a Beethovenian contrast between the dramatic and the lyrical. The development, on the other hand, is more in the spirit of a fantasia. Considerably shorter than the exposition (77 bars as against 147), it falls into three short sections: a central *tutti* framed by duets in which canonic

15 Whittall, *The Music of Britten and Tippett*, 5.

Ex. 10.4 String Quartet No. 5, I: development section motives

(a)

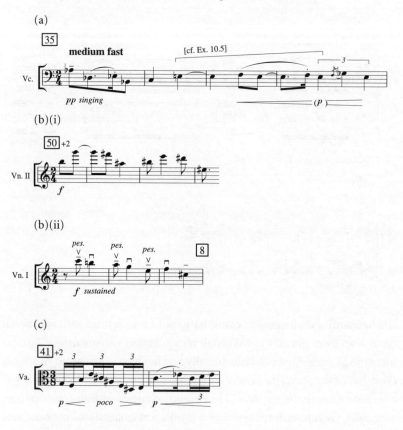

(b)(i)

(b)(ii)

(c)

imitation is the main structural device. There are various oblique references to the exposition, but the technique employed here is of passing allusion rather than development in any proper sense. This is apparent in the casual-sounding references to the first subject, heard in the cello at the opening (Ex. 10.4(a)), and then taken up, fugato-like, by the viola; in the evocation (Ex. 10.4(b,i)) of the syncopated rhythms of the transition (Ex. 10.4(b,ii)); and in the kinship between the triplet-semiquaver figuration of the duet sections (Ex. 10.4(c)) and that heard in the exposition (Ex. 10.3(a)). In each case there is an absence of common pitch-materials, yet the links, which are unmistakable, create a semblance of genuine developmental activity.

Ex. 10.5 String Quartet No. 5, I: development section: 'lyrical heterophony'

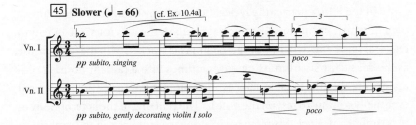

The chief interest of the development, however, lies in its central section, a remarkable passage of two-part counterpoint (Fig. 45ff.; Ex. 10.5) in which first violin and cello, doubling at a distance of three octaves, play one line, marked 'singing', while second violin and viola, doubling at the octave, present a closely related version of the same material. The latter is described in the score as 'gently decorating' the former, though in fact it both simplifies and embellishes. Its chief function is to shadow the main line, but it also pre-empts and coincides with this part, thereby creating a deliberate confusion of identity between the two. It is this fluid, unpredictable aspect of their relationship that has such a spellbinding effect on the ear. Tippett's 'lyrical heterophony', as it has been aptly described, has its origins in the melismas associated with the character Pelegrin in the opera *New Year* (1986–8; see, for example, Fig. 171ff.); and a very similar kind of music occurs in the closing pages of *The Rose Lake* (1991–3), as 'The lake sings itself to sleep' (Fig. 152ff.). The technique – an astonishing example of the composer's capacity for innovation in old age[16] – may owe something to far-eastern influence;[17] yet it is also worth remembering the close association between two-part counterpoint, octave doublings and the interval of a major second in various of his earlier works (for example, at the openings of

16 In the documentary film *Tippett's New Quartet* (Yorkshire Television, 1992), the composer, in a characteristic aside, describes the lyrical heterophony as 'the only new thing' in the work. I am grateful to the director, Tony Scull, for his generous loan of a copy of his film.

17 Tippett visited the Far East first in 1978 and again in 1984. He briefly refers to the influence of gamelan music on his Triple Concerto in *Those Twentieth Century Blues: An Autobiography* (London: Hutchinson, 1991), 258. For a discussion of how this impinges on the thematic processes of the concerto see Stephen Collisson's contribution to the present volume, pp. 146, 150–7.

the Concerto for Double String Orchestra (1938–9), String Quartet No. 2 (1941–2), and Piano Sonata No. 1 (1936–8, rev. 1942, 1954)).

In the Fifth Quartet the lyrical heterophony comprises four phrases, each of which begins on B♭ and expands upon the previous one in length, registral space and dynamic range. A climax is reached with the final phrase, as the music bursts from its narrow confines into a radiant flourish of F♯ major (Fig. 49), the most tonally explicit moment of the entire movement, eventually coming to rest on the note C. The centring of the heterophony on B♭ is significant, since this pitch is given special emphasis in the exposition, where it is strategically located within a variety of contexts: as the very first note of the work that we hear, placed at the top of a chord in which quartal and triadic elements vie with one another (Ex. 10.6(a)); as the pitch that initiates the developmental process a few bars later (Ex. 10.6(b)); as part of a dyad, with C, which forms a point of repose between the conclusion of the second subject and the start of the next section – an arresting moment, made all the more distinctive by its use of harmonics (Ex. 10.6(c)); as part of the decorated broken chord of B♭ that emerges as the eventual goal of the triplet-semiquaver passage (Ex. 10.6(d)); and, finally, as part of the penultimate chord of the exposition (Ex. 10.6(e)), itself a skeletal version of the opening chord. The lyrical heterophony, which could be seen as an elaboration of the earlier dyad (both in its oscillations between the two pitches in question and in its description of a broad progression from one to the other), confirms B♭'s pre-eminent status.

The effect of the heterophonic passage is revelatory, as suddenly we are shown a world of which we previously had no real inkling.[18] It is precisely such moments that earn Tippett the label 'visionary'. The sense of surprise is no less than that created by the introduction of the E minor theme into the first movement development section of the 'Eroica' Symphony – to take the most celebrated classical example of its kind – though the means of achieving it (texture, counterpoint) are of course quite different from Beethoven's (tonal remoteness, melodic profile). At the same time there are, as we have seen, delicate connective tissues linking the heterophony to the

18 In fact the melodic contour of the first bar and a half of the main line is adumbrated by a comparable oscillation between E and F in the cello's melody at the beginning of the development (compare Exx. 10.4 (a) and 10.5), subsequently imitated a perfect eleventh higher by the viola; but none of this diminishes the sense of surprise when the heterophony begins.

Ex. 10.6 String Quartet No. 5, I: B♭ as a strategic pitch

(a)

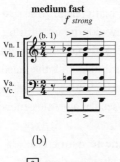

(b)

(c)

(d)

(e)

exposition, with the result that the relationship between these sections is ambiguous. Tippett may have rejected the idea of a conventional development section partly because he saw the main development as having already taken place in the opening pages of the score, but the main reason, one suspects, is that a more traditional approach would have conflicted with his evident wish to sustain the sense of diversity and renewal that characterise the exposition. Indeed the tension between this impulse and the need within a sonata-form framework to keep the material under control (a tension also characteristic of late Beethoven) may be seen as a prime generating force behind the first movement.

As a result of this continuing sense of renewal, the need for consolidation by the time we reach the recapitulation is that much greater, and it is perhaps this rather than any lack of formal adventurousness on Tippett's part that accounts for his close adherence to the pattern of the exposition. There are just five points of divergence: at the beginning of the recapitulation (Fig. 55), where the threefold statement of the first subject is punctuated by cello figuration carried over from the end of the development; at the end of the transition (Fig. 69^{+3}), where the insertion of two extra bars facilitates transposition of the opening of the second subject from its original pitch; at two points during the second subject itself (Fig. 71^{+2} and Fig. 76^{+3}), where, as if to underline the importance of the movement's lyrical dimension, the material is briefly expanded; and at the very end, where the exposition's codetta is transformed into a full-scale coda (Fig. 94^{+2}). Otherwise, exposition and recapitulation are identical.

IV

The first movement of the Fifth Quartet is, as we have seen, a truly Beethovenian sonata-allegro in the way in which it thrives on the tension between the dramatic and the lyrical. What kind of movement could follow one as highly charged and as purposeful as this? Certainly not another of comparable character. Tippett needed a movement which would not only contrast well with the first but, in order to balance that movement successfully, would itself contain strongly contrasted elements. Once again, Beethoven was his model.

A similarity has been noted between the ground-plan of Tippett's

Ex. 10.7 (a) Tippett, String Quartet No. 5, II: opening

(b) Beethoven, String Quartet, Op. 132, III

slow movement and that of the central *Heiliger Dankgesang* ('Holy Song of Thanksgiving') of Beethoven's late A minor quartet, Op. 132. In both cases 'slow, contemplative music of utter simplicity', as Meirion Bowen puts it, alternates with 'episodes straining towards affirmation';[19] but whereas Beethoven uses the material of the first episode as the basis of the second and significantly modifies the main theme in its final statement, Tippett uses different material for each episode and twice restates his main idea in full. Thus the form of Beethoven's movement may be summarised as $A^1-B^1-A^2-B^2-A^x$, that of Tippett's as $A^1-B-A^2-C-A^3$. These alone are hardly grounds for positing a connection (other works of Beethoven employ similar schemes), yet, as so often with Tippett, the influence of Beethoven runs deeper than formal planning.

The two ideas which form the basis of Beethoven's slow movement are not merely contrasted, they belong to different worlds – worlds that seem to be mutually exclusive. On the one hand there is the hymn tune,

19 Liner notes to the Lindsay String Quartet recordings of Quartet No. 5 (ASV CD DCA 879 (1993)), and the complete string quartets (ASV CD DCS 231). See also Meirion Bowen, *Michael Tippett*, 2nd edn (London: Robson Books, 1997), 207.

Ex. 10.8 String Quartet No. 5, II: section A

written in the Lydian mode, an archaism which has been likened, in its radical effect, to a neoclassical work of Stravinsky.[20] It enabled Beethoven to achieve the most extreme possible contrast with classical tonality that was available to him, and provided him with a remote and mystical aura in which to express thanks following his recovery from illness. Twice the hymn is interrupted by a powerful vision of new strength ('neue Kraft fühlend'), as the music changes abruptly from slow, subdued, modal counterpoint to a lively, tonal theme-plus-accompaniment. It is difficult to imagine a greater degree of musical contrast than this.

Tippett also presents us with two distinct soundworlds, though these are not as mutually exclusive as Beethoven's. On the one hand there is the slow, contemplative, lyrical music of the A sections; on the other the quick, extrovert, dance-like music of the intervening episodes. The contrast, essentially, is between song and dance, stasis and motion.

Section A unfolds a succession of seemingly disconnected ideas. It opens with a series of rising imitative entries built on the combined major–minor triad that played an important part in the first movement (Ex. 10.7(a)).[21] This is followed by a plaintive, unaccompanied melody in the first violin which closes with a falling augmented fourth played *glissando*. The entire opening paragraph is then repeated an augmented fourth higher (Fig. 103), with the *glissando* figure expanded into a series of imitative entries. The rising and falling thematic shapes ascend and descend

20 See Joseph Kerman, *The Beethoven Quartets* (London: Oxford University Press, 1967), 254.
21 The same chord opens Tippett's Fourth Symphony and is featured in *The Mask of Time* (1980–2) and the Fourth Piano Sonata (1984).

214

Ex. 10.9 String Quartet No. 5, II: section A

respectively through the quartet texture, each set quietly evoking the inter-
ludes which frame the phrases of Beethoven's cantus firmus, but less in the
manner of a quotation or parody than as a profession of affinity (compare
Ex. 10.7 (a) and (b)). Next, the first violin, supported by static harmonies,
describes a melody of languishing, neo-romantic contours (Fig. 107; Ex.
10.8), which likewise is restated, this time a perfect fifth lower (Fig. 109). For
a few bars the music assumes a sombre, even menacing tone, with rapid
oscillations on an augmented fourth, but this quickly gives way at Fig. 113
to a serene passage in D major (Ex. 10.9) – a transcendent moment similar
in effect to the introduction of the A major chords at the close of
Beethoven's hymn and as striking in its tonal explicitness as the burst of F#
major in the first movement (Fig. 49). The pulsating first violin line evokes
the lyrical heterophony of that movement, while recalling the *Andante
espressivo* passage preceding the fugue of Tippett's *Fantasia Concertante on
a Theme of Corelli*, written nearly forty years earlier (1953).

Section A concludes with a remarkable pair of four-bar phrases, iden-
tical save for the final chord and a slight variation in the dynamic markings.
The similarities to Beethoven's hymn, if initially obscured by the
differences, are nevertheless unmistakable (see Ex. 10.10): the number of
chords to a phrase (eight in each case, if one excludes Beethoven's anacru-
sis); the strict rhythmic unison between parts, except on the penultimate
chord; and the crescendo from a dynamic level of *piano*. As with the allu-
sions to Beethoven's interludes, the relationship is oblique, tangential,
elusive. (At the very end of the Tippett movement a variant of the four-bar
phrase is heard, with the note values doubled and the broad melodic
contour of the music retained, but the exact pitches altered. A cadence on A

is reached, confirming the central importance of this pitch to the movement. As in *The Midsummer Marriage*, the opening of the Fifth Quartet centres on B♭, the close on A.)

One is immediately struck by the extraordinary subtlety and delicacy of the music of section A: by the way in which such a range of ideas, harmonies and colours coheres into a satisfying whole. The mood is subdued, hesitant, uncertain; yet to question, as one commentator has done, whether the air of uncertainty is the result of miscalculation[22] is surely to mistake the intentions of a composer who, in this instance at least, is manifestly unconcerned with unity and goal-directedness. There can be little doubt that the air of uncertainty is calculated, and that in juxtaposing such diverse melodic and harmonic types Tippett has sought a particular effect. Wholetone, modal, diatonic and atonal elements are all present, with the first especially strongly felt – whether in the opening chords, the augmented triad in the central section, the harmonies which interrupt the recollection of the lyrical heterophony at Fig. 115[−1] or, most importantly, the use of the augmented fourth. It is not until the concluding chords of section A that the true reason for the emphasis on this interval becomes apparent. While the tonal material of these chords may be that of C major, it is clear from the melodic direction and emphasis of the individual lines that the composer's thinking here is conditioned by the Lydian mode. At the mid-point cadence (Ex. 10.10(a)) a wonderful chord is heard which comprises the first four notes of the mode (which also happen to be the first four notes of the wholetone scale), widely spaced so as to underline the chord's special significance as mediator between Beethoven's world and Tippett's.

No less remarkable than the allusions to modality is the neo-Mahlerian writing of the central part of section A (Ex. 10.8), a passage apparently quite unlike anything else that Tippett composed. It is as if, in the Indian summer of his creative life, he had discovered the joys of romantic harmony. The music sounds as far removed from the norms of his late style as does the Lydian hymn from those of Beethoven's: each composer, by embracing an archaic idiom, seems to be deliberately putting a distance between himself and the listener. Yet in neither case does the idiom sound out of place. Quite the contrary. Carl Dahlhaus, writing about Beethoven's

22 Hill, 'Tippett's Fifth String Quartet', 29.

Ex. 10.10 Allusions between (a) Tippett, String Quartet No. 5, II; and (b) Beethoven, String Quartet, Op. 132, III

(a)

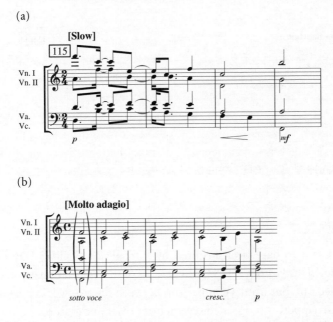

(b)

use of the old church modes, has commented on the way in which 'the distinction between past [and] present . . . fades and becomes unimportant', of how 'the aesthetic "present" proves independent of the chronological distinctions between "past" and "present"'.[23] His remarks seem every bit as pertinent to Tippett, who, like Beethoven, succeeds in making the 'old' style his own and avoids any sense of parody.

For the episodes of this movement, Tippett reverts to a familiar idiom, with music whose affirmative qualities throw the preceding sections into sharp relief. Quick in tempo, dance-like in character, each is based on a single musical idea which is repeated, varied and briefly developed, the instruments largely paired, in a manner reminiscent of some of the first movement's textures – all of this in marked contrast to the heterogeneity and solo-plus-accompaniment writing of the A sections. The second

23 Carl Dahlhaus, *Ludwig van Beethoven: Approaches to his Music*, trans. Mary Whittall (Oxford: Clarendon Press, 1991), 220.

Ex. 10.11 Allusions between (a) Tippett, String Quartet No. 5, II, section C; and (b) Purcell, *Welcome to All the Pleasures*, instrumental ritornello

(a)

(b)

episode is said to have been inspired by Purcell's St Cecilia's Day ode *Welcome to All the Pleasures* (1683).[24] The basis of this association has never been spelled out, but from a comparison between the two works it would appear that Tippett appropriated several brief rhythmic gestures from the instrumental ritornello of Purcell's opening chorus (see Ex. 10.11). So commonplace are the borrowed rhythms, however, so pronounced the melodic and harmonic differences between the original and its reincarnation, that it is difficult to imagine even the most discerning listener inferring an association.

The sheer contrast between these episodes and the variation sections with which they alternate is in many ways as pronounced as it is in the *Heiliger Dankgesang*. It is not in his adoption of a similar ground-plan for the slow movement that Tippett's principal debt to Beethoven lies, then, or even, necessarily, in his symbolic references to the Lydian hymn, but rather in the nature of the contrasts he presents us with. Perhaps here, as in the *Heiliger Dankgesang*, there lurks an autobiographical programme; it was, after all, just two years before he began writing the Fifth String Quartet that Tippett underwent a major operation for colonic cancer – an event which,

24 According to Peter Cropper, first violinist of the Lindsay Quartet: see liner notes to ASV CD DCA 879.

as he later recalled in his preface to *Those Twentieth Century Blues*, gave him his 'first real intimation of mortality'.[25] With this knowledge in mind, it is difficult not to hear the contrasts in Tippett's movement, like those of Beethoven's, as an alternation between frailty and strength, acceptance and hope. Just as the *Heiliger Dankgesang* is Beethoven the convalescent's expression of gratitude, so may Tippett's slow movement be heard as the composer's own song of thanksgiving.

Whether or not one accepts such an interpretation, there can be no denying the central importance of song both to this movement and to its companion; indeed lyricism is really the binding force between the two. Prefacing the score is a quotation from a French folksong, 'Chante, rossignol, chante toi qui as le cœur gai',[26] which recalls the composer's own description, nearly fifty years earlier, of the way in which the 'peculiar liquid tone' of the nightingale's song 'can sound like someone sobbing from heartbreak, which makes us respond deep down inside'.[27] If there is a passage in the work that attempts to capture this effect, it is surely the unaccompanied violin line of the slow movement. Tippett marks this 'singing', as he does the most lyrical moments in the score, suggesting that behind the music, as in the late Beethoven quartets, there lies a strong vocal impulse. Joseph Kerman has written of the 'sheer songfulness' of those works, of 'lyricism in all its manifestations',[28] and one has only to think, for instance, of the *Cavatina* of Op. 130 or the slow movement of Op. 135 to recognise what he is describing. Tippett's adoption of the marking 'singing' may even owe something to Beethoven's unusual use of the Italian equivalent, *cantante*, at the start of the Op. 135 slow movement, in preference to the more conventional but less explicit expression marking *cantabile* ('singable' or 'songlike').

Several commentators have noted ways in which Tippett's other string quartets are influenced by Beethoven. The revised version of the opening movement of the First Quartet, for instance, is regarded as closely

25 Tippett, *Those Twentieth Century Blues*, xii.

26 The song from which this is taken is 'A la claire fontaine', for which information I am grateful to Hélène Renvez. (The published score of the Fifth String Quartet gives the form of the imperative as 'chantes'.)

27 Michael Tippett, 'A composer's point of view', in *Moving into Aquarius*, 2nd edn (St Albans: Paladin Books, 1974), 14; *Tippett on Music*, 3.

28 Kerman, *The Beethoven Quartets*, 195.

based on the Beethovenian sonata model, while both the fugal slow movement and the finale of the Quartet No. 2 are seen as specifically indebted to Op. 131.[29] If the Third Quartet owes more to Bartók than to anyone else, its fugues have nevertheless been described as Beethovenian and its opening likened to that of Op. 127.[30] But it is the Fourth Quartet that is the most explicitly Beethovenian of them all, in that its final section – with material 'full of Promethean struggle', as Kemp so aptly puts it[31] – refers directly to the main theme of the *Grosse Fuge*. While the first movement of the Fifth Quartet owes much to the general example of Beethoven, the second engages, perhaps more fully than any other of Tippett's quartet movements, with a specific model, and through this, with its composer's physical and spiritual struggles. When he wrote it Tippett knew this quartet would be his last, and that his *œuvre* was nearly complete; it is therefore especially fitting that this work should have become the vehicle for so personal a tribute to his life-long mentor.

V

It will come as no surprise, in the light of the foregoing discussion, to discover that the present writer finds no evidence, at least in this particular work, of the decline which Puffett alleges. To be sure, the Fifth String Quartet, like the Fourth, is concerned with a very different set of compositional problems from those of the first three. But then that is only what is to be expected from a composer whose musical language underwent such far-reaching changes – from an essentially tonal language in which sustained thematic development and transformation play a central role, to an essentially atonal one which, while embracing tonal elements, no longer has these processes as its main formal objectives. Far from being an unworthy companion to its predecessors, the Fifth Quartet seems to be every bit their equal in terms of the quality of its ideas, the skill and

29 David Matthews, '"Mirror upon mirror mirrored": some notes on Tippett's allusions', in *Michael Tippett, O.M.: A Celebration*, ed. Geraint Lewis (Tunbridge Wells: Baton Press, 1985), 36–7; on the slow movement, see Derrick Puffett, 'The fugue from Tippett's Second String Quartet', *Music Analysis* 5/2–3 (1986), 241–3.

30 David Matthews, *Michael Tippett: An Introductory Study* (London: Faber & Faber, 1980), 42–3. 31 Kemp, *Tippett*, 479.

imagination with which they are handled, and the level of engagement with new formal challenges and, in particular, with the example of Beethoven.[32] It is a work which carries powerful resonances of the musical past, both Tippett's own and that of his most cherished predecessors, while remaining thoroughly of its time. Its finest moments have a beauty arguably no less intense or magical than the most inspired in all the composer's music. Above all, Tippett shows a remarkable capacity for renewal, for a freshness and spontaneity of invention, and for surprise – whether in the lyrical heterophony of the first movement or the Mahlerian harmonies of the second.

This is not to suggest that the quartet is a flawless masterpiece. But then Tippett was, by consensus, a flawed genius; one must expect to have one's reservations. In quoting those of Paul Driver and Arnold Whittall earlier, the important fact that both writers have subsequently revised their views was deliberately omitted. Driver, in a glowing eightieth birthday tribute to the composer, wrote of previous doubts being 'swept away' and 'old amazement' 'restored',[33] while Whittall significantly modified his reservations about the quality of the late works: 'it would be difficult', he wrote in the second edition of his book, 'to claim that any of the works written since the mid-1970s clearly surpass [replacing 'are the equal of'] the earlier compositions'.[34] It is to the credit of both writers that they have been ready to modify their views in this way, yet in doing so they follow an all-too-familiar pattern in the reception of Tippett's music: initial doubt, subsequent acceptance. That, it seems, has been the experience of a number of writers, and, who knows, had personal circumstance allowed it perhaps even Derrick Puffett would himself one day have found an accommodation with the late music. Ian Kemp may well be right, as Puffett so vehemently maintained, in regarding *The Midsummer Marriage* as 'the fulfilment of an artistic programme which remains the touchstone against which all

32 Tippett's own misgivings as to whether, in his late eighties, he would be capable of producing a work that would match the standard of his earlier quartets are recounted in the film *Tippett's New Quartet* (see note 16, above).

33 Paul Driver, 'Tippett at 80: a personal tribute', *The Musical Times* 126, No. 1703 (January 1985), 12.

34 Whittall, *The Music of Britten and Tippett*, 2nd edn (Cambridge: Cambridge University Press, 1990), 292.

[Tippett's] works can be measured'.[35] Yet such an approach carries with it the risk of inhibiting a fuller critical acceptance of the late music, of making us prisoners of the composer's past who spend our time yearning for the restitution of what we perceive as a kind of fallen creative world. The one person who did not become a prisoner of his past was Tippett himself, a fact which his advocates as well as his detractors would do well to remember.

35 Kemp, *Tippett*, 86. Interestingly Wilfrid Mellers, in the preceding chapter in the present volume, considers 'the peaks of Tippett's work' to be in the earlier part of the composer's *œuvre* (p. 193), while at the same time finding the music of *New Year* 'hardly less lyrically compelling' than that of *The Midsummer Marriage* and 'perhaps slightly more luminous in harmonic and orchestral texture' (p. 197).

Appendix: glossary of terms used in pitch-class set theory

Note: this Appendix is not intended to be a comprehensive list, nor are the definitions provided meant to be complete or formal; the intention is essentially to offer a guide to set-theoretical terms used in this book. The classic text on pitch-class set theory is Allen Forte's *The Structure of Atonal Music* (New Haven and London: Yale University Press, 1973). User-friendly introductions are to be found in Nicholas Cook's *A Guide to Musical Analysis*, paperback edn (London: J. M. Dent & Sons: 1989), chapter 4; Joseph Straus's *Introduction to Post-Tonal Theory* (Englewood Cliffs, New Jersey: Prentice Hall, 1990); and Jonathan Dunsby and Arnold Whittall's *Music Analysis in Theory and Practice* (London: Faber Music, 1988), chapter 12.

Pitch class (*pc*): Any representative of a given pitch, regardless of register. Thus pitch class C could be represented by middle C, C an octave higher, C an octave lower, etc. Pitch classes may also be referred to using **integer notation**, which reduces enharmonically equivalent terms to the same numeric indicator. Thus C (or B♯, or D♭♭) = 0; C♯ (or D♭) = 1; D (or C𝖝, or E♭♭) = 2; and so on to B (or A𝖝 or C♭)=11.

Pitch-class set (*pc set*): A collection of pitch classes, which may be configured linearly (melodically), or vertically (harmonically) or as some form of aggregate – usually as the result (one hopes) of some meaningful analytical segmentation of musical material. Pc sets are normally described using integer notation, for example [2,3,5,8].

Set class: An entire class of pc sets that are transpositionally and inversionally equivalent. For example, set class [0,1,6] could be represented by the pcs [C, C♯, F♯]. But it could equally be represented by its inversional equivalent [C, B, F♯]; or by any transposition of either of these sets, e.g. [D, E♭, A♭] or [D, C♯, G♯]. (In these cases the pcs are transposed by two semitones, described technically as the **transposition operator** t = 2.)

Moreover set classes are examples of **unordered sets**. That is, the cited order of their pcs may not correspond to the order in which they occur in an actual musical instance. Thus if set class [0,1,6] is represented by the collection [C, D♭, G♭], these pcs might in fact occur in the order [D♭, G♭, C]. The high level of abstraction characteristic of set classes makes it possible to posit a large range of equivalence between sets.

Set classes are also often referred to by their **set name**. For example the name for set class [0,1,6] is 3-5. The numeral to the left of the hyphen refers to the set's

cardinality, that is, the number of elements it contains. The numeral to the right of the hyphen refers to the ordinal position of the set in the inventory of set classes given as Appendix 1 of Forte's *The Structure of Atonal Music*.

Interval class (*ic*): An integer used to describe an interval in semitones, but which also conflates that interval with its inversional equivalent. Thus interval class 1 (ic1) is represented by the interval of a semitone and its inversion, the major seventh; ic2 by a major second and minor seventh; and so on. There are only six interval classes, since intervals bigger than a tritone (ic6) are already equivalent to intervals smaller than that compass; for example a major sixth is equivalent to a minor third (ic3).

 Interval classes are in fact a way of describing the intervallic distance between pitch classes. Thus, as with pcs, register is disregarded. Hence ic4 might represent a major third, or major tenth; minor sixth or minor thirteenth; and so on.

Complement: The complement of a pc set x is the set of all pcs not included in x.

Kh- and K-relations: species of **inclusion relations** between set classes of differing size. Two set classes x and y are Kh-related if x contains y, *and* if the complement of x is contained within the complement of y. If only one of these conditions obtains then the two sets are K-related.

R-relations: species of **similarity relations** between set classes of the same size. Two set classes are R_p-related if all elements but one of their pitch class content are identical – e.g. sets 4-4, [0,1,2,5], and 4-6 [0,1,2,7]. Other species of R-relations (e.g. R_1, R_2) describe varying degrees of similarity between the interval class content of a set class (described in more detail in Forte, *The Structure of Atonal Music*, 48–51).

Index